Black Time and the Aesthetic Possibility of Objects

Black Time and the Aesthetic Possibility of Objects

Daphne Lamothe

The University of North Carolina Press CHAPEL HILL

Set in Merope Basic by Westchester Publishing Services
Manufactured in the United States of America

Library of Congress Cataloging-in-Publication Data
Names: Lamothe, Daphne Mary, author.
Title: Black time and the aesthetic possibility of objects / Daphne Lamothe.
Description: Chapel Hill : University of North Carolina Press, [2023] |
 Includes bibliographical references and index.
Identifiers: LCCN 2023034104 | ISBN 9781469675305 (cloth ; alk. paper) |
 ISBN 9781469675312 (paperback ; alk. paper) | ISBN 9781469675329 (ebook)
Subjects: LCSH: Aesthetics, Black. | American literature—African American
 authors—20th century—History and criticism. | American literature—
 African American authors—21st century—History and criticism. | English
 literature—Black authors—20th century—History and criticism. |
 English literature—Black authors—21st century—History and criticism. |
 Musicians, Black—Belgium—History and criticism. | Artists, Black—
 United States—History and criticism. | African diaspora. | BISAC: SOCIAL
 SCIENCE / Ethnic Studies / American / African American & Black Studies |
 SOCIAL SCIENCE / Black Studies (Global)
Classification: LCC BH301.B53 L36 2023 | DDC 111/.8508996073—
 dc23/eng/20230821
LC record available at https://lccn.loc.gov/2023034104

Contents

Figures

Acknowledgments

I am grateful for the loving support of my family, especially my husband, Rutherford; my daughters, Maya and Kira; and my parents, Carlo and Germaine. They gave me space and time when I needed to concentrate, and laughter, nourishment, and companionship when I needed a distraction from work. They buoyed my spirits during the long, sometimes challenging, process of bringing this book to life.

Thank you to the staff at The University of North Carolina Press. They graced me with their steadfast guidance and dedication on each step of this journey. I'm especially thankful for the press's amazing cover designer and the anonymous readers whose shrewd and discerning feedback inspired me to stake my claims with greater boldness and clarity. I don't have enough words to express the depths of my gratitude for my editor, Lucas Church. Lucas was my first "outside reader" to see this work's potential. As my arguments gradually took shape and inevitably evolved, Lucas expressed nothing but trust and support in my vision. Thank you.

I could not have completed this book without the institutional support of Smith College. In the earliest stages of this project, I worked on some of its central ideas as a fellow at the Kahn Liberal Arts Institute. As much as the college's generous institutional resources helped, I am especially grateful for the intelligence and friendship of my faculty colleagues, especially in the departments of Africana and American Studies, the Study of Women and Gender, and English. Carrie Baker, Ginetta Candelario, Andrea Hairston, Rick Millington, and Cornelia Pearsall offered meaningful support at a critical juncture, helping me to move this project forward. Thanks also to Tarika Pather for being a great reader and superb research assistant.

Cynthia Dobbs, Kate McCullough, Sonnet Retman, Theresa Tensuan, Valorie Thomas, and I organized several panels at the American Comparative Literature Association that allowed me to workshop early versions of my ideas while in the company of some of the smartest, kindest, and most critically astute scholars whom I have the pleasure of knowing. The year I spent at Duke University as a Humanities-Writ-Large (HWL) fellow gave me access to yet another brilliant and generous community of scholars. I am especially grateful to Lee Baker, J. Kameron Carter, Laurent DuBois, Adriane Lentz-

Smith, and Joseph Winters for welcoming me into their intellectual exchanges and conversations and for their friendship. Most of all, I value the hours spent exploring the Raleigh-Durham area's museums, galleries, bars, and restaurants with the other HWL fellow in my cohort, the art historian and curator Jerry Philogene. During our many visits to museums and galleries, Jerry and I shared the pleasures of "slow looking" at art with open-minded curiosity, which ultimately inspired me to write about visual and musical texts in addition to literature.

Lisa Armstrong's friendship and intellectual companionship played a critical role, especially as I worked through the middle stages of writing. Without the hours of conversation during our walks and runs along Northampton roads and an especially memorable weekend wandering the trails of Woods Hole, Massachusetts, I would not have found my way to the clarity needed to articulate what I needed to say. More than a mere colleague, she is someone whose friendship I treasure.

Writing is mostly a solitary activity, but throughout I have never felt truly alone because of dear friends and colleagues, most especially Kevin Quashie. If it isn't always obvious, his creative-critical brilliance is woven into the very DNA of my own thinking and writing. As I worked to find an authorial voice that felt authentic, Kevin urged me to not lose sight of the rightness of thinking and writing freely, and to trust that the work will ultimately find its right readers. With his encouragement and company, I have embraced the challenge of following the line of an idea wherever it leads and to do so with intellectual rigor and a keen eye for beauty.

Black Time and the Aesthetic
Possibility of Objects

Introduction
A Body in the World

This is a study of art, literature, and culture, made in the last decades of the twentieth and first decades of the twenty-first centuries, by creative and culture workers from across the Black Atlantic world. This is a study of the diasporic imagination, but not in the conventional sense of focusing on narratives by and about Black bodies severed from home. Instead, I am using diasporic subjectivity and formations as a hermeneutic, an analytical framework from which to think about the enduring problems and possibilities of a Black body unmoored in the world. In this way, my analysis approximates that of Sara Ahmed, who in *Queer Phenomenology* uses the language of disorientation and reorientation to consider the perspectives and experiences of migratory subjects and their relationship to the surrounding, often hostile, world.[1]

In the following pages, I foreground the place of the aesthetic in broadening and transforming the ways that we think and write about Blackness, whether as an enduring problem or otherwise. Paul C. Taylor's definition of Black aesthetics in *Black Is Beautiful: A Philosophy of Black Aesthetics* beautifully captures my own understanding and deployment of the term *aesthetics*: "the practice of using art, criticism, or analysis to explore the role that expressive objects and practices play in creating and maintaining black life-worlds."[2] As a literary and cultural studies scholar, I foreground the aesthetic in my engagement of ideas of Blackness and time. That is because time, as Heidegger tells us, is always inherently about being, and in the case of Black being and becoming, so too are imagination and aesthetic invention. My aim here, then, is to offer arguments where the temporality of Blackness is not largely historical or social but rather oriented toward the creativity and inventiveness associated with aesthetic time.

Aesthetic time names a state of suspension that makes space for the multiple, overlapping temporalities of Blackness. Black time can be cyclical and recursive or linear and future-oriented. Depending on one's perspective, it can be static, aimless, or determined in the march toward true emancipation. And almost always, these adjectives index racial experience to the temporalities of history and politics. What marks aesthetic time as distinct,

however, is its capaciousness, its ability to function as a holder of the accumulation of Black temporalities: from the experience and knowledge gleaned from history to the political urgencies of the present and the immediacy of subjective feelings and perceptions. As such, aesthetic time exists outside and against the diachronic rhythms of normativity. Therefore, it can lead from thresholds of thought and imagination to spaces where the possible and impossible coexist.[3]

This book is divided into two sections, both of which use the form of the essay to pursue lines of inquiry into the role of different modes of Black time and their function in the aesthetic invention of Black being. The first section is composed of four chapters that each in their own way meditates what for me are interrelated concepts of aesthetic time and optimism. They are (1) a reading of a musical text that explores the sonic and social geographies of Blackness in a modern European metropolis, (2) a mediation on close reading as a critical orientation toward Blackness, (3) a consideration of aesthetic optimism in the era of Black pessimism, and (4) an analysis of *Black time* that conceptualizes the post-ness of the post-soul aesthetic as the time of Black being and becoming.

One could read these four chapters as different variations on a theme whose intertwined ideas and arguments unfurl in concentric circles, foregrounding different perspectives on the matter of Blackness, being, and time. Grounded in the understanding that Blackness and diaspora represent both dynamic processes and hermeneutical frameworks, my analyses focus on the ways that art-objects and representational acts engage in the invention of ideas of Black being-ness that lie in excess of the objectifying ideas projected onto racialized bodies. Blackness as a concept is so slippery and hard to pin down that we ought of think of Black Studies and racial representation as partial attempts rather than as definitive/defining acts.

In each chapter, aesthetic time, associated with dreaming, imagining, and moments of aesthetic encounter and engagement, figures prominently. Each takes an essayistic approach to the study of the aesthetic possibilities of world-making. In other words, in place of a unifying theory of Blackness, this book argues for a critical praxis, grounded in aesthetic thinking and orientation, that seeks generative possibilities in dialogic, dialectal, and relational thinking about Blackness and its meanings. This approach refuses the false allure of monolithic and totalizing narratives of Blackness and focuses instead on naming and performing flexible and exploratory forms of critical engagement (reading, listening, looking, and writing). Thus, in

form and content, this book represents a curiosity-driven practice of "essayism," defined by Brian Dillon as "tentative and hypothetical . . . a habit of thinking, writing and living that has definite boundaries."[4] Indeed, Dillon's reflections on the genre of the essay resound, as I view each chapter as the product of two impulses: to "hazard or adventure" new and, perhaps, unconventional ideas and to compose a work that is conceptually, thematically, and stylistically whole.

The second section offers four chapters that engage visual and literary works that foreground the role of art and imagination. The first chapter explores the historical and aesthetic temporalities of a visual text that strives to broaden the landscape of the Black imaginary. The next two chapters focus on works by Paule Marshall and Dionne Brand, authors who try to make sense of the present by examining it through the prism of the historical past. Their explorations of the histories of slavery and the Middle Passage and coloniality make use of what Stephen Henderson calls "mascon" symbols: tropes imbued with "a massive concentration of black experiential energy" that carry emotional and psychological resonance.[5] Aesthetic time coexists with historical time in their texts; the two temporalities stay suspended in a vital yet fragile state of symbiosis. What I mean is that Marshall's and Brand's narratives hold the idea of writing Black people into history and also at the same time insist that Black people's humanity need not be legislated or debated but rather, simply, exists.[6] The fourth and final chapter in this section focuses on Zadie Smith's depiction of an unnamed protagonist whose vexed relationship to Blackness inspires a host of provocative, generative questions about race and relationality.

One effect of my decision to write a book about Atlantic World Blackness through an aesthetic framing is the implicit challenge it presents to the primacy of critical frameworks that put the stress on materiality and embodiedness. The terms that repeat in each chapter, be they *aesthetic, poetics, imagination,* or *invention,* gesture implicitly toward the discursive production of Blackness as an idea and epistemology, as a world-building endeavor.[7] As a result, what readers will find in these pages is a critical perspective that focuses less on the racial consciousness and/or identities produced in response to being subjected to structural and state-sanctioned anti-Black violence and more on the aesthetic imaginings that render the presence that Margo Crawford conceptualizes as Black "is-ness." The point in adopting this critical orientation is not to ignore or minimize the enduring significance and material effects of anti-Blackness and other forms of oppression

and injustice. Rather, my point is that without aesthetic invention and imagination, a too narrow focus on structure and ideology threatens to fore-close meaningful conversation about the multiple inhabitances and chang-ing meanings of Blackness. Therefore, in the discussions of creative Black texts that follow, questions of displacement and severance are always in play, and so too is the understanding that imagination and creative inven-tion play vital roles in our encounters with and envisioning of Black being in worlds of relational possibility.

Stromae's Relational Aesthetic

In May 2013, someone anonymously uploaded a sixty-second video titled "Stromae Bourré à Bruxelles!" (Stromae Drunk in Brussels!) to YouTube. The images, seemingly captured by a cellphone, show the musician Paul Van Haver in a state of apparent emotional distress. In the video, Van Haver, who goes by the stage name Stromae, has abandoned his carefully curated persona: known to his fans as a fastidious and elegant dresser, his dishevelment startles.[1] His melancholy matches the mood of the day, which is overcast and dark. Stromae loiters aimlessly in the middle of a major transportation hub called Port Louise. He squints and pinches the bridge of his nose. His posture, usually lithe and lean, curves like a comma as he crumples wearily onto the curb. He barely notices when two young women approach him. We cannot hear their words, but they seem to be warning him of the hazards of sitting so close to oncoming traffic.

Days later, fans of the musician learned they had been watching raw footage for a music video, directed by Jérôme Guiot.[2] In actuality, "Stromae Drunk in Brussels" was meant to be raw material for "Formidable," the video accompanying the second release from the studio album *Racine Carrée*.[3] The director and performer amplified and reassembled elements of the original footage so that its fragments could cohere into a kind of plotless narrative. In the finished product, the camerawork grows more sophisticated and expressive as it moves freely—close to the ground, overhead, long shots, and close-ups—in order to include a broader range of perspectives. The sonic landscape expands too: music and melody now layered over the sounds of ringing streetcar bells, footfall, and rain hitting pavement. What we initially perceived as typical city noise now resounds as a soundtrack to urban life. With this reframing, onlookers and viewers were transformed too: no longer mere witnesses to the spectacle of Stromae on a bender, we are all now the audience for the small yet remarkable dramas of everyday life in a major European city. The video's documentary style transforms "Formidable" from a piece of pop ephemera into a singular work of art and notable example of the contemporary Black aesthetic at the turn of the twenty-first century.

Ironically, Stromae's personal identity and music don't fit neatly or clearly into strict or narrow definitions of Blackness. Moreover, his music, even as

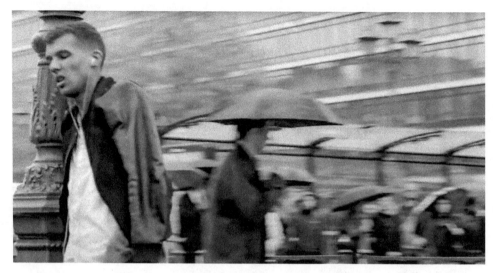

FIGURE 1.1 Still from Guiot, *Formidable (ceci n'est pas une leçon)* (00:51).

it regularly interpolates African American and West African rhythms and sounds, presses against the edges of genres typically labeled as Black (e.g., jazz or hip-hop, reggae or socca, and High Life or Afrobeats). In fact, from some vantage points, the eclecticism of Stromae's influences might appear so global and cosmopolitan as to render his music culturally uprooted and unmoored, with a sound and style anchored primarily in the unique tastes of the performer himself.

Rather than viewing Stromae and his music as uncharacteristically Black, however, it is precisely the dislocation, hybridity, and fluidity that contribute to his sound that make his work representative of contemporary Blackness. The premise of Guiot and Stromae's setup, that their cameras would offer an unmediated window into Brussels' everyday life, lies in tension with the fact that their addition of sound and visual images essentially constructs a loose narrative *and* inspires the audience to create our own stories to help make sense of what we are seeing. In fact, "Formidable's" association with cinema verité filmmaking, a genre associated with the unveiling of reality's hidden truths and subjects, prompts consideration of the aesthetic, temporal, and philosophical moves made that widen the aperture onto Blackness.[4] Viewed through this expanded field of vision, Stromae's performance reveals itself to be less about the spectacle of public drunkenness and more about the unfolding series of encounters with others that spark considerations of the limits and possibilities of envisioning Blackness as a form of "being-in-the-world" (see figure 1.1).

Stromae's performance in the music video suggests that identity operates like time, in that both are changing and dynamic and exist in relation to an/other: we know the present to be distinct from past and future; we think of the "self" as an entity distinct from an Other. These ideas, which operate at the level of allusion in the video, resonate deeply with Martin Heidegger's articulation of "being-in-the-world," which similarly conceives of Being as inextricably informed by relationality and time. Heidegger underscores the idea that relation is constitutive of Being, or Dasein: "Dasein is an entity which does not just occur among other entities. Rather it is ontically distinguished by the fact that, in its very Being that Being is an *issue* for it."[5] He goes on to establish Time as the standpoint from which we develop our understanding of what it means to be a person who has been "thrown" into the world. Taylor Carman cogently summarizes Heidegger's articulation of the relevance of time to ontology: "Time is what *makes possible* our asking of the question of the meaning of being, the question, What does it *mean* to be? What *is* it to be? We ask that question always only against the background (or "horizon") of time, in particular the temporal structure of our own existence—our past history, our contemporary condition, our projects, our future—and we answer the question, whether tacitly in our behaviors and practices or explicitly in our thoughts and words, in irreducibly temporal terms."[6] Though Heidegger certainly never imagined that Black and African people could be subjects of his philosophical musings, his articulation of temporality runs through and resonates with popular and critical discourses on Black existence that focus on historical phenomena, like the Middle Passage and Black Atlantic enslavement, that have led to modern formations of "Blackness" as a signifier of *non*being-in-the-world.[7] Accordingly, Heidegger's articulation of the interconnected and interdependent nature of time and being makes clear the ontological resonances within Black Studies' "commitment to the idea that the slave past provides a ready prism for understanding and apprending the black political present."[8]

As a meditation on social/aesthetic encounter, however, "Formidable" aims for something different in that Stromae's performance of Black-European presence and present-ness focuses instead on Blackness as a form of being produced through aesthetic engagement. In other words, it offers the unpredictable and unscripted nature of mundane and quotidian interactions in order to re-member Black subjective experiences of being-in-the-world.

This reading resonates with the thinking of critic Tavia Nyong'o, who also employs a temporal framework in his exploration of racial representation. Nyong'o argues that the storytelling function of creative Black texts is to "disrupt the hostile and constraining conditions of [the Black subject's] emergence

into representation" through works of "Afro-fabulation."[9] The "fabulist" traverses timelines in that "he carries over concepts, percepts, and affects from one regime of representation into another in a manner that is neither up-to-date nor out-of-date but truly *untimely.*"[10] I take Nyong'o's trenchant articulation of the untimeliness of Black art as a reminder not to conflate or flatten the various dimensions of Black time, which can be historical, political, spiritual, and aesthetic, if not more. As such, we should regard Black forms of being as similarly multitudinous.

WHEN I SAY THAT the visual and sonic elements of "Formidable" produce a narrative arc, what I mean is that they add context, which is necessary for the parsing and interpretation of creative texts to occur. For example, the addition of song lyrics that focus on romantic love and loss helps explain Stromae's melancholy. The setting establishes his social and geographical locale. We recognize that the bystanders are also commuters who gradually fill the streets during rush hour. Preoccupied with reaching their destinations and other mundane concerns, their purposefulness acts as a counterpoint to Stromae's loitering, which amplifies the strangeness of his aimlessness. Some stop to gawk or take pictures of the spectacle he makes of himself. The callousness of these few to his distress and vulnerability cannot help but implicate the curiosity *and* indifference of the many. Their actions, or inaction, contrast with the care shown by the women (white) who guide him to the safety of the sidewalk. A pair of police (also white) approach Stromae and question him mildly because they recognize his celebrity: "Had a bit of a tough night?"

The fact of Stromae's Blackness matters too as it gestures toward even broader historical and geopolitical contexts that shape life in the modern metropole. For example, the appearance of the police inevitably recalls the carceral practices designed by the state to discipline and control the movements of Black and brown subjects, in particular Black men who too often carry the stigma of urban criminality. Moreover, Stromae's vagrancy resonates symbolically as a reminder of the migrants and refugees who travel to Europe from Africa and the Middle East in search of refuge from political conflicts, ecological disasters, and economic privation.[11] His loitering invites scrutiny from the crowd, which hints at the suspicious and hostile reception of those migrants (see figure 1.2).

"Formidable" repeatedly asks viewers to experience the sensations and feelings of Black existence in a time and place where interracial sociality is common, racial hostility is prevalent, and we are as likely to find ourselves surrounded by strangers as by literal or figurative kin.[12] At the 2:57-minute

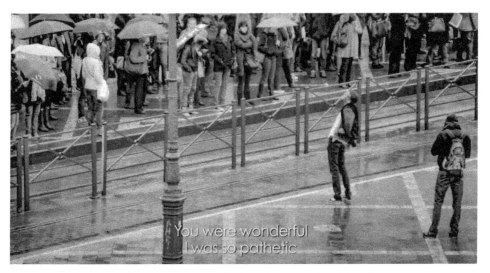

You were wonderful
I was so pathetic

FIGURE 1.2 Still from Guiot, *Formidable (ceci n'est pas une leçon)* (1:03).

mark, a pair of police on patrol approach the singer, and the ghostly presence of structural power and inequality intensifies. Not coincidentally, this particular encounter takes place at the precise moment that the song lyrics refer to racial injury. Up to this point in the video, the music remains non-diegetic as it plays in the background of the interactions on the street. With the eventual departure of the police, however, the music monetarily fades away, and Stromae's voice rises in anger as he shouts, "Et qu'est-ce que vous avez tous, à me regarder comme un singe" (And you, what's wrong with you, looking at me like an ape)! This moment captures the paradox at the heart of Du Boisian double-consciousness in that it conveys both the symbolic violence of the racialized gaze and the conflicting desire to be seen as one sees himself. From this vantage point, the silence and pregnant pause that follows Stromae's outburst, before the music recommences, embody the kind of temporal suspension in art that allows for the duality of Blackness, and the intensity of thought and feeling it inspires, to exist.[13]

As a dark-complected man dressed in a wrinkled yellow shirt and saggy blue cardigan that perfectly match the colors of the passing streetcars, Stromae reads as the embodiment of alienation and dislocation. Certainly, his racial estrangement represents a by-product of "the historical accretions of slavery, race, racism" and, I would add, colonialism.[14] Yet, as I've suggested previously, "Formidable's" emphasis on encounter, in particular aesthetic encounter, raises questions about the possibilities of relationality that exceed

some of the insights afforded by historiographic approaches to the study of Blackness.[15]

An additional note on context and the relation it inspires or forecloses: the fact that Stromae's performance occurs in the midst of a city caught up in the quotidian workings of an ordinary day carries its own particular resonances. Brussels isn't just any city: as the capital of Belgium and the European Union, it also holds symbolic weight as a center of European (i.e., white) power. Moreover, Brussels is a city of immigrants, with 70 percent of its inhabitants claiming foreign ancestry. This locale—defined by the circulation and exchange of people, finance, and political power—can't help but inform "Formidable's" representation of Blackness in the world.

The video's multiple camera angles and perspectives encapsulate this excess, an excess—in the form of stories, perspectives, and possible meanings— with potentially disorienting effects because the meaning-making it inspires can emanate from many, sometimes irreconcilable, locations. The video's treatment of the act of looking captures and conveys the productively unsettling effects of such multiplicity: viewers of the video observe a group of people surreptitiously taking pictures of a celebrity; those people in turn are being recorded by a hidden camera for inclusion in a work that subjects them to the judgments of an audience that may or may not recognize its own complicity as it partakes in the pleasures of looking at others. The circularity of looking and being looked at, judging and being judged, encourages self-reflection. Who are the voyeurs, and who is being violated? What would we do if we had been among the commuters that day? I'm reminded of Sara Ahmed's argument in *Queer Phenomenology* that the conditions that produce feelings of disorientation necessarily precede the reorientation needed to reimagine other forms of being and possibilities of relation.[16] From this vantage point, it becomes apparent that the hint of scandal in the original title is meant to function as both an enticement to look, and an indictment of surrendering to the temptations of voyeurism and spectacle.[17] It signals "Formidable's" interest in injecting confusion in order to explore the many valences of accountability and complicity, vulnerability and care, as they appear in a single (Black) life.

Racine Carrée (2013), like most of Stromae's music, tackles major social and political problems in a style that blends joy and melancholy, or, as a *New York Times* headline states, "disillusion, with a dance beat."[18] Some of the songs from the album explicitly take on topics of societal and political conflict, like "Humain à L'eau" ("Man Overboard"), a rap-inflected song about the human and ecological costs of imperialism, or "Moules et Frites" ("Mussels and Fries"), an irony-filled ballad about sexually transmitted diseases and the

dangers of unprotected sex. In contrast, other songs, like "Formidable" and "Papaoutai" focus on subjective and individual experiences of fragmentation and multiplicity. "Formidable" stands out for its melodic focus on romantic love and loss, which deviates from the album's other more dance- and politically oriented tracks. Commonly celebrated for his merging of eclectic influences like hip-hop, pop and house music, electronica, and Congolese rumba, Stromae's music evidences the "hybrid cut-and-mix practices" that Kobena Mercer describes as typical of late twentieth-century diasporic Black art and culture.[19] "Formidable" sounds like a traditional European ballad from an earlier era—albeit a quirky and slightly dissonant one—because it borrows from the chanson française tradition that originated in France and Belgium in the 1950s.[20] In essence, the song experiments with a familiar European sound to tell a new story about Europe, mediated by the singer's body and sound.

Born in 1985 to a Flemish mother and Rwandan father, Stromae's background embodies cultural hybridity and diasporic alienation.[21] In interviews, he describes childhood feelings of estrangement in a society that, then and now, equates whiteness with Europeanness. He has stated, "I was raised in Brussels as a Belgian . . . but at the same time feeling that I wasn't necessarily from here."[22] In his performances, Stromae habitually made symbolic claims to Belgianness while emphasizing the nation's changing identity. In a concert that I attended in Boston in 2014, he joked about the largely unknown Belgian origins of French fries and the national football (soccer) team.[23] He also ended the performance by highlighting the ethnic diversity of his band members, who claimed ancestry in Italy, Greece, and Japan.[24] As a concerted effort to foreground Belgium's changing identity, these statements illustrate a postmodern, postcolonial dynamic in which, according to Kobena Mercer, "what was once a monologue about otherness became a dialogue about difference."[25]

"Papaoutai," a semi-autobiographical song and video from *Racine Carée*, explores the yearning for (re)connection in more familiar diasporic terms of lost origins and kinship. The father figure in the video refers indirectly to Stromae's own father, who returned to Rwanda when the singer was still a child.[26] The title, a homophone for the question—Papa où t'es? Where are you?—and lyrics assume a backward-facing, nostalgic gaze. We look to the past, "Papaoutai" suggests, for a remedy for the psychic and emotional pain associated with the loss of ancestry, home, and, hence, identity. "Dites-moi d'où il vient/Enfin je saurai où je vais" (Tell me where he comes from/And I'll know where I am going). Ironically, however, the video's visual images

eschew this lyrical search for origins by portraying a living child dancing with a plastic and robotic father in a pastel-colored suburban dreamscape. Together, music and image explore the distance between the immediacy and intensity of the child's yearning and the superficiality and artificiality of the romanticized visions to which nostalgia often leads.

My point in dwelling on "Papaoutai's" emotional textures is to underscore how deeply and effectively a work of art can traverse social and affective geographies. "Papaoutai" depicts the family home as a mythical, idealized site of belonging. "Formidable" also explores these themes, but by representing the city as an unpredictable space in which the terms of collective belonging and affiliation are contested. Neither work shies away from the entanglement of spatial, social, and subjective geographies. "Formidable," in particular, leans on the emotional tenors of the ballad as a genre to express the melancholy and loneliness of urban and racial alienation. In so doing, it invites listeners to turn away from the ethically dubious act of voyeuristic/racialized looking to absorb and experience the music as it conjures the suspended temporality of aesthetic encounter and with it a vision of Blackness, free in its opacity to experience Relation.

"Formidable's" invitation to look closely and carefully—at its Black male protagonist and ourselves, at his presence in a public square, and at the city itself—unsettles the tendency to use social identity as a kind of shorthand for finding meaning in Black texts and their subjects. In this way, it strives to move viewers toward a more expansive, and therefore ethical, understanding of difference and otherness. That ethos asks us to look beyond the racial spectacle symbolized by Stromae's loitering, his doing nothing, and to focus instead on his aesthetic doings. In other words, "Formidable" invites viewers to follow the example of his performance, by refusing and disrupting the pressing rhythms of sociopolitical time, if only momentarily, in order to engage in the equally meaningful effort of aesthetic and ethical reflection.

"Formidable's" implicit framing of diasporic dislocation and estrangement as defining aspects of the modern metropole can lead to different insights compared to imaginings of unbelonging as one of the inescapable and unchanging aspects that render Black existence singular. We see one example of this difference by briefly comparing Stromae's depiction of urban dislocation to Saidiya Hartman's focus on Black Atlantic dispossession in *Lose Your Mother*.[27] For Hartman, the association of the Atlantic Ocean with the Middle Passage renders it the perfect location for meditating on the natal alienation that produces racial estrangement and nonbeing. Yet her portrayal of privately reckoning with the effects of these historical traumas and their

"afterlives" indirectly illuminates the ways that this particular preoccupation can unintentionally foreclose other possibilities of relation.

For example, in a passage that describes Hartman making her way to the water's edge, she depicts the city of Accra's teeming streets as a series of distractions:

> I decided to walk to the ocean to sort out the jumble of painful facts and awful details that I had worked so diligently to learn. I needed to see the Atlantic, which was where I reckoned with the dead, the men and women and children who were all but invisible in most of the history written about the slave trade. . . . There was a small path to the beach on the other side of Labadi Road. The walkway was surrounded by a small settlement of shanties. The rickety houses had been assembled from discarded shipment containers and cardboard boxes and stray pieces of wood and were topped with corrugated tin roofs. I felt like an interloper walking through the community as women washed their children and fanned small coal fires for the evening meal. Poor people couldn't afford gates to keep trespassers out. I looked straight ahead and kept my eyes fixed on the rocky outcrops and dunes, avoiding what I suspected were quizzical and irritated glances. I pretended not to notice the stench and quickened my pace. . . . The black water allowed no reflection of their hovering faces.[28]

The reference to repurposed shipping containers in Hartman's peripheral vision, like the intrusiveness of her own American (quasi-tourist) body, alludes to the other forms of neo- and postcolonial domination and exploitation (globalization, tourism) that affect the lives of ordinary Ghanaians, I think intentionally. Yet because the focus of the text remains on the metaphysical and affective quandary of Blackness, Africans prove no more capable than whites at piercing through the existential loneliness that plagues the descendants of the enslaved. In contrast, even as "Formidable" represents the modern city as a landscape populated by strangers rather than kin, it evokes a kind of presentism that suggests that estrangement *and* the possibility of connection remain always already in play.

Hartman is among the scholars, whose thinking about diaspora, the city, and Blackness rightfully travels through themes of the political and recuperation—the political consequences of racial capitalism alongside the recuperation and assertion of the particularity of US and Caribbean Blackness. Besides Hartman, the writings of Farah Griffin, Madhu Dubey, H. Adlai Murdoch, and Carol Bailey represent an essential but by no

means comprehensive list of critics and theorists whose studies make possible the work of this book, which wants to think intentionally about aesthetics and relation.[29]

In art historical terms, "Formidable" exemplifies a relational aesthetic, a term coined by Nicolas Bourriaud in 1998 to describe the philosophy behind the participatory art forms that emerged in that era.[30] Instead of fetishizing the art-object, relational art transforms everyday forms of sociality, like cooking a meal or a conversation on a street corner, into aesthetic acts. Relational art works to shift the focus from the aesthetic appearance of an object to the social context (i.e., time and place) that shapes aesthetic encounters. This perspective reveals the significance of "Formidable's" turn away from the art-object (i.e., Stromae's body) and turn toward "the story of the work" embedded in the various interactions.[31]

By rejecting a single or primary point of view, "Formidable" generates a productive absence of a center in a context of multiplicity, which in turn invites viewers to bear witness to minority subjects experiencing themselves not as outside and other but rather as part of the human condition.

We shift the terms of relation from the engagement of Black art-objects to interactions with Black people by putting Bourriaud's notion of relational aesthetics in conversation with Édouard Glissant's theory of Relation. As a native of Martinique, Glissant's philosophical insights into alterity, identity, and sociality emerge from and are informed by Caribbean history and culture, yet his ideas resonate beyond their original context because their habitus ultimately resides at the level of epistemology.[32] Particularly in an era of globalization, in societies transformed by the emergence and inclusion of socially marginalized groups of people within the public sphere, the assertion that identities are made through encounter and evolve across time and space resonates widely across national borders. For example, Glissant meant for his conceptualization of the entire world, or *"tout-monde,"* as an open-ended field of relation, to be read as a critique of the West that strives to undermine and uproot nonrelational imaginaries.[33] Accordingly, in order for the worlding potential of relation to be realized, Glissant emphasized the need to reject the totalitarian, colonialist drive to separate, categorize, and ultimately dominate others.[34]

Ironically, though we might equate the formation of new thoughts, feelings, and ideas that are intrinsic to world-building endeavors with the knowledge-producing work of epistemology, Glissant's concept of worlding and Relation also demands a kind of humility, a willingness to grant an other autonomy by acknowledging their inherent right to refuse the expec-

tation of their transparency. Accepting enigma, recognizing the unknowable to be an inherent part of the totality of being, represents the kind of disavowal of mastery (and master narratives) that is required in order for Relation and its world-building possibilities to be achievable. Glissant states:

> Agree not merely to the right to difference but, carrying this further, agree also to the right to opacity that is not enclosure within an impenetrable autarchy but subsistence within an irreducible singularity. *Opacities can coexist and converge, weaving fabrics. To understand these truly one must focus on the texture of the weave and not on the nature of its components.* For the time being, perhaps, give up this old obsession with discovering what lies at the bottom of natures. There would be something great and noble about initiating such a movement, referring not to Humanity but to the exultant divergence of humanities. Thought of self and thought of other here become obsolete in their duality. Every Other is a citizen and no longer a barbarian. What is here is open, as much as this there. I would be incapable of projecting from one to the other. *This-here is the weave, and it weaves no boundaries.* The right to opacity would not establish autism; it would be the real foundation of Relation, in freedoms.[35]

In this rich and layered passage, Glissant makes several propositions worth careful consideration. First, his insistence that opacities coexist, meaning that aspects of every person's inner life remain unavailable—unforeseen and unknown—to those with whom they interact, offers a pathway to envisioning a form of liberated Blackness. Allowing for enigma in moments of intersubjective and social exchange frees Blackness from totalizing narratives that invariably reinscribe the hold of narratives that produce ontological negation and racial subjugation. Importantly, Glissant asserts a mutual right to opacity that remains open and afforded to "the divergence of humanities," even in the midst of racial/colonial subjection. As Adlai Murdoch astutely notes, "*Opacité*, then, serves to posit an unknowable otherness that, in its turn, mediates a new groundwork for being-in-the-world."[36] It is the acknowledgment of opacity that engenders the quality of now-ness—that aesthetic attunement to the presence and present of Blackness—that I attribute to "Formidable." Black aesthetic time shares the premise of opacity, which is that "what is here is open, as much as this there."

Glissant's enjoinder to "focus on the texture of the weave and not on the nature of its components" proves equally compelling because of its call for cultivating a poetics of relation, or what I describe as an aesthetic habit of

mind. To attend to "the texture of the weave," he suggests, would mean focusing on the interactions and entanglements of those enmeshed in relation. This means momentarily setting aside the totalizing and absolutist claims of the master narrative to make space for an ethos of openness and curiosity. Glissant declares that "not knowing this totality is not a weakness. Not wanting to know it certainly is. Hence, we imagine it through a poetics: this imaginary realm provides the full-sense of these always decisive differentiations. *A lack of this poetics, its absence or its negation, would constitute a failing.*"[37] With this, Glissant fruitfully highlights the interdependence of the ethical and the aesthetic, underscoring the moral value in trying to envision and narrate the vital presence of Blackness and other forms of otherness as they engage and are engaged by the world.[38]

Bernadette Cailler's summation of Glissant's vision of *tout-monde* captures the textures of "Formidable's" representation of relation: "A concrete truth, an awakening to the Other through the bonjour, a benediction precede all thought, precede any grasp of the self and of the world, as Levinas would say: the self is not substance, but response and responsibility."[39] Because the accumulation of racial signifiers in "Formidable" fails to cohere into an easily consumable story of Blackness, even though racial signifiers are sighted and cited, implicitly and explicitly, throughout, all we have left to dwell on is the selves fashioned out of response and responsibility. Staying suspended in the time of the aesthetic encounter makes it possible to appreciate the "texture of the weave" of these dynamics, to reckon with the fact that Stromae represents the nowness of Blackness as a product of history and more and to try to make sense of the ambivalences and dissonances of the present day.[40]

"Formidable's" exploration of the longing for connection—made explicit in the lyrical address to the lover and implicit in the dynamics between performer and passersby—puts on display the paradox of Blackness always already suspended between subjecthood and subjection. The critic Jared Sexton famously describes the problem of ontological negation in spatial terms that resonate with the text. "*Black life is not lived in the world that the world lives in*, but is lived underground," Sexton proclaims.[41] These words resonate when the camera angle shifts at the beginning of the video from the commuters' feet to an overhead shot of an escalator moving with mechanical consistency, only to finally pull back to a distance above Stromae's head as he rides the escalator upward and out of the bowels of the station below. As the performer ascends, he appears to notice something: perhaps a security camera of the type that has become common in major cities. His pained squint into the morning sun evokes the crisis of looking that the work inspires

in viewers. Nevertheless, after Stromae steps into a public square that represents the zone of hegemony, what Sexton characterizes as "the world that the world lives in," some interactions confound assumptions of how Black/white, inside/outside dichotomies tend to operate and instead offer glimpses of relational possibility. Such moments amplify the disorienting effects initially felt by viewers who have to figure out the truth that lies somewhere between the Stromae they thought they knew and this "Stromae" caught by the camera.

The art historian Tina Campt includes cameras among the "technologies of capture" that form part of a matrix of visual practices that have historically constructed, "differential or degraded forms of personhood or subjection—images produced with the purpose of tracking, cataloging, and constraining the movement of blacks in and out of diaspora."[42] In "Formidable," the sonic serves that purpose. Campt suggests that we start "listening to images," a practice based in the phenomenological dimensions of sound, that might free Blackness held captive by the racialized gaze. According to Campt, sound evades the fixity and control associated with looking because it is "an inherently embodied process that registers at multiple levels of the human sensorium . . . sound need not be heard to be perceived. Sound can be listened to, and, in equally powerful ways, sound can be felt; it both touches and moves people. In this way, sound must therefore be theorized and understood as a profoundly haptic form of sensory contact."[43] Stromae's performance of heartbreak deploys spoken word, song, and shouting to transform onlookers into listeners who absorb the vibrations of feeling and memory that take flight in the form of these sonic utterances.

Christina Sharpe brings a similar critical awareness to the analysis of race and visuality. When confronted with the photographic evidence of the trauma endured by a young Haitian girl as a result of the catastrophic 2010 earthquake that decimated large sections of the island nation, Sharpe stated, "I marked the violence of the quake that deposited that little girl there, injured, in this archive, and the violence in the name of care of the placement of that taped word on her forehead, and then I kept looking because that could not be all there was to see or say. *I had to take care.*"[44] "Formidable" resonates with both critics when it implicitly asks, "You are looking, but what are you really seeing, and what do you think it means?" as a way to gesture toward the epistemological basis for a poetics of relation that claims worlding capacities.

What I describe as "Formidable's" generation of a crisis of looking places the weight of meaning-making on an unmarked assemblage of individuals

who resist easy categorization. This work imagines collectivity neither as a unified group nor as a crowd of randomly gathered individuals; rather, it represents collectivity as a practice, a kind of creative experiment in living that calls for imagination and self-reflection in order to grapple with the things (historical, ideological, biographical, and structural) that each person carries into the worlds they are making. I hear echoes of this framing in Sharpe's discussion of the need to explore the "ways of seeing and imagining responses to the terror visited on Black life and the ways we inhabit it, are inhabited by it, and refuse it."[45] Sharpe writes, "Most often these images function as a hail to the non-Black person in the Althusserian sense. That is, these images work to confirm the status, location, and already-held opinions within dominant ideology about those exhibitions of spectacular Black bodies whose meanings then remain unchanged.[46] Creative Black texts engage in the production of new images and new narratives that resist these flattening and dehumanizing practices by acknowledging the dynamic and ever-evolving meanings associated with Blackness.

Rather than minimizing or overstating the sociopolitical significance of the police and the white women who help Stromae *or* the meaning of the video's most egregious example of voyeurism when a Black woman moves closer to point her camera directly at Stromae, I view each instance as an example of divergent human citizens engaging—partially and not necessarily consciously or successfully—in meaning-making and world-building praxes (see figure 1.3). Framed in this way, Black worlding has presence in the present, for it isn't the exclusive responsibility of a privileged few and is instead the outcome of mundane yet potentially radical relational acts. The migratory color scheme encoded in Stromae's clothes evokes the theme of dislocation, yet it also at the same time gestures toward the dynamic and flexible creative-critical praxis required to acknowledge the multiplicity of forms of Blackness, of Black being and becoming, that one may encounter and engage in the world.

In a 2014 interview with NPR, Stromae described filming the video as akin to holding up a mirror to society: "We wanted to do this video and we didn't know what we could expect. And it was a big surprise to see that . . . we had a policeman, we had three people who were filming me, somebody who was laughing about me, somebody who was trying to help me, somebody who was just ignoring me, and I think that's what we are."[47] The critical capacity to account for the dynamism and capaciousness of Blackness, what Kevin Quashie frames as a type of "aliveness," becomes possible when we operate from the knowledge that Black subjects exist among the divergence of hu-

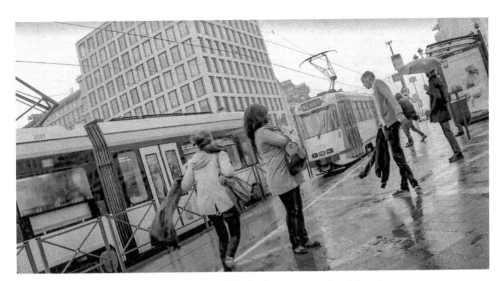

FIGURE 1.3 Still from Guiot, *Formidable (ceci n'est pas une leçon)* (3:34).

manities *even when* the pervasiveness of anti-Blackness makes it seem as if
the world, meaning the dominant social order, will never acknowledge it.[48]
Stromae's lyrical meditation on the spaces traversed between formidable
(wonderful) and fort minable/forminable (pathetic) gives voices to that know-
ing. The lyrics state, "Eh petite, oh pardon, petit / Tu sais dans la vie y'a ni
méchant ni gentil (Hey young girl, oh sorry, young boy / You know in life
there are neither bad nor good)." And in the refrain, Stromae repeats, "Tu étais
formidable, j'étais fort minable / Nous étions formidables" (You were won-
derful, I was so pathetic / We were wonderful).[49] Rather than dismissing
these thoughts as overly sentimental or simplistically humanist, I view in
the lyrical movement from *I*'s to *you*'s and *we*'s a kind of sonic exploration of
the conditions that make Relation, in the Glissantian sense, possible.[50]

Conceptualizing Black aesthetic encounters in this way brings into relief
the often unacknowledged tension that exists between critical aspirations to
attend to the story of a work of art and the not always commensurate striv-
ing to attend to the story of Blackness.[51] In its portrayal of Blackness in
Europe, "Formidable" challenges that assumption that shared identities, or-
igins, or experiences are prerequisites of collectivity and solidarity. Unlike
some of Stromae's other songs, it doesn't offer much by way of sociopoliti-
cal critique and instead ruminates on the ethical bases of relationality. Rather
than telling a Black story, Stromae aestheticizes his Black (male, gender-
fluid) body, treating it as an art-object whose openness to encounter and

engagement inspires new insights and ideas about what it looks and feels like to be Black and human and thrown into the world.[52] At the end of "Formidable," Stromae signals his awareness of this insight because as he walks away from the camera, he turns back toward it (and us) with a final, mischievous glance that conveys the pleasures of mutual recognition. That look seems to say, "I see you looking! Did you see what I just did?" In the end, the pleasure in "Formidable" is shared by all who engage in the ongoing work of meaning-making to which this work of relational art aspires.

In Search of Presence

A *Digressive Reading of* Ordinary Light

It might start with a student's impudent comment: "I think she needed a stronger editor." A student said something like this in class one day after reading Tracy K. Smith's 2015 memoir *Ordinary Light.* I heard that comment as an expression of resistance to Smith's digressive approach to writing about her life, the student's attempt to moor herself in a book that is wildly unmooring. "She left us at night" is how the memoir begins, this book about Black girlhood in the twentieth century, and also language and exchange, communication really: communication, which is another name for the relationality of language. So the prose, particularly in the prologue, is unmoored and unmooring—it suspends the reader in an instance of collaboration, trying to meet the invitation of its language. What is that invitation? To be present, to put it vernacularly:

> She left us at night. It had felt like night for a long time, the days at once short and ceaselessly long. November-dark. She'd been lifting her hand to signal for relief, a code we'd concocted once it became too much effort for her to speak and too difficult for us to understand her when she did. When it became clear that it was taking everything out of her just to lift the arm, we told her to blink, a movement that, when you're watching for it, becomes impossibly hard to discern. "Was that a blink?" we'd ask when her eyelids just seemed to ripple or twitch. "Are you blinking, Mom? Was that a blink?" until finally, she'd heave the lids up and let them thud back down to say, *Yes the pain weighs that much, and I am lying there, pinned beneath it. Do something.*[1]

The prologue's deliberate withholding of identifying characteristics challenges the reader by refusing to immediately contextualize its primary characters as we so often assume that books should do.

Toni Morrison describes this kind of opening as one specifically designed to draw readers to participate in the writing of the text: "Invisible ink is what lies under, between, outside the lines, hidden until the right reader discovers it. . . . The reader who is 'made for' the book is the one attuned to the invisible ink."[2] In this first sentence, the narrator refers to a "she" who

remains unnamed until nearly the end of the paragraph, to a "we" whose relationship to the departing figure remains unclear up until the point that the narrator calls her "Mom," and to a leave-taking that hints at illness and death but seems all the more mysterious because these happenings take place at night. Even the passage of time strains against the desire for predictability according to the speaker, for the day feels never-ending even as the minutes and hours pass quickly. Language, syntax, and imagery work together to render in vivid detail Smith and her siblings' feelings of anxiety, fear, and helplessness, the sense of having been set emotionally adrift because of the impending death of a beloved parent. Morrison reminds us too that authors like Smith intentionally use language to extend an invitation to their readers, to join in writing's meaning-making endeavor. The reader attuned to the wild, uncharted terrain of Black feeling, thoughts, and ideas needs to think of reading as an act of discovery that is fueled by curiosity and desire to explore the unknown and unknowable.

Smith's prologue is full of what Morrison calls "invisible ink" because this account, of growing up Black and female in the wake of the civil rights movement of the sixties, offers none of the familiar themes, tropes, or linguistic clues (e.g., the use of vernacular speech) that readers have come to expect in narratives of Blackness. Instead, Smith follows this anecdote, which is also a meditation on loss, grief, and the longing for connection, with a collection of anecdotes whose relevance to the narrative's overarching themes isn't always clear. Focused on her formative years in the northern California city where her family settled in the 1970s, Ordinary Light presents a loosely chronological pastiche of the experiences and relationships that shaped the author's sense of selfhood and nurtured her imagination.[3] Structurally, the book is organized around a series of impressionistic and elliptical recollections: for example, of her mother's passing, an improvised Halloween costume with inadvertently bizarre racial implications, a misadventure with an ornery cow during a family trip to a local ranch owned by people with a strikingly Scandinavian (i.e., white) name, and a summer trip to her parents' native Alabama home. Readers looking for connections along this winding narrative line to explain the linkages among the cow, the costume, the Gustafssons, and the ancestral Southern home inevitably come away disappointed.

Reading Ordinary Light requires patience with the enigmatic and contradictory meanings and messages embedded in these stories, even as the memoir begins to gradually assume a recognizably Black form by depicting Tracy's development of a racialized consciousness as she moves into adulthood. In this way, the text conforms to a tradition within African American

life-writing that, beginning with eighteenth-century slave narratives, represents the subject's coming of age as a process of learning how to negotiate the material and psychological effects of being racially othered as Black.[4] Nevertheless, the reader's experience is impoverished if in clinging to this conventional arc we overlook the lines of inquiry suggested by the narrative's imaginative flights and detours in memory.[5]

With this in mind, I read the narrative digression in *Ordinary Light* as an example of the kind of destabilizing storytelling that invites the reader's active and collaborative participation in narrative-making. In "Invisible Ink," Morrison describes a variety of ways that she chose to begin her novels in order to prompt her readers to use their imaginations to fill in the blanks and answer the questions in a passage—for example, beginning with a question or withholding a character's gender or racial identity.[6] Her goal in "destabilizing the text and reorienting the reader" is to "force" readers "into helping to write the book."[7] In *Ordinary Light*, digressive storytelling represents this kind of summoning, or activation of the reader, in that it presents multiple gateways that are open to a range of interpretations. Moreover, this narrative multiplicity resonates sociohistorically and metaphysically, reflecting the ways that the transformations associated with the post-movement era (e.g., societal integration and the rise of the Black middle class) has inspired authors like Smith to grapple with the heterogeneous, fragmented, and contingent nature of Blackness in the present.[8]

Framed in philosophical terms, the text's digressive approach to storytelling heightens the reader's perception of the enigmatic, which in turn reflects upon the totality of the Black subject. If we think of subjectivity as a construct produced in relation to others, then the acknowledgment of enigma reveals subjectivity to be a temporary product of an ongoing process of relation or, as Glissant would say, "Relation." In fact, *Ordinary Light*'s digressive form inspires the spirit of "errantry" that Glissant theorizes in *Poetics of Relation*: "one who is errant (who is no longer traveler, discoverer, or conqueror) strives to know the totality of the world yet already knows he will never accomplish this—and know that is precisely where the threatened beauty of the world resides."[9] The errant reader welcomes the memoir's many thematic entry points, the variety of paths toward meaning-making that it presents. She engages the narrative's "invisible ink," understanding it to be an exercise in the habits of meaning-making.

IN CHAPTER 1, I focused on Stromae's *Formidable*, a performance and performative text that foregrounds the plurality of Black being. Here, I shift my

focus to the act of reading, methods of close reading in particular, in order to consider how the reception and critical engagement of creative Black works can shape our ability to acknowledge and reckon with the complexities of being and becoming. I find the philosopher Andrew Benjamin's analysis of the ontological and relational foundations of art historical interpretation to be generative in this respect for two reasons. First, Benjamin describes "understanding" as an interpretive category, "gesturing toward the posited centrality of the experiencing subject," and, second, he stresses the emphasis that "interpretation" places on the subject's responses to an object that exists "not *qua* simple material object . . . but as an object of interpretation.[10] In other words, it is the subject's interpretive actions that produce an object's meaning. If we embrace, as I do, Morrison's description of the ideal reader as someone who is "active and activated," then focusing on the reader as "experiencing subject" is self-evident, although I will argue that the praxis of *close* reading is hardly natural or automatic.

Second, Benjamin underscores the dynamism and fluidity associated with interpretation when he asserts that identifying an art-object (or literary work) as an object of interpretation gestures toward the existence of truths that resist predetermination and fixity. Moreover, he identifies this diversity of meaning with potentiality and futurity when he states, "Each [interpretation] has a different temporality and mode of being. It is not therefore the determination in advance but rather a pause; an opening."[11] These arguments pertain if we replace Benjamin's references to the *work of art* with *work of Black art* or *Black person subject to objectification* or simply *Blackness*. The value of thinking about Blackness through the lens of an aesthetic ontology emerges when we focus on the roles played by art and imagination in the creation of openings for the potentiality that Benjamin finds so liberating in his writing on "interpretation." According to Benjamin, interpretation presumes, "There is therefore no question of Being qua Being, there is simply the plurality of questions pertaining to the plurality of ways in which things are."[12] How can we use this framing to inform our readings of a work like *Ordinary Light*? How might we extend and expand the concept of "the becoming-object of the work of art" to allow for considerations of Blackness as potentiality?[13]

If we turn once again to *Ordinary Light*, we can discern within its formal, rhetorical, and thematic aspects the author's efforts to conjure images and ideas of Black presence that surpass the limits of the dominant social imaginary, which tends to project notions of abjection and lack onto Blackness.[14] The word "presence" appears three times in the section of *Ordinary Light*'s prologue that describes the mother's final moments. The text refers to the

remaining evidence of "her presence in this world" and the "vivid presence" of her last breath: "a sound that seemed to carve a tunnel between our world and some other."[15] In fact, the narrator twice links presence (i.e., personhood) with breath, stating: "I would come back to the sound and the presence of that breath again and again, thinking how miraculous it was that she had ridden off on that last exhalation."[16] Ashon Crowley conceptualizes breathing as a "constitutive gesture" for personhood, an idea that the memoir evokes through its repeated references to a presence, connected to but not equated with the mother's Black and female body, that makes itself felt and known to the others in the room.[17] The notion of "presence" gestures toward the totality of aliveness that Kevin Quashie theorizes as Blackness, "in the tussle of being, in reverie and terribleness, in exception and in ordinariness."[18] These ruminations focus our attention on forms of Black being that anti-Blackness and its racial logics fail to consider.

If these references to "breath" and "presence" direct readers' attention to modes of being, then the narrative's depiction of speaking and other forms of communication emphasizes the possibility of Blackness-in-relation. For example, the introductory paragraph foregrounds a series of partial, occasionally unsuccessful, speech-acts as the mother asks for relief from her pain. The effort to speak gradually unravels, moving from labored speech to unintelligible words and eventually to a kind of sign language that finds Smith and her siblings looking for meaning in the movement of an arm or eyelid. All of it, even the word "pain" itself, proves inadequate. Smith states, "*Pain*. The word itself doesn't hurt enough, doesn't know how to tell us what it stands for."[19] Despite this deficit, the passage stresses that each attempt to communicate represents a vulnerability in that each gesture is a reaching outward in hope of finding a receptive and responsive listener. The passage also depicts the family's struggle to discern meaning in her movements and utterances as a reciprocal striving to understand, an effort to respond to her vulnerability with love and care. This depiction of relational communication as care calls to mind the kind of "wake work" that Christina Sharpe describes as "a form of consciousness," one oriented toward the humanity that survives in the face of "the ongoing problem of Black exclusion from social, political, and cultural belonging; our abjection from the realm of the human."[20]

Sharpe represents a growing body of scholars, which also includes Quashie, Margo Crawford, and Stephen Best, who locate in poetics and aesthetics ways of expanding the discussion of Blackness as a form of being and becoming. This turn in Black Studies looks beyond some of the conventional frameworks, exemplified by the arguments made during the New

Negro Renaissance and the Black Art/Black Power movements, that have historically governed discussions of the Black aesthetic. In both movements, often in direct response to the overt state sanctioning of forms of racial domination (e.g., Jim Crow segregation), the form and value of the Black aesthetic have been determined by its sociopolitical relevance, its impact on the racial collective.

For example, during the Renaissance era, leaders of the movement like W. E. B. Du Bois and Alain Locke advocated for positive literary and visual depictions of Black people, based on a politics of respectability, because they viewed art to be intrinsically bound to the political, in that both forms of representation should contribute to the movement toward greater racial progress and social advancement.[21] Other, often younger and more rebellious, members of the Renaissance—like Langston Hughes and Zora Neale Hurston—chafed against these demands and claimed the right to aesthetic sovereignty. Their aesthetic theorizations tended to dwell on questions of style rather than politics and propaganda. Their attempts at identifying the essential characteristics of the Black aesthetic tended to foreground ideas of racial authenticity by focusing on the integration of oral traditions, vernacular language, and other recognizably Black cultural forms like the blues and jazz music in their literary works.[22] Similar discussions took place decades later, during the era of Black Arts/Black Power; and though the particulars of the debates differed, the emphasis remained on these twined priorities: the political valences of aesthetic representation and the stylistic expressions of Black cultural forms.[23]

It is important to note that these questions continue to resonate, inspiring literary scholars to introduce new critical paradigms in their analyses of these movements. I am thinking, for example, of the astute argument Margo Crawford makes in *Black Post-Blackness* for Black Arts/Black Power's aesthetic and ideological expansion of Blackness.[24] Nevertheless, it is precisely because conventional framings of the politics of racial representation tend to drive the critical conversation that I choose to frame my analysis in terms of the ontology of aesthetic objects, what Benjamin calls the "becoming-object of the work of art." This brief reflection on the history of race and representation also suggests how easy it is for arguments designed to contest the absolutisms of anti-Blackness to rely on their own totalizing narratives of Black resistance, healing, or wholeness.

Hortense Spillers illustrates this fact in a meditation on the representational claims of the "black creative intellectual" when she points to a "mono-myth of a version of community" as an example of the kind of rhetoric that does little more than displace anxieties about the psychological and social

alienation that arise because of post-sixties social mobility and societal integration.[25] Spillers invites Black intellectuals in particular to carefully consider what we overlook or minimize when we privilege certain shibboleths over other stories, perhaps unexpected, unfamiliar, or uncomfortable, that we should also be telling about ourselves.

Ann Cheng's discussion of "symptomatic reading" resonates with Spillers's critique. In fact, both critics turn to psychoanalysis in order to examine the rhetorical and ideological gestures performed in the effort to assuage the anxieties of modern racialized existence. According to Cheng, symptomatic reading extends the "promise of the pleasure and relief of *insight.*"[26] Yet she reminds us that, even more than offering answers or solutions to problems, literature invites the reader "to remain in the gift of discomfort"; including the discomfort of aspiring for understanding without the promise of mastery or control.[27] This thinking resonates with Quashie's conceptualization of literature as a space in which "the invocation of the black world is the operating assumption of black texts, a world where *blackness exists in the tussle of being*, in reverie and terribleness, in exception and ordinariness."[28] Turning once again to *Ordinary Light*, we can see that its digressive approach to storytelling signals the author's delight in the "tussle" of ordinary being and represents a refusal to chart the kind of straightforward path from innocence to racial maturity, or from intersubjective/ interracial conflict to resolution, that would appease the symptomatic reader.[29]

Spillers's reference to the "creative intellectual" hearkens back to the notion of Black aesthetic becoming that has been the primary concern of this chapter, along with the critical tools used to reckon with the capaciousness and complexities of Blackness. It suggests that when Black Studies scholars acknowledge the things we study as becoming-objects, it can be the basis for capacious and expansive analyses of Blackness, as well as its changing contexts and forms of relations.[30] Moreover, as I've suggested previously in my discussion of Benjamin, the notion of interpretation suggests an openness to the multiplicity of meanings in an art-object that therefore connotes *futurity*.[31] In other words, because the potentiality associated with aesthetic thinking arises out of the awareness of the processual and plural nature, the "becoming," of the Black-art-object, thinking aesthetically is inherently and inevitably tied to the intricacies of Black time. Relatedly, the futurity implied by interpretation intersects with the textual worlding that Quashie links to becoming. It also stands in contradistinction to debates about historicity, which center on the merits of trying to heal or overcome historical wounds, which Aida Levy-Hussen identifies as a discourse of *was-ness*.[32]

If Levy-Hussen asks her readers to consider the ideology of *was-ness*, in *What Is African American Literature?*, Margo Crawford focuses on *is-ness* by building on Alain Locke's articulation of literary self-possession. Reframing discussions of racial representation, she notes, "For Locke, the *is-ness* of African American literature emerges when writers stop 'speaking for' black people and 'speak as' black people (when they 'stop posing' and approach the 'attainment of poise')."[33] Crawford's emphasis of the idiom of *is-ness* has both ontological and temporal connotations by gesturing toward a mode of being ("I am") while at the same time using a present tense conjugation of "to be."[34] The poise she, via Locke, attributes to writing that aspires to self-expression more than self-assertion resonates with Quashie's notion of Black textual worlding in that they conceptualize writing as a vehicle for and instantiation of beingness (i.e., *is-ness*). In fact, in *Black Aliveness*, Quashie underscores the role of the aesthetic in the production of ethical spaces of engagement with Blackness: "I am embracing the luxuries of thinking with and through the materiality of texts. That is, in a black world, in whatever manifestations of black worldness texts create, *blackness* (not antiblackness) is totality; in such a world, black being is capacious and right—not more-right-than, just right-as-is. Life-as-is. I believe that the worldness of black texts, if one reads with such a temperament, makes it possible to withstand black being as human being, to behold blackness as one's ethical reckoning with being alive."[35] The notion of beingness, or *is-ness*, comes closest to articulating the questions that concern me when I focus on the temporal and other dimensions of literary *now-ness*. In fact, as I have been suggesting, focusing on the now of encounter has to do with more than interpretive methods in that it calls forth metaphysical and ethical questions that shape our understandings of Blackness.

By focusing on the act of reading and other interpretive acts, we can direct attention to questions having to do with habits of mind, embodiment, *and* ethics. For example, Morrison's articulation of reading as an amalgam of writer's and reader's imaginations foregrounds the kind of creative thinking and making that can inspire subjective and relational possibilities typically viewed as unseen or impossible in critical and societal discourses of Blackness and anti-Blackness. Underscoring this point, the materiality of the book, which is after all a physical object, signals its unwieldiness in regard to notions of Blackness, sociality, and subjectivity that, often implicitly, foreground dominant societal acts of misrecognition and nonrecognition, such as Quashie's interiority, Jared Sexton's subterraneanity, Sarah Jane Cervanak's articulation of outside, and Candace Williamson's

analysis of sociality as another form of interiority. The dynamic that shapes a practice of "writing the reading" neither corresponds neatly with theories of interiority as subjectivity nor lends itself to notions of sociality. And paradoxically, the external qualities, or *object*-ness, of the book proves central to its function, which is to ensnare the reader in the Black worldness of interiority. Therefore, centering the subject's experience of the book proves uncanny in the sense of locating the strangeness in the ordinary and mundane. It is the sensation of readerly estrangement that produces the openings in thought and imagination that allow the meaning-making of textual worlding to happen. From this vantage point, reading is like writing; in fact *it colludes with writing* to produce the textual worlding that makes manifest Black modes of being, in all of their complexities, ever-new and ever-changing.

Slowness, Closeness; Nowness

For decades since the mid-twentieth century, literary critics have tended to describe the kind of inquiry-driven reading practice that I am modeling with language that invokes time and space. I am thinking specifically of "close reading," which refers to an analytical method adopted in the 1930s and '40s by members of what has come to be known as the school of American New Criticism.[36] The proponents of close reading argued that in the search for literary meaning, text mattered more than context. For decades, because of their immense influence on the discipline, scholars focused on questions of language, style, and form to the exclusion of other details like authorial intention, cultural context, or ideology. In the ensuing years, new generations of critics rejected the rigidity of an approach that treated works of literature as enclosed and self-referential. This is especially true for specialists in the Black and other minoritized literatures. Nevertheless, English departments around the United States have continued to train their students to search for meaning in a work's formal elements no matter how small or seemingly inconsequential.

Nevertheless, in an analysis of New Criticism's legacy, Jonathan Culler acknowledges the limitations of trying to separate a literary work from its historical and social contexts while arguing at the same time for the generative possibilities to be found in close reading's disorienting effect: "The crucial thing is to slow down. . . . *Close* asks for a certain myopia—a *Verfremdungseffeckt*. It enjoins looking at rather than through the language of the text and thinking about how it is functioning, finding it puzzling."[37] Ultimately, "its

goal is to estrange reading, to give it a different optic."[38] Reading so as to render a story's language puzzling proves central to any critical praxis that aspires to an attunement to the openness of a creative text, its status as a becoming-object of art. Close reading facilitates this dynamic because in this method, "The close reader needs to take seriously the difficulties of singular, unexpected turns of phrase, juxtaposition, and opacity. Close reading teaches an interest in the strangeness or distinctiveness of individual works and parts of works."[39] In other words, close reading moves toward the digressive and welcomes the textual invitation to remain suspended in the literary encounter, even when it withholds the promise of leading to the kind of conclusions about what makes narratives relevant or meaningful that readers have come to expect.

This way of thinking about the critical engagement of literature extends to other types of aesthetic encounters. For example, DJ Jace Clayton coins the phrase "slow listening" to describe the kind of auditory experience of music that strives for the fullness of a song's sonic, lyrical, rhythmic, kinesthetic, and emotional registers. He states that "listening to a song I love, *I don't want it to end*. Music needs time to unfold, as sure as that unfolding directs our attention to *the mysterious moment of now*."[40] Riffing off a lyric found in rap music that says, "My presence is a present," Clayton reframes the egotistical boast to be an ecstatic declaration of the revelation experienced in the immediacy of the aesthetic encounter: "*This nowness I inhabit is a gift*."[41] We hear echoes of the tenants of close reading when Clayton declares, "Good music suggests that every moment is provisional. The details matter more than the scale."[42] This also emphasizes the changing possibilities (changing moods, feelings, bodily sensations, interpretations, and so on) that the encounter with a work of art affords. Yet the sensation of nowness is (re)produced only as long as the listener slows the linear march of chronological time and stays in the space-time suspension of the moment.

Even though slow listening resembles close reading in that both methods prize a work's formal aspects, small and large, the notion of aesthetic nowness makes it possible to bridge the divide between the formalism of close reading and the justice-oriented projects typically associated with Black/ Feminist Studies. We can discern a shared sensibility if we think of close reading as a form or mode of relation, and we link this method to disciplines concerned with envisioning other, more just, ways of being in the world. What I mean is that approaching literature as a kind of becoming-object of art turns reading into a meaning-making practice of reciprocity, an action whose

potentiality resides in the chance that a work might move a reader emotionally or cognitively and a reader might participate in the writing/envisioning initiated by the author.

A similar ethos informs Christina Sharpe's theorization of "wake work" as a practice of caring for the well-being of the vulnerable and dispossessed. She asks, "What does it mean to defend the dead? To tend to the Black dead and dying: to tend to the Black person, to Black people, always living in the push toward our death? It means work."[43] According to Sharpe, the physical, emotional, and intellectual labor that comprises wake work encompasses "vigilant attention" being paid to the material conditions, ideologies, and discursive acts that contribute to the dispossession and injury of Black subjects. Thus, wake work means reckoning with literary, visual, and quotidian representations of Blackness as social and physical death *as well as* those modes of being that exceed death.[44]

What is wake work, if not an invitation to come close to the complexities of Black existence? Note the proximity implied by Sharpe's symbolic traversal of space and closure of distance in the following passage: "What happens when instead of becoming enraged and shocked every time a Black person is killed in the United States, we recognize Black death as a predictable and constitutive aspect of this democracy? . . . What happens when we proceed as if we *know* this, antiblackness, to be the ground on which we stand, the ground from which we attempt to speak, for instance, an 'I' or a 'we' who know, an 'I' or a 'we' who care?"[45] Proximity eschews the false innocence and comforts of distance and detachment. It frames closeness as an ethical stance, required in order to put in the work of caring for society's most vulnerable and marginalized subjects.

Jennifer Nash suggests something similar in her conceptualization of antiracist and feminist activism as examples of "love-politics."[46] And in a second essay on Black feminist deployments of the autobiographical in their writing, Nash, like Sharpe and Quashie, also foregrounds the ethical resonances within an aesthetic framing of Blackness. She states, "I use the amorphous and slippery term *beautiful* to describe certain writing practices, though I do not mean beautiful as a form of valuation. Instead, I use it to describe the aesthetic properties of contemporary black feminist theoretical work and to capture an ethical commitment that this kind of writing project evidences, particularly its aspiration to move the reader (even as it might move the reader in a variety of ways, or may not move the reader at all)."[47] Here, Nash's turn to aesthetic reinforces the idea that taking seriously the interpretive work that a reader does on a creative Black text, as well as

the work that the text does on the reader, can point in the direction of envisioning emancipatory possibilities for Blackness in the world.

Reading with Attention: Toward Blackness

Analyses of close reading, like Culler's, tend to stress its productively alienating effects by using words like "peculiar," "disorienting," and "estranging" to describe the experience. These descriptors resonate with Quashie's reminder of the reorientation of perspective, the "paying attention in a different way," that is necessary in order to develop the capacity to behold the interior landscape of Black subjectivity.[48] Etymologically, the word "attention" derives from the Latin *attendere*, which indicates a stretching outward and toward another (*at* meaning "to" and *tendere* meaning "stretch"). This context gestures to the ways that a discussion of disciplinary methods can speak to the ethical and more broadly to the philosophical in the sense of suggesting a phenomenological approach to Blackness.

Think, for example, of Sara Ahmed's description of phenomenology's central claim: "that consciousness is intentional: it is directed toward something."[49] When Ahmed states that "what is perceived depends on where we are located, which gives us a certain take on things," she offers a necessary reminder that phenomenology has as much to do with the world's availability and openness to the subject as it does to the subject's experience of themselves in the world.[50] For Black and other minoritized subjects, this fact is especially fraught because in an anti-Black world, the reciprocity and respect implied by "stretching toward" is far from a given and often denied.[51] What I find most generative in Ahmed's reflection on queer phenomenology, however, is her reminder that discussions of being-in-the-world inevitably call for a reckoning with the spatial and temporal arrangements that govern the social world as well as our imaginations.

When Presence Is a Present

Ordinary Light's aesthetic qualities, not only its subject matter but also its formal, symbolic, and syntactical elements, exemplify the ways that a literary work can direct a reader's attention to possibilities that lie beyond the constraints anti-Blackness places on racialized existence. The narrative accomplishes this by inviting the reader to hold back the desire for comprehension and mastery (*How do the anecdotes all add up? What does it all mean?*) and to stay

suspended in the readerly freedom and pleasures of Smith's lyrical prose and vivid imagery, even to dwell in more prosaic aspects like the narrative's syntax and grammar.[52] Consider, for example, the text's first and only use of present-tense narration in the memoir's final passage, which paints a picture of Smith curling tenderly into her mother's body.

> I am three, resting my head on my mother's hip, tucking my body into the crook of her knees as she lies on her side on the couch. She doesn't speak. It is early afternoon and we are alone together in the house. I can hear the quiet mewling of her stomach, digesting the lunch she's just eaten. I have eaten the same thing, but my body is silent. The only sound I make is my breathing. . . .
>
> "Mommy?" I'll say, finally, knowing she is there, that it is her body my small body has burrowed into, but wanting to know that she knows I am there, too. "Mommy?"
>
> "Yes, Tracy?" she'll ask, calmly, once I have punctured her sleep with my need to hear her voice, to feel it rise through her and hum against my ear.
>
> "Oh, nothing," I'll answer. "Nothing."[53]

Here, the opening pages' emphasis on the frustrations and failures of communication seem not to exist. Reading this portrait of maternal love and bonding, knowing the protagonist has already lost her mother, inevitably moves me to tears every time I come back to it. Indeed, Smith's use of present tense imbues this scene of nurturing and love with emotions that *this* reader experiences as intensely and insistently real.

At the same time, Smith makes another syntactical move that brilliantly alludes to the tenuous, perhaps even illusory, nature of this idyllic portrait of wholeness and completion. Partway through the passage, the grammar shifts once more, from present tense to the future perfect subjunctive, a rhetorical gesture toward a future that exists after another undetermined point in time. Thus, the certainty, fixity, and assurances conveyed by *I am three* give way to a different feeling of possibility more than completion, of hope more than assurance. The locution of *I will say, she will ask, I will answer* represents a conditional gesture.[54] One question leads to another, which leads to Tracy's final utterance, which is really not an answer at all. In a Black aesthetic-textual world, "Nothing" signifies differently: not a Black Nothing referring to ontological negation and racial abjection but rather to the Everything and Anything of aliveness and Totality. A reader who trains their

attention carefully and caringly—we might even say *peculiarly*—toward this passage's syntactical moves, its grammatical weaving of past, present, and future, finds herself swept in a torrent of thoughts and feelings about Tracy's gauze-filled memories of a mythic time before the separation from home and family and geographic dispersal have occurred. It opens a small window of insight into her feelings of ambivalence and yearning for a mythic ideal, a dream of whole and unified Blackness, which may seem graspable though it may have never existed at all.

The Freedom in Black Aesthetic Optimism

There's something unnatural—and, as Cullers reminds us, even estranging—about a critical process that calls for slowness and closeness that runs counter to the rhythms of ordinary life, *especially* in the accelerated context of the digital era. As I've already suggested, this is especially true of creative Black texts, which audiences and institutions tend to evaluate according to expectations that Black texts reflect and respond to the political urgencies of a given moment. Nevertheless, I have been arguing that a critical practice immersed in an aesthetic temporality also represents a refusal of presumptions that Blackness must necessarily be treated as an idea or experience to be asserted, negotiated, debated, defended, or dissected.[1] The concept of aesthetic time focuses on and amplifies questions having to do with Black presence and self-possession and foregrounds themes of encounter, engagement, and relation in ways that allow for the centering of the Black imaginary.[2] Borrowing from theorist critic David Marriott, we might describe this as the difference between an analytical framework that focuses on "the twists and turns of what it means to be *socially dead*" (Marriot's summation of Black pessimist thought) and one that "is on the side of life" (his definition of optimism).[3] In other words, the notion of aesthetic time invites a critical orientation toward expressions and experiences of liveness to which, Quashie reminds us, the realms of art and imagination are uniquely attuned.

I confess that it does take a certain amount of optimism to claim to value narratives that focus on the subjective, on ordinary and everyday experiences and expressions of Blackness, and to seek insight and understanding in narratives that look beyond structures of racial violence and ontological negation. Historically, institutions that participate in the production of knowledge and culture, like education, publishing, and museums and galleries, have tended to crave and reward representations of subjection. That is because the social imaginary typically identifies certain kinds of trauma, particularly that which is state sanctioned, as the kind of event that instantiates Blackness. This is the context that compels reflection on the merits of aesthetic optimism.

To be clear, from my vantage point, aesthetic and political forms of optimism (and pessimism) aren't unrelated, but they are also not the same. That

is, my formulation of aesthetic optimism builds on Stephen Best's arguments about the value of "thinking like a work of art." The optimism inherent to aesthetic thinking and feeling lies in the conviction that the unsettled, multiple, and contradictory in Black texts can function as springboards for questioning, exploration, and discovery.[4] Aesthetic optimism reckons with the unresolvable dimensions of Blackness, as does critical/political pessimism, but its reckoning takes a different form than that of the critical school of pessimism, whose analyses of structural, institutional, and ideological forms of domination and their effects overlap with discussions of race, racism, and the (im)possibility of Black people's future liberation taking place outside the academy.

Consider, for example, the insights afforded by Marriott's juxtaposition of pessimist and optimist perspectives, which for him is always already a matter of language, discourse, and narration. Even as he distinguishes between these critical perspectives, he at the same time argues that pessimism and optimism "frequently coexist in one and the same individual."[5] From this vantage point, "reading begins at the point where either becomes *impossible* (in the sense of an aporia)."[6] In my articulation of aesthetic optimism, the irresolvable internal contradiction that defines Blackness and informs the Black imagination represents a threshold rather than an obstacle. To follow the rhythms of aesthetic is to enter a gateway onto the contradictions and paradoxical, the capaciousness and complexity of Blackness as idea and identity.

A BRIEF DISCUSSION OF THE critical insights afforded by recently published works of Ta-Nehisi Coates and Imani Perry, considered two of the preeminent Black intellectuals today, pertains. In *Between the World and Me* (2015) and *Breathe: A Letter to My Sons* (2019), Coates and Perry employ a highly symbolic narrative strategy: envisioning a child or children as their primary audience. This representational choice betrays something about the duality of perspective that Marriott discusses and aesthetic optimism brings to the surface. I read the epistolary form of address as a rhetorical gesture, an expression of hope that is otherwise hard to discern in narratives otherwise concerned with examining the seemingly permanent imprint of anti-Blackness in contemporary Black life and delineating the reasons that the struggle for racial justice and equality necessarily persists.[7]

Because Coates's focus on social death is unwavering, starting with a discussion of Perry's *Breathe* can help illuminate the trace of optimism betrayed by the epistolary form. Because she frames the narrative as a conversation

between mother and sons, Perry grapples overtly with the risks of mounting a critique of American history and institutions without offering an alternative vision of the ways to bring about change for their futures. She grounds her feelings of disillusionment with systems of justice in experiential knowledge: "I learned, practically from birth, that judicial procedure was a cruel choreography and not a fact finding when it came to violence against Black people."[8] Yet she also describes herself as inspired by a maternal sense of obligation to nurture her children's ambitions and aspirations: "And I know that, despite my fear, I cannot clip your wings, as though cowering is a respectful tribute to the beauty we have lost. No, I want your wingspan wide."[9] Looking to the past for stories that impart the values and worldviews that have historically sustained Black people and their freedom dreams becomes the main source of inspiration and hope. Thus, the author urges her children to "Every day, drink in the stories and the knowledge that teach you to refuse the pernicious myth that you are inferior. And not just of and about your own. Of all who have been desecrated and ground into nothingness."[10] In *Breathe*, historicity operates paradoxically, leavening the impulse toward uncritical optimism while at the same time offering stories of resistance that may buffer against the feelings of resignation, defeat, or nihilistic despair. In these passages, Perry evinces the kind of "concrete utopia" that Muñoz, distinguishing it from uncritical optimism, argues is shaped by the lessons of the past and anchored in earlier social justice struggles.[11]

In contrast, *Between the World and Me* maintains its focus on the kind of structural analysis characteristic of the critical school of Black pessimism, envisioning that as the only viable way through the morass of American racism. Though Coates doesn't use this exact vocabulary, he frames his analysis as a lesson in the racial antagonisms that, according to Frank Wilderson, are a constitutive feature of society. Moreover, he explicitly challenges the framing of race relations as a series of conflicts that will eventually be resolved and lead to reconciliation.[12] Hence the narrative repetition of a refrain through the book's introductory pages: "your body can be destroyed" and "no one is held responsible."[13]

The ontological negation that Frantz Fanon names "the fact of blackness" in *Black Skin, White Masks* makes it possible to envision Black masculinity as a coherent and cohesive construct, unified despite a myriad of social, temporal, and geographical differences, by racial precarity. This framing enables author and critics to draw an unbroken line connecting aspects of Baldwin's life as a gay man who came of age in the pre–civil rights period, to Coates's upbringing in Baltimore in the hip-hop era, to his son's (presumably since

the narrative never addresses class issues directly) more socially integrated and economically privileged circumstances. Stated plainly, Black male precarity joins their fates to each other as well as to a long line of unjustly and prematurely killed victims of over-policing and other forms of racialized violence. Coates names Tamir Rice, Eric Garner, Renisha McBride, and John Crawford, figures who follow and likely precede a long line of victims of racialized violence and terror. The political ontology of Blackness as non/not quite human or citizen represents a tie that binds, not only across time and circumstance but also even when the physical threat stems from the actions of other Black people. Coates underscores this point repeatedly, when he describes his adolescent fear of an older boy who wields a gun as silent threat ("He had already learned the lesson he would teach me that day: that his body was in constant jeopardy"[14]) or observes after the Baltimore police kill his college friend Prince Jones that the city's institutions, from the police to the politicians, are run by Black people.

Across these differences Coates emphasizes the point that pervasive forces of anti-Blackness ensure that "your [his, their] body can be killed" with impunity. In comparison, early in her text, Perry identifies herself and her sons as "second-generation integrator(s)," gesturing clearly toward the ways that their class and social mobility, and access to predominantly white institutions, inevitably informs their individual experiences of and perspectives on Blackness. Marking the specificity of experience of the young people on the receiving end of her message represents a rhetorical gesture, an acknowledgment not only of intra-racial differences but also of sociohistorical change. This authorial decision gestures toward Perry's broader aim to write a narrative that will help future generations navigate their present and futures by negotiating difference. In other words, "second-generation integrator" gestures toward the paradoxical nature of Black consciousness today: defined simultaneously by the coexistence of individual experiences of mobility and opportunity and the intransigent persistence of anti-Black and other forms of discrimination. Juxtaposing these narrative choices with Coates's makes plain that his elision of difference represents a narrative choice too, one designed to emphasize the recursiveness of histories of anti-Black oppression and the inability or refusal of the dominant society to change.

In their attempts to guide young people on how to navigate their worlds, these more recent works follow the example set by James Baldwin in 1962 in *The Fire Next Time*. Writing in the sixties, fifty years before Coates and Perry, during a period of heightened anti-racist organizing

and protest, the author famously addressed his fifteen-year-old nephew, also named James, about the psychological and material harms of racism and the refuge to be found in their family legacy of strength and resilience. Baldwin urges James to draw power from Black history, both personal and collective, in order to "make America what America must become. It will be hard, James, but you come from sturdy, peasant stock, men who picked cotton and dammed rivers and built railroads, and in the teeth of the most terrifying odds, achieved an unassailable and monumental dignity."[15] Clearly, Perry's rhetoric and analysis resonate with Baldwin's.

In contrast, Coates presents his lack of faith in the capacity of white Americans to change not as a failure of imagination fueled by the absence of ancestral knowledge, but rather as mature, historically grounded political critique. Thus, his assertion "I did not tell you that it would be okay, because I have never believed it would be okay."[16] A trace of Calvin Warren's Afro-pessimist insistence that a nihilistic orientation is necessary for the achievement of the kind of revolutionary sociopolitical action that could lead to liberated Blackness can be heard in Coates's rhetoric. Warren argues that "there was no solution to the problem of antiblackness; it will continue without end, as long as the world exists"; moreover, the "humanist *affect* (the good feeling we get from hopeful solutions) will not translate into freedom, justice, recognition, or resolution."[17] This thinking resonates even when Coates gestures toward ancestry in ways that resonate with Baldwin and Perry, as when he declares: "What I told you is what your grandparents tried to tell me: that this is your country, that this is your world, that this is your body, and you must find some way to live within the all of it."[18]

To comprehend the distinction between the *aesthetic affect* that concerns me and the humanist affect that Warren cautions against, it's important to first consider why and how it is that ultimately, despite their differences, each of these authors (Baldwin, Perry, and even Coates) locates empowerment and agency within the Black interior's social and subjective geographies. This, in turn, calls for a brief rehearsal of some of the ways that scholars, from Quashie to Hartman to Terrion Williamson, have crafted different responses to a question posed by the poet Elizabeth Alexander in her 2004 collection of essays *The Black Interior*. Namely, "When we are not 'public,' with all that the word connotes for black people then how do we live and who are we?"[19]

For Williamson, the answer resides in the domestic and communal spaces and social relations cultivated by Black women. Acknowledging the Black

feminist consciousness and practice that shape these social and spatial relations, Williams argues that within spheres of sociality, "they have taught me more about what it means to resist oppression, demand accountability, struggle for voice, and cherish all people than anyone or anything else."[20] This framing of sociality, which Williamson envisions as an "interplay between the intramural (black community) and the interior (black self)," undoubtedly resonates with the narrative and rhetorical invocations of family and intergenerational transmission of knowledge that I have been discussing.[21]

What this approach risks leaving relatively underexamined, however, is a reckoning with what the scholar of the post-soul aesthetic Bertram Ashe describes as post-modern, post-structural fragmentations of Blackness that belie notions of racial wholeness and unity. Williamson acknowledges as much when she references Hortense Spillers's provocation for Black Studies scholars to query the meaning of "home" and "community" in order to eschew nostalgic or salvific narratives of Black social life and approach sociality critically as a "layering of negotiable differences."[22]

In comparison, Kevin Quashie frames his analysis of interiority in terms of subjectivity and an idea of the inner life that cannot be "determined entirely by publicness."[23] For Quashie, the metaphor of "quiet" proves absolutely pivotal because his critical focus remains not on the whole of Black consciousness and experiences of selfhood but rather on literary and poetic explorations of "the wild vagary of the inner life" beyond the expectations and demands of publicness and the racial imaginary.[24] More familiar articulations of racialized consciousness, like Du Boisian double-consciousness or Darlene Clark Hine's articulation of "dissemblance" to characterize Black female ambivalence, are "calibrated and sensitive to the exterior world," whereas "quiet" strives to come closer, to stay open to "the subtlety of the human subject."[25]

For both Quashie and Williamson, privileging the Black imaginary over the dominant racial imaginary is the thread that runs through and connects their analyses. Similarly, despite their different emphases, both strive to elucidate "the register of black experience that is not reducible to the terror that calls it into existence."[26] Or, as Quashie puts it, "the ways that blackness serves as an emblem of social ailment and progress."[27] Most importantly, each critic endeavors to develop new critical language, images, and frameworks for narrating and interpreting the stories designed to organize and make sense of Black life.

In her groundbreaking article "Venus in Two Acts," Saidiya Hartman foregrounds the complicated ethics of narrating Black life in ways that

help me build on and extend these analyses of Black subjectivity and soci-ality. Turning to the example of "Venus," an African girl who was kid-napped into slavery and failed to survive the Middle Passage, Hartman begins with an indictment of the archive of enslavement, which exists ex-clusively as a record of social and physical death: "In this incarnation, she appears in the archive of slavery as a *dead girl* named in a legal indictment against a slave ship captain tried for the murder of two Negro girls."[28] Yet Hartman also wrestles with the implications of her wanting to correct the historical archive by rewriting Venus's story to tell of her inner life and so-cial bonds in the form of a brief yet comforting friendship between two "frightened and lonely girls" that would be designed to restore and com-memorate Venus's humanity.[29]

Hartman's reflexive analysis of the effort to rewrite the story of Blackness is multilayered, provocative, and morally complex. First, she notes the im-possibility of "trespass[ing] the boundaries of the archive," which is com-posed of legal documents limited to facts and evidence of exploitation, violation, and degradation.[30] The humanity of enslaved peoples ought not, *cannot*, be reduced to the things done to them, and yet the historical record offers little else by way of documentation otherwise. Hartman notes too the problem of historiography and the "protocols of intellectual disciplines" that reinscribe "the fictions history" by relying on the euphemisms, "ru-mors, scandals, lies," and other fabrications that derive from the enslavers and killers' imaginations and represent their "manufactured certainties."[31]

Creating counternarratives that can "expose and exploit the incommen-surability between the experience of the enslaved and the fictions of history" calls for a historiographic method of writing, "critical fabulation," embod-ied by "Venus in Two Acts." Hartman offers her own writing as an exemplar of a practice of "playing with and rearranging the basic elements of the story, by re-presenting the sequence of events in divergent stories and from con-tested points of view."[32] At the same time, however, she insists on reckon-ing with the challenges of telling "impossible stories" of Black life by "amplify[ing] the impossibility of its telling."[33] Hartman frames critical fab-ulation as a mode of narration that emerges from present-day yearnings to repair the traumas of the past but that inevitably fails to change the fate of the dead: "I wanted to represent the affiliations severed and remade in the hollow of the slave ship by imagining the two girls as friends, by giving them to one another. But in the end I was forced to admit that I wanted to console myself and to escape the slave hold with a vision of something other than the bodies of two girls settling on the floor of the Atlantic."[34]

This meditation on "Venus in Two Acts" may seem like a digression, but in fact what I find especially compelling and relevant to my analysis of contemporary Black texts is Hartman's illumination and *amplification* of the ethical complexities of creative-critical practices and writerly processes that strive for an "aesthetic mode suitable or adequate to rendering the lives of these two girls" and Black people more broadly.[35] Similar reckonings with the contradictions and confusions engendered by the opposing yet co-existent truths of Black life and death shape the authorial choices in any and all stories of Blackness, including those presented with greater measures of moral certitude. In *Between the World and Me*, the hybridity of the essay cum letter stands for just such a reckoning, for it implicitly represents an effort to imagine otherwise, an unspoken yearning for an open and un-bounded audience that the narrative goes to great lengths to disavow.

Because Coates's use of epistolary form, coupled with his address to his son, serves as a rhetorical gesture toward an ideal of racial collectivity as family and Black sociality, this particular interpretation cuts against the grain of most critical readings of the book and even of how the book asks to be read. Coates repeatedly expresses skepticism in the possibility of relation outside the boundaries of a Black community.[36] In one example, he describes an encounter with the host of a TV program whose investment in notions of hope and innocence forecloses an empathetic or even thoughtful response to a conversation about Black struggle: "I tried to explain this as best I could within the time allotted. But at the end of the segment, the host flashed a widely shared picture of an eleven-year-old black boy tearfully hugging a white police officer. Then she asked me about 'hope.' And I knew then that I had failed. And I remembered that I had expected to fail."[37] As Michelle Alexander notes astutely in a review of *Between the World and Me*, Coates's choice *not* to address white people can be seen as a virtue: "The usual hedging and filtering and softening and overall distortion that seems to happen automatically—even unconsciously—when black people attempt to speak about race to white people in public is absent."[38] Accurate as this reading may be, what it displaces is the fact that the narrative neverthe-less, almost inevitably, continues to center whiteness even as it strives to represent how Black people speak about race—I would say how Black people speak about white power, privilege, and racism—to each other. Juxtaposing the TV announcer's inane insistence on hope with the vision of a son/family that is equally invested in and affected by these issues may effectively illuminate and amplify societal racism and its effects, yet it does little to reveal the complex, complicated exchanges taking place "intramu-

rally" (e.g., between elders and the second-generation integrators in a family) or internally within an individual person's consciousness. From this vantage point, a similar conversation about the horizon of possibility for societal change and liberated Blackness might probe other questions and conflicts than the ones explored here or unearth a different set of irreconcilable and irresolvable truths about Blackness in all of its diversity, multiplicity, and complexity.

My point here is not to fault or second-guess Coates's narrative focus and approach but rather to think critically about the expectations readers bring to the epistolary form and the presumptions it holds about the type of reader (Black) who, as Toni Morrison puts it, "is made for the book." My aim is to underscore Morrison's eternally trenchant point that "there is no escape from racially inflected language, and the work writers do to unhobble the imagination from the demands of that language *is complicated, interesting and definitive.*"[39] The complicated truth of these contemporary texts is that the young person addressed does actually stand in for a wider, heterogeneous, multiracial audience, one that is primarily imagined as predominantly white since the discourse around contemporary race relations centers the Black-white binary. Moreover, despite Coates's disavowal of hope, a trace of it persists in the "letter's" essayistic form, which betrays some measure of faith in his authorial powers of persuasion. Otherwise, why publish the letter as a book, the literary embodiment of publicness?

MORRISON'S AND HARTMAN'S theoretical and critical writings help illuminate the complicated and interesting dynamics involved in the aesthetic inventions of writers who strive to find new, creative, and affecting ways to represent Blackness. Similarly, author Zadie Smith's critical ruminations yield great insight on the subject of freedom and the Black imagination in ways that resonate. In the collection of essays *Feel Free*, Smith enunciates and illustrates a poetics of freedom that eschews orthodoxy and embraces the uncertainty of subjectivity. One hears traces of Morrison's assertion in *Playing in the Dark* that her job is to think "about how free I can be as an African-American woman writer" in Smith's own meditations on writing and selfhood:

Writing exists (for me) at the intersection of three precarious, uncertain elements: language, the world, the self. The first is never wholly mine; the second I can only ever know in a partial sense; the third is a malleable and improvised response to the previous two. . . . It's *this*

self—whose boundaries are uncertain, whose language is never pure, whose world is in no way "self-evident"—that I try to write from and to. My hope is for a reader who, like the author, often wonders how free she really is, and takes it for granted that reading involves all the same liberties and exigencies as writing.[40]

What this passage reveals is that, for Smith, an unburdened literary imagination allows itself to dwell in uncertainty, ambiguity, and ambivalence, qualities that I have been associating with aesthetic optimism. That is, this conceptualization of freedom describes a creative-critical receptivity to subjective, intersubjective, and ideological changeability because it remains open to the contingencies, uncertainties, and unpredictability of life.

In an earlier collection of essays, *Changing My Mind: Occasional Essays*, Smith describes the title as confessional, stating: "I'm forced to recognize that ideological inconsistency is, for me, practically an article of faith."[41] Taken together, the essays in both collections reveal a writer whose experience of imaginative freedom and sovereignty is deeply informed by a commitment to the psychological vagaries of the individual. In addition, the preceding sentence performs via the pause of the qualifying phrase a relational orientation to otherness and difference, one grounded in an ethos of mutuality. "For me" acknowledges that the writer's and reader's perspectives will inevitably differ, which, in turn, implicitly positions both as coparticipants in the process of meaning-making. Or, as Smith asserts in the foreword to *Feel Free*, "To the reader *still curious about freedom* I offer these essays—to be used, changed, dismantled, destroyed or ignored as necessary."[42]

This privileging of difference and multiplicity may be one reason that Smith's representations of childhood and parenthood in fiction and nonfiction tend to be more exploratory than didactic, the relationships more horizontal than hierarchical, and the characters' identities more fluid than static. Childhood typically forms a terrain from which to explore the (re)formation of selfhood in concert with the chaos and unpredictability of living in a heterogeneous and ever-changing world.

An example from *NW*, Smith's 2012 novel about unlikely encounters between strangers and kin in northwest London illustrates this point. In a passage that appears in the section titled *in the playground*, the characters' race, class, and gender identities, along with questions of power, remain always already in play as they negotiate the spatial and social dynamics of a public space. Narrated from the perspective of a central character named Keisha, the daughter of Jamaican immigrants who has rechristened herself

"Natalie" while moving up social and professional ladders (Keisha could easily be described as a "second-generation integrator"), this playground encounter presents a staging ground for the exploration of a subject's malleable and shifting sense of selfhood in a moment of encounter with other subjectivities and perspectives. Smith depicts Natalie as an ambivalent participant in the drama that entangles Natalie, an elderly white woman, a middle-aged woman wearing "a formidable-looking Rasta in a giant Zulu hat," and three teenagers whose speech and affect mark them as working class and racially othered.

The passage begins with "an old white lady" making a statement that sets off a debate about respect and the rules governing public spaces: "You can't smoke in a playground. It's obvious. Any half-civilized person ought to know that."[43] Blending the omniscient narrator and Natalie's perspectives through free indirect discourse, the narrative tells us that Natalie agrees, "Yes, of course," while simultaneously feeling ambivalent. She thinks, "They looked quite nice together, lounging on the roundabout. But it could not be denied: the smoking boy was standing on the roundabout. Smoking."[44] The character's inner conflict arises almost immediately, engendered perhaps by the white woman's categorization of people as civilized and half (or un-)civilized. The reader understands from other parts of Natalie's story that these words evince a colonial and classist mentality that she has had to agree to or ignore in order to pave her way out of the working class and up the social ladder.

Natalie's quiet appreciation of the teenagers is one of several narrative details that signal her anxiety over her complicity; that more than agreeing with park rules, she is actually doing harm by siding with the white woman. In a telling moment, Natalie and the boy exchange glances: "Easing into triumph, she accidentally locked eyes with Marcus—briefly causing her to stutter—but soon she found a void above his right shoulder and addressed all further remarks to this vanishing point."[45] The distinction between looking and seeing highlights the central conflict that torments Natalie throughout the story: her refusal to see and recognize uncomfortable truths that threaten to shatter her sense of self. It exemplifies the narrative's overall approach to identity, selfhood, and self-revelation, which is to represent them subtly and obliquely. In another less consequential example, the narrator habitually identifies the race of the white characters only—the old woman and one teenager—leaving readers to deduce that the others are if not Black, then decidedly not white.

These narrative and rhetorical strategies evoke a specificity of time and place that amplify the contradictions of contemporary London's multicultural, multiracial context. In this locale, presumably, overt displays of

racism and classism by the white woman would likely be condemned, yet the legacies of empire and coloniality can be felt in the inequities and biases embedded within the nation's institutions and ideologies. These circumstances shape the dynamics that unfold and present readers with multiple angles from which to consider the interactions. Even as the teenagers reject the various signs of authority—from the posted signage to the women's age to their appeals for common courtesy—the narrative presents the encounter as a matter not of taking sides but rather of considering other perspectives.

The white woman's Anglo-centric objection to their youthful transgressions rings differently when uttered by the Rasta woman, who scolds, "That lady is your elder. You should be ashamed of yourself."[46] In this instance, she bases the measure of respectability rooted in a West Indian value system rather than in some notion of cultural superiority. And when the smoker replies, "But why did she have to get in my face in that manner? / . . . Listen, I don't do like you lot do round here. This ain't my manor," he challenges their definitions of propriety by reminding them that respect should be reciprocated and standards of respectability are culturally relative.[47]

Given Smith's well-known aversion to identity politics and its presumption that social identity grants knowledge about the totality of a person, it makes sense that the novel conveys the characters' identities and their placement within social hierarchies through language. In *NW*, language and place function as synecdochic representations of class and race. For example, feeling attacked by the three older woman, one boy responds, "You can't really chat to me. I'm Hackney, so," to which the middle-aged woman in the Rasta hat claps back, "I'm not Queen's Park, love, I'm HARLESDEN."[48] Readers need not know the demography or histories of Hackney and Harlesden to understand the meaning behind these declarations. In the context of urbanity in the years since hip-hop culture's ascendancy, several messages are conveyed when the woman and the boy rep the places they come from: their rejection of stereotypes of poverty, crime, and so on, that result in their neighborhoods and their inhabitants being overlooked or looked down upon; their association of neighborhood pride with self-regard; and, most importantly given the power dynamics at play, place (like the Rasta woman's "HARLESDEN") functioning as a reminder of their *realness*, meaning an authentic identity rooted in struggle.

One could use this exchange as a launching point for a discussion of critical frameworks of identity (e.g., anti-essentialism or performativity), but what I find especially compelling is the passage's representation of power at

play, as energy emanating from different centers and capable of traveling in multiple directions at once. Ironically, the woman who provided the catalyst for these disagreements by insisting on rules of respectable public behavior and coding them Anglo/white remains a bystander through much of these interactions. In other words, the narrative acknowledges the gravitational pull of whiteness, even as it focuses our attention on and privileges the layered and sometimes conflicted thoughts, feelings, investments, and allegiances of the other characters. The passage ends with the characters in various states of exhaustion, frustration, and bewilderment. The reader is left with the freedom to question, consider, and reconsider the freedom afforded by the aesthetic optimism of a literary work that confers multiplicity and fluidity onto the identities and perspective of the characters and reading audience.

Smith published *Feel Free* two years after Donald Trump successfully rode a campaign fueled by anti-immigrant rhetoric and isolationism to the US presidency in 2016. In the United Kingdom, 2016 was the same year that these very same issues informed debates on the Brexit referendum that led to the United Kingdom's withdrawal from the European Union. By 2018, eight years after *NW*, sociopolitical circumstances had changed to such an extent that Smith finds herself openly wrestling with the value and implications of the humanism that shapes her imagination. In *Feel Free*, Smith assumes an almost confessional tone, admitting that the ambivalence associated with imaginative freedom to change one's mind may in fact be "the product of a bygone world" and out of step in a time of intense, high-stakes political strife.[49] She elaborates: "I realize my somewhat ambivalent view of human selves is wholly out of fashion. . . . Millions of more or less amorphous selves will now necessarily find themselves solidifying into protesters, activists, marchers, voters, firebrands, impeachers, lobbyists, soldiers, champions, defenders, historians, experts, critic. You can't fight fire with air."[50] Notably, however, this truth coexists with another competing one, articulated in the foreword's concluding sentence: that *Feel Free* extends to the reader who remains curious, "who wonders how free she really is," an experience of liberty through the practice of reading in the encounter with a range of stories, experiences, and ideas.

In the essays that follow, Smith extends this line of inquiry. For example, in "Fences: A Brexit Diary," she grapples with feelings of disappointment and disillusionment when the idea and ideal of democratic pluralism feels increasingly out of reach. An elementary school, the one that she attended as a child, symbolizes this horizon of possibility foreclosed. She writes:

I valued this little school especially, symbolically, as a mixed institution in which the children of the relatively rich and the poor, the children of Muslims, Jews, Hindus, Sikhs, Protestants, Catholics, atheists, Marxists and the kind of people who are religious about Pilates, are all educated together in the same rooms, play together in the same playground, speak about their faiths—or lack of them—to each other, while I walk by and often look in, and thus receive a vital symbolic reassurance that the world of my own childhood has not yet completely disappeared.[51]

Yet she is forced to conclude, "It sounded right, and I wanted it to be true, but the evidence of my own eyes offered a counter-narrative. For the people who truly live a multicultural life in this city are those whose children are educated in mixed environments, or who live in genuinely mixed environments, in public housing or in a handful of historically mixed neighborhoods, and there are no longer as many of those as we like to believe."[52] In the face of harsh political truths, Smith admits to feeling "nostalgia for a country that doesn't yet exist on a map."

Smith replaces the melancholy tone of "Fences" with a more insistent and determined reflection on the value of optimism in "On Optimism and Despair," an essay that takes a retrospective look at the author's career.[53] Here Smith openly addresses and attempts to answer a question frequently posed to her by readers who regularly ask her to explain why the optimism of her first novels has given way to books now "tinged with despair"; or who challenge this former "champion" of multiculturalism to "admit now that it has failed."[54] As in "Fences," Smith grants those skeptics the point that optimism can be associated with naivete, though in this case over the expectations readers bring to the text.

Of course, as a child I did not realize that the life I was living was considered in any way provisional or experimental by others: *I thought it was just life*. And when I wrote a novel about the London I grew up in, I further did not realize that by describing an environment in which people from different places lived relatively peaceably side by side, I was "championing" a situation that was in fact on trial and whose conditions could suddenly be revoked. This is all to say I was very innocent, aged twenty-one. . . . I did not understand that I was "championing" multiculturalism simply by depicting it, or by describing it as anything other than incipient tragedy.[55]

Unlike "Fences," which reads as a meditation on a failed social experiment, this second essay makes a stronger case for the value of optimism and utopian thinking and writing. One can sense a note of defiance in the preceding passage: "*I thought it was just life*" (because it was the life I had lived up to that point); "I further did not realize that by describing an environment" (which is what writers of fiction do), "I was "championing a situation" (which is what polemicists do). The defense of subjective experience and aesthetic sovereignty hinted at in these lines read as the author's defense of Morrison's reminder of the author's responsibility to think "about how free I can be as [a Black woman] writer." From the juxtaposition of the two essays, readers ascertain that Smith's opinions about optimism are . . . complicated. In the context of contemporary neoliberalism, it smacks too much of ineffectual nostalgia and political complicity. In the context of writing fiction, however, optimism licenses her to tell stories that feel authentic to her characters' subjective experiences of the worlds they inhabit while remaining oriented to a totality that refuses mastery or categorization.[56]

In fact, in "Optimism and Despair," Smith does more than defend optimism as a creative right; she depicts it as an ethical responsibility. She questions the tendency of ideological writing to "carve society up into victim and victimizers"; ideology also holds fast to the belief in "political or personal identity of pure innocence and absolute rectitude."[57] An example of the kind of ideological thinking that Smith interrogates can be found in the case that Calvin Warren makes against the idea of Black ethicality. This impossibility is premised on modernity's conceptualization of the Black as Other to the human. Therefore, Warren argues, "Ethics is a relationality between coherent ontologies that is predicated on fractured blackness, or the nonrelational landscape between the human and blacks."[58] With this, we reach the inevitable impasse that pessimism arrives at in its consideration of Black being in the world. This reading of the modern world's ontological violence posits a theoretical truth that at the same time doesn't begin to touch on the phenomenological and its embodied or experiential truths. Readers may experience these narratives' partial or incomplete truths as a vexing conundrum. If we think back to Best's enjoinder to think like a work of art, however, we might consider that, sometimes, the point of reading is not to wield answers but rather to grapple with the paradoxes and impasses and sit with the irresolution of Blackness suspended between subjecthood (where ethics is not only possible but imperative) and objecthood (where it is not).[59]

Smith's ruminations offer a necessary reminder of the line that divides representation from reality. She states, "If the clouds have rolled in over my fiction it is not because what was perfect has been proved empty but because what was becoming possible—and is still experienced as possible by millions—is now denied as if it never did and never could exist."[60] These passages underscore the central idea running through my analysis in this chapter: that recognizing the ways that discourse, the language we use, and stories we tell shape and inform perceptions of reality ought not obscure the fact that discourse does not in fact represent a totality. And beyond that, the aesthetic realm is uniquely endowed with the capacity to hold and express multiple, sometimes competing, truths about Blackness without having to organize those realities according to a hierarchy of value.

Black Time Matters

In *The Order of Time*, the theoretical physicist Carlo Rovelli notes that reality often differs from how it appears, an observation that leads to his characterization of the structure and nature of time as "perhaps the greatest remaining mystery."[1] Intellectuals from a range a disciplines, from physicists like Rovelli to continental philosophers like Husserl and Heidegger, have been motivated by the desire to understand the complexities of human perceptions and experiences of time. These questions motivate Black Studies scholars too, and out of this preoccupation has emerged an awareness of the existence of a temporality of Blackness, *Black time*, that refuses the modern imperative to measure time chronologically and progressively—for example, via a linear trajectory from slavery to emancipation. Julius B. Fleming characterizes this school of critical inquiry, which he designates as Black Time Studies, as a field concerned with mapping "the racial character and the social function of time."[2]

Kenneth Warren's historicist analysis of the African American literary tradition marks a critical turning point in Black Time Studies. In *What Was African American Literature?*, Warren proposes a thesis that has proven both highly influential and also contested: that "African American literature is over" in the post–civil rights era because of the demise of a shared sociohistorical condition, legalized racial subjugation, and segregation. He grounds this premise in the understanding that the formation of a canon or tradition depends on an audience's agreement of the criteria that determine the constitution of a "literature."[3] He states, "Indeed, it was largely in the light of imperatives determined by the Jim Crow era that antebellum texts were assimilated into the collective project we recognize as African American literature."[4] Accordingly, with the de facto end to segregation, the premise of racial unity undergirding literary tradition no longer pertains.

Warren's thesis represents a version of what another Time Studies scholar, Michelle Wright, calls Middle Passage epistemology in that it links "our cultural practices and expressions, our politics and social sensibilities, to the historical experience of slavery in the Americas and the struggle to achieve full human suffrage in the West."[5] Though Warren's provocation has inspired much debate, Wright's epistemological framework helps illuminate the ways

that his engagement of a Middle Passage epistemology illustrates the use of that timeline as a narratological instrument designed to theorize Blackness as identity, collectivity, and tradition.[6]

Notably, because the production of historically informed scholarship has, from its inception, been one of the methodological pillars of Black Studies as a discipline, it has been naturalized to the point that it goes unnamed. There is no correlate — say, Afrohistoricism — to a clearly established movement like Afrofuturism or an emergent line of inquiry like Afropresentism. The insights afforded by Black Times Studies scholarship inform my own articulation of Black aesthetic time. In particular, the work of scholars like Wright and Best, who unearth the underlying psychological, affective, and discursive subtexts for the Black Studies' mobilization of history and historical thinking, has proven especially helpful. Their reminders and analyses of the discursivity of *Black time* render alternate timescapes conceivable. Moreover, my conceptualization of aesthetic time as a portal leading to free, in the sense of multiple and malleable, imaginings and interpretations also resonates with the thinking of Time Studies scholars like Wright, Derik Smith, and others, who query the disciplinary tendency to use Middle Passage history as a single and regulatory timeline in the ordering of Blackness.[7]

In this as in previous chapters, I privilege the critical and theoretical turns toward aesthetics and poetics in order to compel consideration of how Black thought and imaginings endeavor to disrupt the forces that reduce the totality of Blackness to objecthood and abjection. Incontestably, the quandary of the political ontology of Black nonbeing originates in modernity and its formation of a social world order in which whiteness establishes the criteria for universal ideas of the human. In "Unsettling the Coloniality of Being/Power/Truth/Freedom," Sylvia Wynter characterizes this phenomenon as the "overrepresentation of Man."[8] At the same time, however, Quashie's conceptualization of *quiet* and *aliveness*, like Crawford's writing on *is-ness*, reminds us of the risks of tethering discussions of Blackness exclusively to a Middle Passage timeline that remains always already entrapped by the violence and violation of Western modernity to the exclusion of Blackness's other temporal dimensions.

Stephen Best's recent publication *None Like Us* addresses and challenges this habit of mind in provocative ways. If Kenneth Warren presents the question of racial unity as a discourse informed by historical context, Best frames the issue primarily as an ideological and discursive phenomenon in and of itself, stemming from the yearning in Black Studies scholarship to use

history and historical thinking as a vehicle that could resolve and/or recuperate slavery's originary negation of personhood, the alienation that represents the instantiation of Blackness. Best declares:

> A communitarian impulse runs deep within black studies. It announces itself in the assumption that in writing about the black past "we" discover "our" history; it is implied in the thesis that black identity is uniquely grounded in slavery and middle passage; it registers in the suggestion that what makes black people black is their continued navigation of an 'afterlife of slavery,' recursions of slavery and Jim Crow for which no one appears able to find the exit; it may even be detected in an allergy within the field to self-critique, a certain *politesse*, although I have no doubt that this last may be a bridge too far for some."[9]

The quotation marks around "we" and "our" set apart and de-naturalize the idea that Blackness as racial identity is always already equated with the collective. Rather than treating this connection as inherent and inevitable, Best reminds us that a unified "we" is not a static thing.[10] Rather, it is an assemblage, or a processual phenomenon marked by continuities and discontinuities that inevitably centers some subjects while relegating others to the margins or outside the imagined community.

In the past several decades, Best argues, historicity has come to play a pivotal role in (re)articulations of collectivity in Black Studies. Like Kenneth Warren, Best's willingness to engage in critical and disciplinary "self-critique" has proven provocative, even vexing to some.[11] The perspective of Black pessimism brings to the question of the meaning of Blackness in relation to time a wariness toward this perspective that merits further attention. For example, citing Homi Bhabha's concept of "the enunciatory present," Calvin Warren dismisses the discourse of presentism as "nothing more than a discursive maneuver, a perspective within modernity, a way of continually enunciating the self into existence."[12] Crucially, Warren links presentism to Western ideals of subjecthood and individualism. The present becomes synonymous with a neoliberal discourse of "progress, betterment, equality, citizenship, and justice—the metaphysical organization of social existence."[13] It symbolizes nothing more than a bankrupt and complicit version of neoliberal humanism and an erasure of the "injured and mutilated bodies" who "constitute a fatal rupture of the Political; these signifiers, stained in blood, refuse the closure that the Political promises."[14]

From this vantage point, when taken up by Black Studies scholars, the enunciation of selfhood through anything other than historicism represents a futile attempt to transcend, implicitly or explicitly, the limits that race and racism place on the individual. This framing leads to skepticism over Best's argument about the relationship of the past to the present. Calvin Warren declares, "Best must enunciate this present throughout the text to conceal the ontological crisis that undergirds it: there can be no present without the disjuncture of black ontology and black time."[15] What this framing overlooks, however, is the generative possibility within Best's call to heed the differences and distinctions within Black time.

In fact, although Best's stated intention is to write about the uses of history with the "goal of replacing holding with letting go, clutching with disavowal," I'm not fully persuaded that a total disavowal of history lies behind his examination of "melancholy historicism"—"a kind of crime scene investigation in which the forensic imagination is directed toward the archive"— is to entirely replace historicism with a presentist point of view.[16] Instead, I read Best's analysis of the limits to the melancholic mode of critique as an attempt to discover and foreground other ways "to think about loss," including the ontological loss that haunts and informs the present. One hears traces of Warren and other pessimists when Best, citing David Scott, argues, "Any revisionary practice of historical criticism in the present must unfold against the backdrop of 'the dead end of the hopes that defined the futures of the anticolonial and . . . postcolonial projects.'"[17] Moreover, disambiguating the present from the past leads to conclusions about slavery's psychic and affective residue in the present that resonate very much with Hartman's analysis in "Venus in Two Acts"—for example, when he states, "To be historical in our work, we might thus have to resist the impulse to redeem the past and instead rest content with the fact that our orientation toward it remains forever perverse, queer, askew."[18]

What I find especially valuable in this deconstruction of this critical tendency is the space-clearing pressures it places on Black Time Studies. That is, querying the critical tendency to frame slavery as "the event horizon of blackness" makes it increasingly possible to explore and perhaps expand the limits and possibilities of racialized discourse; to tell, and value, stories of Blackness that wonder and wander beyond easily recognizable boundaries. Certainly, the insights and ideas afforded by this refusal to elide the past and present can *feel* confounding for it asks us to hold two contradictory perspectives simultaneously: that slavery is, indeed, the event horizon of Blackness and also at the same time that *Black time* is relative.[19] Michelle Wright's

articulation of the physics of Blackness emphasizes exactly this point, for she reminds readers that the perception of the flow of Black time depends on the individual's situatedness in time and space, their position in relation to others.

Thinking back to Best's thesis, I find myself reflecting on the ways that the pessimist turn in Black Studies has amplified the historicism that has always undergirded the discipline. How, I ask, have the particularities of pessimism's political present, its sociohistorical context, informed the emergence of a version of Afrohistoricism that views the timeline of the Middle Passage epistemology as fixed and/or recursive? Best argues that this has not always been the case, that in previous eras African American thinkers and writers envisioned a different dynamic between the past and the present/future. I would add that other contemporaneous branches of Black Time Studies arrive at other frameworks as well, even in works that share Black historicism's conceptualization of *Black time* as an entity that exists outside and other to the progressive teleology of Western modernity and its social order.

For example, when Mark Dery coined the term *Afrofuturism* in 1994, he emphasized the utopian impulse and technological investments within the Afrofuturist aesthetic—for example, describing the literature as "speculative fiction that treats African-American themes and addresses African-American concerns in the context of twentieth-century technoculture."[20] Alondra Nelson's articulation of Afrofuturism takes up the themes of futurity and utopianism. She writes, "Afrofuturism can be broadly defined as 'African American voices' with 'other stories to tell about culture, technology and things to come.'"[21] At the same time, Nelson complicates the temporal landscape of futurity by engaging notions of historicity. She declares, "These works represent new directions in the study of African diaspora culture that are grounded in the histories of black communities, rather than seeking to sever all connections to them."[22] Nelson also identifies "African diasporic cultural retentions in modern technoculture" as one of the defining elements of the Afrofuturistic aesthetic.[23] Critical discourse on the Afrofuturist aesthetic movement reveals a myriad of texts—the music of Sun Ra and Janelle Monae; novels by Octavia Butler, Samuel Delany, and Nalo Hopkinson; and other expressive forms like comics and fashion—that envision futurity as a construct inextricably connected to the Black past and present. The Afrofuturist angle on the past filters it through a lens of speculative possibility that in turn informs the shape the stories, ideas, and images aesthetic makers produce.

The recent emergence of a line of inquiry that we might call Afropresentism is helping make the case that a multiplicity of sometimes overlapping Black *timelines* can and should be mobilized in new and productive ways that contribute to the study of Blackness. Instead of the conventional understanding of an uncritical adherence to present-day values and concepts (e.g., neoliberal humanism), *Black presentism* aspires to a more nuanced and layered understanding of the now. Margo Crawford's meditation on literary *is-ness*, like Emily Lordi's conceptualization of Afropresentist aesthetics, offers a model of presentism that "uses the archive of the past to critique and complicate the present."[24] For example, Lordi locates evidence in the tradition of soul music and soul logic that "AfroPresentists think beyond the here and now—but they do so by reckoning with notions of the 'beyond' that have come before, turning back to earlier freedom dreams to see what was lost and what might be regained."[25] Julius Fleming theorizes Afropresentism differently in that he identifies it as "a political, affective, and philosophical orientation toward enjoying and demanding the 'good life' in the here and now, in the present."[26] Despite the differences in focus and emphasis, each of these critics approaches the aesthetic—Black literature, music, and theater—as a realm that grants "access to a different way of being in the world—however fleeting—puts pressure on prescriptions for black racial being that take teleology's force of finality, or white supremacy's violence, as their chief grounds of critical imagination."[27]

Clearly, these theories of Afropresentism resonate with my own articulation of Black aesthetic time as a phenomenon rooted in the now-ness of a subject's encounter with a creative text.[28] Much like these other articulations of Black presentism, the notion of Black aesthetic time aspires to a vision of the beyond that ought not be equated with a refusal of or desire for transcendence from the scene of racialized subjection. As Lordi succinctly puts it, "Afropresentists figure the present as the yet unfulfilled future of a radical past."[29] Their figurations lean on aesthetics and poetics to make manifest those visions. Rather than moving past the a priori of the racialized past, however, the aesthetic symbolizes a striving to know what else, what *more*, there is to discover in the Black imaginary, or beyond historical overdeterminations in Black forms of being and becoming. This vision of interpretive openness and possibility recalls Quashie's figuration of Black textual worlding as a space in which "blackness is totality, where every human question and possibility is of people who are black."[30] Privileging the notion of Black aesthetic time may lead to associations with presentism or interpreted as an expression of optimism. Nevertheless, the critical stance it compels is

neither unidirectional nor ahistorical; rather, the presentism of Black aesthetic engagement is fractal and prismatic. It understands that the immediacy of the aesthetic encounter can function as a portal into the capaciousness of the Black imagination and offer a gateway into the complexity of Blackness and its many dimensions.

The Post-Soul Interregnum

The discourse surrounding the development of a post-soul aesthetic in the 1980s intersects with discussions of Black time in interesting ways because it marks a historical juncture in which the political present was defined increasingly by demographic, cultural, and societal changes that fractured and challenged traditional ways of thinking and writing about Blackness and racial collectivity. As a simple historical indicator, post-soul denotes the end of one era defined by political activism in the struggle for civil rights in the United States and colonial independence across the rest of the diaspora and the beginning of another defined by societal integration, pluralism, and diversity.[31]

In popular and scholarly discussions, references to *post-soul* and *post-Blackness*, which are often used synonymously, tend to mark a milestone, albeit a contested one, in the long march toward justice and Black liberation. Most scholarship on the post-soul aesthetic begins with an analysis of the paradigm shift that led to the questioning of conventional representations of Blackness. Given how common it is to frame Black consciousness and experience through the lens of history, it should come as no surprise that the concept of time, broadly defined, persists in post-soul discourse. For example, in a special issue of *African American Review* dedicated to the post-soul aesthetic, Bertram Ashe begins his introduction with the pronouncement "It's time. Clearly, it's time."[32] Ashe goes on to historicize post-soul, stating that it "refers to art produced by African Americans who were either born or came of age after the Civil Rights movement."[33] In *Sounding Like a No-No*, a study of Black eccentricity, Francesca Royster elaborates on this context by describing the phenomena that shaped the imaginations of Black "eccentrics"—the amplification of the voices of Black women, queers, and other historically marginalized subjects in public life as well as Black activist and political groups; "recently integrated schools and blurring neighborhood color and class lines"; and changes to American popular and consumer culture that led to greater "interracial cultural identification."[34] According to Royster, historical and sociocultural transformations manifest in the form

of nonnormative, or eccentric, expressions of Blackness that articulate "a changing sense of community rules and possibilities of the time."[35]

Another example of the deployment of a historical framework can be found in Mark Anthony Neal's analysis of the conceptualization of Blackness within post-soul cultural texts. He argues that given "post-soul's" postmodernist orientation, it "ultimately renders many 'traditional' tropes of blackness dated and even meaningless."[36] In their analyses, all three scholars acknowledge the complexities of Black time by addressing the limitations of the rhetoric of progress as it applies to race and racism. Joseph Winters, another scholar whose work focuses on post-Blackness, describes the "ideological commitment to progress" and the mantra of post-racialism as a fundamental aspect of contemporary American culture that, "when invoked, mitigates experiences and memories of racial trauma and loss."[37] Yet even as they astutely and incisively grapple with the tensions of writing about Black change while still reckoning with the enduring forces of anti-Blackness, these remarks reveal the extent to which the rhetoric of post-ness exerts a gravitational pull toward conceptualizations of time as linear and progressive.[38]

When filtered through the lens of Blackness, history itself becomes not context but contested ground. We see this, for example, in critiques of post-Black (and to some extent post-soul) discourse, which focuses on the artists' perceived aspirations for racial transcendence, a notion engendered by a lack of historical consciousness. In *Who's Afraid of Post-Blackness: What It Means to Be Black Now*, the journalist Touré characterizes the essence of Blackness through a familiar dualism: "To be born Black is an extraordinary gift bestowing access to an unbelievably rich legacy of joy. It'll lift you to ecstasy and give you pain that can make you stronger than you imagined possible."[39] When the second half of the author's description gestures toward a kind of racial transcendence, he enters fraught terrain: "To experience the full possibilities of Blackness, you must break free of the strictures sometimes placed on Blackness from outside the African-American culture and also from within it."[40]

The experiential and intellectual diversity that Touré emphatically celebrates bother critics much less than the historical vacuum surrounding his discussions of Blackness and post-Blackness, the absence of political analysis in favor of representing race as a cultural identity or performative condition of being. Critic K. Merinda Simmons lays out a thorough and cogent response to Touré's provocation in her introduction to *The Trouble with Post-Blackness*: "Where the rhetoric of post-blackness is concerned, the concentrated focus on how African Americans perform their blackness too often gets presented as a reflection of Touré's subtitle: what it means to be black

now, rather than these performances being necessarily coterminous with the discursive rubrics that identify them as distinct or signifying 'what it means to be black' at all."[41] Here, it becomes clear that the problem with his thesis resides somewhere other than in his arguments against essentialism in passages that decry concepts like racial authenticity or legitimacy—Touré insists, "There is no such thing."[42] Rather, Simmons focuses on the presentism in an articulation of post-Blackness that displaces the problem of history, the problem of anti-Blackness, rather than confronting it head-on. In an essay included in the same collection, Margo Crawford sums this up accordingly: "The trouble with many performances of post-blackness is the failure to remember Ralph Ellison's temporal dimension of invisibility—the 'different sense of time,' that leaps ahead and backward."[43]

Simmons's counter to the question posed by Touré, that the fundamental question should in fact be "what it means to be black at all," signifies mightily in the preceding passage. It challenges Touré's privileging of individual performances of Blackness over discursive productions and projections that govern the racial categorization of the group. It also links Touré's advocacy of Black stories that transcend the particularities of race to notions of humanism that ultimately leave untouched and uninterrogated the implicit claim whiteness holds over ideas of universality.[44] Later in her analysis, she raises the issue of Touré's privileging of individuality, his framing of Blackness, "as a deeply personal journey of self-discovery."[45] Simmons's analysis of Touré reveals the underlying logic that renders post-Black conceptualizations of *identity* contested: the historical amnesia or naivete that makes it possible to conflate (racial) identity with the personal, risks minimizing or erasing past and present threats posed by forms of anti-Black racism. Hence Simmons's declaration, "[Touré's] insistence on this personal space as one beyond discourse and impervious to question or critique is what I find less than compelling."[46]

The implications underlying post-Black rhetoric, its gesture toward a time after Blackness, practically compel the kind of scrutiny exemplified by Simmons's and Crawford's analyses. In comparison, when Nelson George introduced the term *post-soul* in 1992, it offered scholars a critical vocabulary that could theoretically inject more acuity into conversations about what Blackness means now by placing the emphasis on questions of anti-essentialism, pluralism, and difference.[47] In other words, *post-soul*'s entry into the critical vocabulary of the academy held out that promise that critics could shift the focus away from mythic notions of racial transcendence to focus instead on questions of identity, pluralism, change, and expansion.

Though sometimes used interchangeably, the suffixes to the compound words *post-Black* and *post-soul* differ in emphasis and meaning. Post-Blackness presumes that *Blackness*, at its core, is uncontested; regardless of the diversity of individual experiences, the word's function as a signifier of social identity remains relatively fixed. Moreover, because *post* gestures toward a time or condition of being *after* Blackness despite the proponents' assertions of racial pride (e.g., "an extraordinary gift bestowing access to an unbelievably rich legacy of joy," according to Touré), the prefix suggests that, fundamentally, being interpellated as Black imposes a burden that one would or should yearn to surpass. More likely, this suggestion contributes to the profound skepticism and scrutiny directed toward the concept in popular and scholarly realms, in particular toward the connotation of racial transcendence.

Emily Lordi and Margo Crawford offer compelling critiques of post-soul discourse, focused on the problem with the movement's historical consciousness. Specifically, they decry what they see as an inclination to pit the post-soul aesthetic against the Black Arts Movement that preceded it. Lordi objects to the appropriation of "soul" by the discourse of post-soul, arguing, "To conflate it [soul] with the worst impulses of the Black Arts and Black Power movements—for instance, with the masculinism, misogyny, and binary vision of race that are indeed extant in [Larry] Neal's Black Arts manifesto (though not in all Neal's work)—is insufficient."[48] Similarly, Crawford strives to "open[] up a space in which the *not yet here* of the 1960s and early 1970s Black Arts Movement converges with the *not yet here* of early twenty-first-century African American literature and visual art."[49] She does so by challenging what she too views as caricatures of Black Power/Black Art philosophy: "The movement's love affair with blackness has been misread as a love affair with something known and stabilized. The collective love affair with blackness was actually a collective process of falling in love with the idea that 'black' could be beautiful and powerful and known more intimately than the sticky white masks."[50]

It's worth noting that Ashe anticipated a version of Crawford's first critique that the *not yet here* of post-soul scarcely differed from the *not yet here* of the past. Acknowledging a plethora of figures from earlier generations (W. E. B. Du Bois, playwright Adrienne Kennedy) whose works engage in the kind of aesthetic troubling associated with post-soul, he states, "I can almost *hear* synapses firing in the brains of some of my readers, as you demand: 'What's new . . . about *this*?'"[51] The post-soul preoccupation with the concept that Royster describes as "difference from within," and its attendant questions of intersectionality, multiplicity, and fluidity of identity, may not have been en-

tirely new as Lordi and Crawford remind us, but it certainly *feels* meaningfully different from what had come before. The significance of this critical orientation toward difference becomes clearer when Neal and Royster shift from discussing the post-ness of soul as a matter of historical context to considerations of the challenges it poses to sedimented ideas of race and authenticity. From this angle, *soul* has as much, perhaps more, to do with the common understanding that it referred to aesthetic objects and performances (e.g., music, food, style, etc.) that could be read as essentially Black as it does to associations with the regressive gender and sexual politics of Black Power's mostly male leaders. Nelson George explains that "soul signaled not simply a style of pop music but the entire heritage and culture of blacks (or Negroes or colored or Afro-Americans, depending on the year and context)."[52]

I'm persuaded by Lordi's argument regarding the complex and layered meanings embedded in soul music and "soul logic." She and Crawford are not alone among critics who caution against a tendency in post-soul rhetoric to overemphasize the differences between past and present, to erase or obscure the diversity that has always been a part of Black life.[53] Perhaps Ashe overstates the case when he claims that post-soul artists "were born or raised into a far more complicated African American milieu than earlier generations."[54] Yet most scholars would find uncontroversial his characterization of the era's political environment as "this squishy, hazy, post–Civil Rights movement era of sometimes-real, sometimes-imagined freedom."[55] His assertion that certain paradigm shifts reconfigured *"the way blackness was addressed and practiced"* seems to be similarly valid.[56]

Consider, for example, the unexpected resonances between Ashe's summation of the post-soul era and Frank Wilderson's pessimist analysis of Black life. Not surprisingly given his theoretical orientation, Wilderson eschews the kind of presentism typically associated with post-soul/post-Black rhetoric when he states that Blackness "cannot be approached through the rubric of gains or reversals in struggles with the state and civil society, not unless and until the interlocutor first explains how the Slave is of the world."[57] That said, in Wilderson's analysis, one hears echoes of Ashe's observations about the "squishy, hazy" politics of post-soul and of Black consciousness suspended between being and nonbeing and also of their influence on post-soul culture and discourse. He declares, "Between 1967 and 1980, we could think cinematically and intellectually of Blackness and Redness as having the coherence of full-blown discourses. From 1980 to the present, however, Blackness and Redness manifest only in the rebar of cinematic and intellectual

(political) discourse, that is, as unspoken grammars."[58] Naturally given pessimism's critical orientation, Wilderson reads impoverishment in the generational shift from the political "coherence" of anti-racist activism to a period in which Black culture and scholarship sublimate the political ontology of Blackness, which he equates with slave.[59] Yet rather than viewing post-soul's prioritization of questions of difference over otherness as a failing or problem, it is in fact possible to read it as an effort to craft new language, thoughts, and ideas as an attempt, albeit imperfectly, in an attempt to come closer to the complexities of Blackness beyond the totalizing discourses produced from without and within.

IN 2001, when the curator Thelma Golden and artist Glenn Ligon mounted the *Freestyle* exhibition at the Studio Museum in Harlem, Golden and Ligon coined the term *post-Blackness,* explaining that they used it as a kind of shorthand to describe a generation of artists who "were adamant about not being labeled as 'black' artists, though their work was steeped, in fact deeply interested in redefining complex notions of blackness."[60] In 2007, when Ashe wrote the introduction to the special issue of *African American Review* on the post-soul aesthetic, he posited that the year marked "the end of the beginning of this post-soul aesthetic."[61] Now, a decade and a half after its publication, a strong case can be made that yet another paradigm shift has occurred, signaling the end of the post-soul aesthetic movement. That is, the invigorated mood of post-soul creatives and culture-workers fell out of favor (recall Zadie Smith's meditations on optimism) in the years between Barack Obama's and Donald Trump's presidencies. Rather than being propelled by questions of mobility, hybridity, and fluidity as in the 1980s, 1990s, and early 2000s, Black Studies scholarship has tended toward concepts, topics, and themes (like anti-Blackness, racial melancholia, and pessimism) that are informed by the social upheaval, political turmoil, and ecological disaster that define the present moment.

In this era of seemingly unending catastrophes, both natural and human-made, awareness of the ubiquity and enduring power of anti-Black assaults on Black life and well-being has intensified. News reports and social media regularly circulate images of Black death, literal and social, with such regularity that they convey a paradoxical message: these scenes of racialized subjection function as reminders of the slave past that is the "event horizon" of Blackness *and also at the same time* feels like an inevitable part of quotidian Black life. Against this backdrop, the imperative for Black art and literature to *represent* has intensified, and the question of *presence* threatens to recede

into the margins. Nevertheless, one can also find in popular and scholarly discourse the recurrence of the kinds of questions foregrounded in the post-soul aesthetic movement as well as in criticism that focuses on the landscape of interiority, questions like where are the locations where Black people feel licensed to express ourselves freely? Where do we feel our humanity affirmed? What kinds of stories allow Black subjects the freedom to simply be? There remains also the enduring question: What does it mean to be Black and free? The persistence of such questions and yearnings suggests that post-soul's aesthetic explorations continue to resonate.

From Historicity to an Aesthetic Temporality of Black Being

Let's return to Thelma Golden and Glen Ligon's description of the contemporary Black aesthetic as one committed to "redefining complex notions of blackness." In *Who We Be: The Colorization of America*, Jeff Chang suggests that in a context in which societal barriers to equality seemed to have been lowered, *identity* as opposed to political struggle became the ready material with which artists could work on this project. When asked by Chang to reflect on this origin story, Ligon underscores this idea, stating, "[It was] as if identity was this thing that artists of color had the most immediate access to. There's the bucket and you just dip into it. There's your content. Throw it on the canvas."[62] If, as Ligon asserts, identity provided the artist with content, Ashe characterizes their aesthetic practice as "troubling blackness." "They worry blackness; they stir it up, touch it, feel it out, and hold it up for examination in ways that depart significantly from previous—and necessary—preoccupations with struggling for political freedom, or with an attempt to establish and sustain a coherent black identity."[63] These reflections hint at some of the ways that the framing of post-soul as an aesthetic with an artistic philosophy renders the prefix *post* open to other interpretations beyond the historical. Even as it indexes the idea of a progression via the temporality of *after*, post-soul also gestures toward the complexities of Black being-ness in ways that resonate beyond the particularities of the *now* and address the enduring question posed by Simmons: "What does it mean to be black at all?"

Before elaborating on this idea, the power of language, rhetoric, and narrative is worth further consideration, for even critical responses to post-soul's nomenclature reveal the challenges of displacing the historicity of Middle Passage epistemology with an alternate timeline. Take, for example, Lordi's objections to "progressive accounts of history" in post-soul discourse, arguing that it distorts and discounts the complexities of earlier

generations' performances of Blackness.[64] Lordi's reasoning, which echoes Margo Crawford's recuperative examination of the Black Arts Movement in *Black Post-Blackness*, is that the name compels *soul* to "stand in for the most restrictive heteropatriarchal impulses of the Black Arts and Black Power movements," thus flattening and simplifying the soul tradition.[65] If heteropatriarchy represents the worst impulses of the period, soul represents its best because "soul discourse would, by the end of the 1960s, racialize [a] habit of thought, training black people to recuperate their past and present struggles into a narrative of belonging to and with other black people."[66] Hence Lordi's indictment of post-soul discourse for its adoption of a critical orientation to the past that disregards soul logic's communitarian ethos.

This last point carries the additional implication that post-soul ahistoricism/presentism leads to a critical framework that emphasizes the heterogeneity of Blackness in ways that are evacuated of political astuteness or critique. Lordi addresses this explicitly in her discussion of Ashe's conceptualization of post-soul racial representation. She argues that Ashe "codified post-soul literature as a body of work that represented 'unconventional' aspects of black experience (queerness, mixed ancestry, nerdiness), as if the representation was a good unto itself. To *whom* such internal variety was being announced—and how its announcement constituted a 'service to black people'—was unclear."[67] My own reading of Ashe leads to different conclusions, for he is in fact fairly straightforward in identifying the value of the post-soul approach to representation.

Ashe concedes that "these artists do not have a singular, coherent political stance from which to articulate a specific political argument."[68] The comparison need not be made explicit for readers to understand the contrast to the activism and political militancy of participants in the Black Power/Black Art movement. Rather than framing this as a problem, however, Ashe introduces a new metric of value: "these post-soul artists maintain a dogged allegiance to their communities, however *non-essentialized and gorged with critiques* said allegiance might be."[69] Moreover, "post-soul artists, given their stance on personal artistic freedom, sustain[s] into the twenty-first century an argument about black artistic freedom . . . which lasted throughout the twentieth century."[70] The unspoken assumption behind the suggestion that Ashe should have made clear "to whom such internal variety was being announced" is that political critique matters most, perhaps only, when directed outward toward social or political institutions or toward discourse and ideologies that perpetuate anti-Black racism.

This begs the question of the difference between ethical and political orientations to Blackness. That is, how else if not through allegiances and affiliations "gorged with critiques" would it be possible for Black people to form communities based on more ethical, inclusive, and reciprocal forms of relation? If we were to bypass the post-soul generation, a straight line could be drawn connecting the radical activism of the sixties to the "coherent political stance" of the Black Lives Matter (BLM) movement, founded in 2013 by three Black, queer women: Alicia Garza, Patrisse Cullors, and Opal Tometi. BLM's mission statement declares, "Black liberation movements in this country have created room, space, and leadership mostly for Black heterosexual, cisgender men — leaving women, queer and transgender people, and others either out of the movement of in the background to move the work forward with little or no recognition."[71] The genealogical link to and influence of a previous generation of Black and queer feminists is clear, particularly that of the Combahee River Collective, which published its own manifesto, or Statement, in 1977. That said, if not for the post-soul interregnum and its envisioning of Black sociality that is capable of sustaining anti-essentialist and other forms of critique, it's not at all clear how else we could arrive at a place in time where BLM's statement of intention to "center the leadership of women and queer and trans people" would be widely accepted and sustained throughout a global network of activists and organizers.

THESE CRITIQUES OF THE post-soul frame of analysis illustrate the challenges of attempting to think and write beyond resistance in Black culture. (Here, I intentionally allude to Quashie's *The Sovereignty of Quiet*.) And yet I persist because the discourse of post-soul informs my efforts to think and write about Blackness through philosophical frameworks such as aesthetics, phenomenology, and ethical relation. In fact, from my vantage point, post-soul's most interesting provocation has as much to do with the ways that the artistic inclination to trouble Blackness produces philosophical and aesthetic provocations as its historical contextualization of Blackness. There is, indeed, purpose and inherent value in an aesthetic in which Blackness manifests as a feeling whose calculus is unsettledness.

As my previous analysis suggests, the critical discourse on post-soul and post-Blackness tends to frame it as a movement overly invested in the linear trajectory of racial progress. By turning away from sociohistorical questions, however, a different underexplored temporality at work in post-soul discourse comes to the fore, one that grapples with the metaphysics of Black-beingness. When Ashe describes post-soul as "an aesthetic that takes

[Blackness's] vastness and unpredictability as a point of pride," it sounds completely at odds with the pessimist imperative to reckon with the ontological terror of Blackness.[72] Certainly, Ashe's reference to a vast and unpredictable condition of being emblematizes the aesthetic optimism I theorize in the previous chapter.

Looking beyond historicity in order to think through aesthetic time signals an investment in thinking about Blackness *through* time, which then is also an investment in thinking about Blackness *beyond* time in conceptual and philosophical terms. Here, the space-clearing gestures of post-soul, its striving to unsettle and open up ongoing debates about race and representation, resonate. Why? Because post-soul logic presumes that Black feeling (which denotes the human capacity for emotion) and feeling Black (which conveys the processes by which one comes to identify as Black) are inseparable and intertwined. And while all feeling is produced via encounter, it is the realm of the aesthetic—for example, literature, storytelling, visual art, or music—that proves most capable of allowing Black feeling and feeling Black to coexist.

Rather than indulging in a superficial and ineffectual practice of creative naming and renaming some "thing" universally recognized as Blackness then, the post-soul aesthetic calls for a different but related kind of ontological reckoning. That is, post-soul's engagement with the elusive, slippery, vulnerable, disillusioning qualities of Blackness results in the framing of racial identity as an entity that is always already threatened with falling apart. As much as anti-Blackness's negation of Black personhood, this possibility too informs the ways that Black subjects navigate political regimes and societal dynamics.[73]

In truth, the genealogical case for post-soul recognizes a quality that might be bold to say: the civil rights movement broke Black time. Post-soul represents a sort of culmination of the long march toward and discrete reckonings with the possibilities of Black citizenship. In both its achievements and failures, the post-soul aesthetic reveals that it is no longer possible to uncomplicatedly index Blackness according to historical time. In other words, it marks the failure of the time logic for Black being because it is no longer possible to argue for Blackness, citizenship, and emancipation in a linear way, particularly in an epoch in which Black people experience more legal and material freedom than ever before in history.

The ontological turn in Black Studies scholarship represents an attempt to respond to this rupture. We tend to think of the school of pessimism's recursive framing of history, with its conceptualization of the present in

terms of "unfreedom" and the "afterlife" of slavery as a rebuttal of post-soul's presentism. In other words, Black pessimism signals a decisive turn away from the question of "what blackness means now" and toward the irresolvable quandary of "what it means to be black at all." Yet we also can acknowledge that, like post-soul, pessimism too is a discourse that emerges in response to a paradigm shift, in this case the rupture of conventional notions of Black time that post-soul heralded. And as with its predecessor post-soul, this paradigm shift profoundly influenced "the way blackness was addressed and practiced."

Black Consciousness on the Threshold of Time

I have strived in my analysis so far to demonstrate the extent that Blackness in all of its forms refuses the containment that the discursive deployment of time seeks to impose. Specifically, I conceptualize the temporality of the post-soul aesthetic as a kind of out-of-timeness in the sense of breaking the idea of Blackness away from an agenda focused on the achievement of a single and collectively shared destination. This interpretation of post-soul as a movement that *fractures* Black time may seem at odds with the abundance of criticism that deploy it as a historical marker of the end of one epoch and beginning of another. However, if we take seriously post-soul's claims to rupture static and fixed ideas of Blackness, then it also becomes clear that the beginning it instantiates refers to a conceptualization of Blackness as a construct that we still don't know how to organize or fully understand. Post-soul aspires to an idea for which art is best suited: namely, a striving to mobilize the chaos of being through the exploration and expansion of the boundaries of Blackness.[74]

Paul Taylor's deconstruction of the rhetoric of "post-ness" helps flesh out this idea. Riffing off Golden's assertion that at "the end of the 1990s . . . post-black had fully entered the art world's consciousness. Post-black was the new black," Taylor asks, "How can post-black be the new black? Postmodernity is precisely not the new modernity; and ditto for postcolonialism and colonialism. And if post-black can be the new black, in what sense is it really 'post' blackness at all? Why isn't it just a new stage of blackness? And, if it is just a new stage of blackness, then why not name it accordingly? Not 'post-black,' as if blackness has been superseded, but, say neo-black. Or, since that stinks, something else?"[75] Taylor's reference to postcolonialism, and postmodernism is especially astute because the absence of a hyphen signals a scholarly consensus to shift the focus from chronology to complicating and

querying dualisms, such as colonialism/after colonialism that have histori-
cally been treated as fixed binaristic oppositions.

Taylor goes on to note some of the reasons scholars object to the rhetoric
of "post-ness," including the difficulty of defining art gathered under this la-
bel, which makes sense given the emphasis on diversity and difference. As a
consequence, despite post-soul's retention of the hyphen, Taylor describes
the *now* that it indexes as something other than a mapping along a chrono-
logical trajectory. Instead, the post-ness of post-soul represents an "emerg-
ing practice or situation [that] is still trying to establish an identity."[76] From
this vantage point it becomes clear that "posteriority in time" functions as a
heuristic tool in the sense, Taylor argues, of being "a negative assertion, a
gesture toward a lack—the lack of any other common theme by appeal to
which we can unify the diversity of the present."[77] Taylor's discussion of "pos-
teriority in time" focuses as I have on the discursivity of Blackness, a quality
that post-soul's theorization shares with narrations of Blackness that precede
it. I would go so far as to say that there is nothing uniquely contemporary
about post-soul's striving "to understand some unfolding state of affairs,"
even as it works to construct a coherent narrative by positing some relation
to the past. For any reliance on language and narration to explain the mean-
ing of Blackness inherently, inevitably, represents an attempt to order the
inchoate, ungoverned, and ungovernable.

Taylor's analysis makes clear how the "posteriority" of the post-soul aes-
thetic withholds the satisfactions of arrival, which in turn envisions Black
personhood now as a condition of being suspended between unlimited and
foreclosed possibility. This theorizing of posteriority clarifies the rewards of
conceptualizing Black time beyond historicity, the potential it holds to ar-
ticulate a philosophy of Black being. The post-soul aesthetic in particular of-
fers an opportunity to simultaneously hold, and hold at bay, the linearity of
racial progress alongside of the recursive nature of anti-Blackness. In so
doing, it becomes possible to enter the imagined and conceptual spaces made
by post-soul creativity, where past and present intersect to form nodal points
from which to reflect on the complexities of Blackness's idiomatic forms as
well as forms of Black being.

A turn to the aesthetic may feel like a risk because Black feeling dwells
within the internal landscape of the individual subject and its contours are
impossible to anticipate or predict. The political idealogue might want to dis-
count individual thoughts or actions that detract from or undermine the
collective's social and political agenda. The sociologist might focus on
the structural manifestations of inequality and oppression and their im-

pacts on the racial collective. In contrast, art, even the most politically oriented works, tends to make space for feeling to exist, often without necessarily feeling compelled to explain in a way that maintains the integrity of a collective narrative or political project. This turn to the aesthetic may even feel treacherous because, by focusing on subjectivity—how society engages "this Black" instead of or as well as how it engages "the Black"—art illuminates the complexities of experiences, thoughts, and feelings that can't be fully explained or understood by their membership in the group.[78]

Post-soul logic informs the second half of this book in which I proceed to a series of close readings that seize the freedom, extended by the aesthetic, to follow the subject even when it diverges from the politics and political ontology of Blackness. We will see that regardless of a work's investment in teleological histories of racial emancipation, the aesthetic realm possesses a unique capacity to bear witness to Black presence in all of its complexity. What post-soul highlights is the ways that, from the vantage point of the aesthetic, Black life is always already on the threshold of freedom, albeit a freedom not easily recognized by or accommodating of sociological, political, or legal arguments. Focusing on this dimension of Blackness licenses, indeed emboldens, us to pay attention and assign value to representations of the vast and myriad ways that Black people experience our personhood as we move, feel, and relate in and to the world.

To Wander Determined
A Portal to Blackness and Being

In artist Toyin Ojih Odutola's hands, paper, ink, chalk, graphite, charcoal, and pastels are world-building instruments. In the early stages of her career, Ojih Odutola relied primarily on ballpoint pens to create figurative drawings of Black subjects, often set against stark-white backgrounds. One example, *Maebel* (2012), illustrates the artist's distinctive style, in which she layers ink so as to create the perception of shading, variegation, and dimensionality (see figure 5.1). In her drawings, Black skin undulates, dances, and shimmers; one almost feels the texture of the figure's natural Afro-textured curls. The layers and gradations of Blackness produce the curves and valleys of Maebel's features, producing two (if not more) perceptual effects: that the drawing could be a portrait of an individual rather than a subject meant to be representative of the group and that the surface of Black skin is topographical. Both impressions are in fact invented, fabrications of the artist's creative mind and making and the viewer's active and considered looking.[1]

Maebel exemplifies an impressive body of work that strives to widen the aperture on Blackness by representing skin as a geographical landscape. Ojih Odutola's unconventional techniques represent a refusal of the visual and ideological limitations of traditional art-historical depictions of Black people. Her treatment of visual representation as a form of immersive storytelling plays a central role in that endeavor, primarily by honing the viewer's attention to the existence of inner lives and experiences that have been overlooked and excluded and that she aims to excavate. In an artist statement written for her first solo exhibition, Ojih Odutola asserts, "Skin as geography is the terrain I expand by emphasizing the specificity of blackness, where an individual's subjectivity, various realities and experiences can literally be drawn onto the diverse topography of the epidermis. From there, the possibilities of portraying a fully-fledged person are endless."[2] These remarks gesture toward representational possibilities for Blackness to signify capaciously: not only as a foreclosure of ontological being, agency, or self-possession but also as an overture or opening into a totality that can't be reduced to a set of fixed and immovable tropes.[3]

FIGURE 5.1 Toyin Ojih Odutola, *Maebel*, 2012. Pen ink on paper, 19 × 12 inches (paper), 21 1/4 × 18 1/4 × 1 1/2 inches (framed). ©Toyin Ojih Odutola. Courtesy of the artist and Jack Shainman Gallery, New York.

This philosophy persists after 2015, when Ojih Odutola began to build on her tendency to use evocative and enigmatic titles by integrating more elaborate stories into the work. In fact, her addition of narrative seems like a natural, almost inevitable, evolution given that her favorite drawing implement, the ballpoint pen, is primarily used for writing and she has long conceptualized drawing as a form of visual storytelling. Later works, like *To Wander Determined* (2017) and *A Countervailing Theory* (2020), include detailed expository narratives that describe the histories and surroundings of and relationships between the subjects portrayed. In earlier artworks, the extreme contrast between the Black figures and white backdrops provides the necessary context for the observer to consider the complicity of art-historical traditions in modernity's production of racial distortions and erasures. In these later works, the context derives from a tricksterish approach to history, which the artist deploys in order to break down, and

break out from, the boundaries typically erected around representations of Blackness. Whether the form of storytelling is visual or linguistic, however, Ojih Odutola borrows from a storehouse of ideas (e.g., singularity and collectivity) and representational strategies (e.g., realism and abstraction) to produce art designed to provoke, incite curiosity, and inspire new interpretations. In other words, she takes a dynamic approach to the questions of representation *and* orientation in order to incite curiosity about the preconceptions and perceptions that inform understandings of what and how Blackness signifies.

In her more narrative-driven pieces, Ojih Odutola's evocation of history engages with notions of space and time. For example, in *A Countervailing Theory*, she creates an Afrofuturistic study of origin myths, power, and domination through the depiction of a society of women warriors named Eshu that create a class of humanoid men named the Koba. In this inverted world in which the gender hierarchy is reversed and heterosexual coupling is viewed as aberrant, race seems not to exist. Yet the Koba's only purpose is to serve their masters, and in fact they share the subjugated status as fungible commodities and labor that is typically associated with New World Blackness and enslavement.[4] Ojih Odutola renders the Eshu and Koba using her characteristic technique, though; in this case, her layering of shades of Blackness in the surrounding landscape creates a monochromatic effect. In an interview on the *TalkArt* podcast, Ojih Odutola explains that this turn to monochromatic grays represents an attempt at interrupting the tendency for viewers to linger over her rendering of Black skin at the expense of noticing the stories embedded in other aspects of the work that the history of Blackness does not necessarily explain.[5] Because the Eshu and Koba inhabit a different space-time continuum, *A Countervailing Theory* represents "an afro-futurist tale of ancient myth, popular culture and contemporary politics."[6] It is, in other words, what Nyong'o characterizes as "untimely."[7]

To Wander Determined, which was mounted by the Whitney Museum of American Art three years earlier, is similarly untimely but also uncharacteristically polychromatic. Ojih Odutola's use of pastels produces an enhanced sense of color and brightness that emphasizes the physical beauty and idyllic nature of this piece.[8] The drawings read more like portraits of individuals rather than figurative works meant to generate ideas about Blackness as a general category or condition of being. Composed of large-scale drawings of members of two fictive Nigerian dynasties who are connected by the union through marriage of two of their sons, *To Wander Determined* feels more rooted in a recognizable place and time. Closer scrutiny reveals, however,

that this is a feeling produced in the moment of encounter, and the subjects depicted inhabit liminal spaces and timelines of the imagination.

The impression of reality that *To Wander Determined* conveys suggests that associating Blackness with liberated being ought not to be considered an oxymoron. Yet this belief cuts against the grain of European modernity, which has historically posited freedom and Being philosophically as the property of bourgeois white male subjectivity and viewed these ideals as antithetical to Blackness. Nicole Fleetwood conceptualizes the vision of Blackness manufactured by art-historical traditions as a representation of absence, erasure, and lack, or an obliterating and overdetermining signifying void: "Blackness fills in space between matter, between object and subject, between bodies, between looking and being looked upon. It fills in the void and is the void. Through its circulation, blackness attaches to bodies and narratives coded as such but it always exceeds these attachments."[9] In other words, from the hegemonic point of view, racial categories are designed to tell us everything we need to know about the "thing" regarded.

The group portrait "Representatives of the State" illustrates this effect when, rather than treating Black as the color of backgrounds, shadows, and the occasional servant (as is common in traditional Western portraiture), the artist places Black subjects at the center of the frame (see figure 5.2). It showcases four individuals, standing before a picture window and bathed in light and color.

The framing provided by the window is not inconsequential. Though they are mostly enclosed by the window frame, the figures on the edges also break its borders, gesturing subtly to the fleshly "excess" that according to Fleetwood refuses to be subsumed by the racial imaginary. Moreover, rather than emphasizing the blue sky in the background, as a picture window typically does, it instead draws attention to the subjects of the composition. This movement between inside and outside, center and border, provides our first hint that the artist conceives of the Black interior in dialogic relation to the social imaginary of race.

It would be problematic, however, if Ojih Odutola were to uncritically embrace humanist ideals without troubling the ways that Western conceptualizations of the human subject have historically relied on the exclusion and exploitation of groups marked as non- and subhuman. Rather than simply creating a Black version of a European ideal, Ojih Odutola weaves into each image elements that highlight the subversion of coloniality and its racial imaginary in order for any manifestation of Black being to come into fruition. Moreover, by experimenting with perspective and relationality, she

FIGURE 5.2 Toyin Ojih Odutola, *Representatives of State*, 2016–2017. Charcoal, pastel, and pencil on paper, 75 1/2 × 50 inches (paper), 78 7/8 × 56 3/8 × 2 1/2 inches (framed). ©Toyin Ojih Odutola. Courtesy of the artist and Jack Shainman Gallery, New York.

approaches Black portraiture as an exercise in creative discovery, an imaginary exploration of multitudinous modes of being and belonging.

A New Orientation

Disorientation and reorientation play central roles in this work. Thus, Ojih Odutola plays with perspective in ways that invite the observer to consider how the preconceptions and perspectives we bring to the encounter shape the aesthetic experience. Her inclusion of a drawing of inanimate objects, one of the few in the exhibit, serves as a prompt for the viewer to pause and pay closer attention to *how* and *what* she perceives. That piece, "Excavations," highlights the artist's unconventional approach to composition, such as her use of unexpected and improbable angles, which also appear in other drawings in the series but would otherwise be easily overlooked. Although the focus of "Excavations" on physical objects is unique among all of the pieces included in the exhibit, it establishes the ethos and the method that observers must bring to their encounters with the rest of the images: a series of portraits that could easily be viewed as depictions of real individuals. Moreover, the majority of the portraits tend to position each figure next to architectural thresholds (e.g., hallways, entryways, stairwells, and windows) that represent portals into other ways of being and other ways of knowing and/or relating to Blackness, which is to say that they clear space for the consideration of Black people's experiences of their own humanity.

At the center of the frame of "Excavations" is an object that appears to be a West African ritual mask, which sits near the foreground on the landing of a staircase or perhaps on the floor or platform so far in the foreground that it becomes impossible to discern its relationship to the other details in the drawing (see figure 5.3).

In every way, in-betweenness defines this totem of Africanness. Its place, its *home*, is always already liminal in that it exists between the ground-floor level and the space above that the flight of stairs leads to. In contrast to Ojih Odutola's earlier works, the idea of spatiality in the form of domesticity assumes a primacy of place, for the characters inhabit beautifully appointed, lavishly furnished rooms that sometimes look out upon impressive vistas. In addition to locating the figures in space, the artist situates the family in time, in part by identifying the artworks as part of a two-hundred-year-old legacy. A letter written by "Toyin Ojih Odutola, Deputy Private Secretary, Udoka House, Lagos" states, "*To Wander Determined* presents the private collections of two aristocratic families: the UmuEze Amara, one of the oldest

FIGURE 5.3 Toyin Ojih Odutola, *Excavations*, 2017. Charcoal, pastel, and pencil on paper, 24 × 19 inches (paper), 29 3/4 × 24 3/4 × 1 1/2 inches (framed). ©Toyin Ojih Odutola. Courtesy of the artist and Jack Shainman Gallery, New York.

noble clans in Nigeria, and the Obafemi, a minor aristocratic house whose prominence stems from their work as traders and ambassadors for various governances." The arrangement of domestic objects, identified alternately with Europe and Nigeria, indicates a temporal liminality too: modernist yet nondescript furniture appears in the background, in contrapuntal relationship to the mask and its suggestion of tradition.

These dynamics call for "slow looking," particularly because so many of the details belie what the viewer initially thinks they are seeing. Given the symbolic resonances of masks, the centrality of this particular object in the drawing hails the viewer and calls for an attunement to the hidden, multitudinous, and performative aspects of identity. Multiplicity extends to the mask itself, which may actually be a bust, for it sits upright without support, and the set of the jaw and furrowed brow suggest a face rather than an abstraction. Even the shadow beneath it creates the illusion of a torso, a gesture toward embodiment produced by light and shadow. These ambiguities disorient the viewer, as do others. All of the works in the exhibition, not only "Excavations," aspire to producing the feeling of not only appreciation but puzzlement, an example of the kind of generative disorientation that makes it possible to swerve from familiar ideas and images and remain curious and open to other interpretations. The embroidered edges of two rugs appear in the foreground on both sides of the mask, or perhaps one of these borders is actually the edge of a cabinet. In the middle distance, a cowrie shell–covered gourd, perhaps a *shekere*, peeks from behind the column. Though perhaps that too is a trick of the eye, in which case what looks to be a musical instrument may only be a vase whose form is partially obscured.

The skewed perspective in "Excavations" extends to the artist's rendering of architectural and topographical details. For example, a foreshortened wall bends at an off-kilter angle, and a field of green grass and rolling hills evoke a Tuscan hillside, one of Ojih Odutola's inspirations, rather than Nigerian terrain. According to Sara Ahmed, the disorienting effects of images such as this is necessary in order to experience the reorientation of perspectives that can lead to transformation.[10] As a result, Ojih Odutola can be counted among the emergent group of artists whose works, Tina Campt argues, "make audiences *work*. They refuse to create spectators, as it is neither easy nor indeed possible to passively consume their art."[11] Campt too recognizes the relational ethos associated with a willingness toward reorientation: "Their work requires *labor*—the labor of discomfort, felling, positioning, and repositioning—and solicits visceral responses to the

visualization of Black precarity."[12] Slow looking creates the foundation for the kind of labor Campt describes and *To Wander Determined* demands. This critical visual praxis cultivates an awareness of the plurality of interpretations contained in a figure, of the multiplicity that defines the becoming-art-object.

The title "Excavations" hints at the imperative Ojih Odutola's work places on the observer. Encountering her art calls for something other than a passive or voyeuristic gaze on Blackness. Looking is transformed into a process of discovery: a striving to unearth the significance of each figure, which can only be determined by studying its relationship to the other objects around it. Ahmed's study of phenomenology in *Queer Phenomenology* elucidates the connection between material objects and Black subjects as well as between creative thinking and doing and self-fashioning. First, using the example of sexual identity, Ahmed tells us that the experience of personhood manifests as a sense of taking up space: "If orientation is a matter of how we reside in space, then sexual orientation might also be a matter of residence; of how we inhabit spaces as well as 'who' or 'what' we inhabit spaces with."[13]

The deliberate setting askew of objects and perspective in "Excavations" exemplifies the perspective that Tina Campt identifies as a "black gaze," which centers the Black imagination and reckons with the ways that creative texts transport the viewer into spaces capable of freeing Blackness from what Barbara Johnson calls the "already-read text."[14] Borrowing from Ahmed, we might describe the positioning of the objects as "slantwise" and a symbol of a queer possibility to envision Blackness differently, through a fugitive lens and hence more freely.[15]

By shifting from black ink on paper to brightly colored pastels, Ojih Odutola indicates her intention to turn away from the earlier work's implicit thematic focus on the Black/white opposition of racial antagonisms and toward relational possibilities.[16] Although *To Wander Determined*'s technical rendering of Black skin resembles the approach of her earlier work, these drawings also gesture toward ideas of space, place, and belonging that draw attention to the complexity of her subjects' social and inner worlds. This represents a turn toward questions of relation and orientation. In addition, the replacement of the paper's stark whiteness with color signals Ojih Odutola's investment in dimensions of Black experience typically undervalued, like experiences and expressions of beauty, connection, freedom, and joy. What facilitates these shifts in perception and

perspective, the artist claims, is the absence of the colonial presence and the objectifying force of the racialized gaze.

Still, the subject of orientation produces a tension that resonates with the artist's claim that *To Wander Determined* represents a world beyond the historical determinations of coloniality. What I mean is that the very concept of orientation implies a system of measurement, a norm against which certain figures are judged as aberrant and thus queerly aligned. Ahmed makes clear the Eurocentric heterosexist patriarchal structures that govern the phenomenal world and lead to the refusal of rights, respect, care, and reciprocity toward those deemed society's Others. As a consequence, from this vantage point, a relational orientation always already has to do with "the ways in which the world is available as a space for action, a space where things 'have a certain place' or are 'in place.'"[17] Ojih Odutola's approach is to embrace mis- and non-alignment as a gesture of refusal of the conventions and tropes that have historically relegated Blackness and Black people to the margins of art-historical traditions in the West. This convention, premised on the exclusion of Blackness from the category of the human, finds its correlate in Hegelian philosophy's articulation of Africa as outside the time of European modernity and its teleological narratives of emancipation, development, and progress.[18]

Central to Ojih Odutola's project, then, is the placement of her characters within a different timeline from that of the post-Enlightenment world. Her vision/version of untimeliness frees Black subjects from the burdens of double-consciousness and licenses them to be their unvarnished selves, on their own terms. From this perspective, they experience themselves in complete alignment with a world that remains always already open and available to Blackness.

The truth remains, however, that *To Wander Determined* is in fact the invention of a diasporic artist's imagination, and her critical orientation to modernity and the dominant social order informs her and her audience's understanding of the artwork.[19] In other words, the history of Blackness (i.e., imperial conquest, colonial domination, and slavery) casts a shadow in the gallery; history remains invisible yet present in every moment of aesthetic encounter. Certainly, Ojih Odutola's speculative drawings represent a postcolonial rupture of colonial epistemologies and ideologies. At the same time, what becomes clear is that the artist's lived experiences as a Nigerian immigrant raised in the American South, like her embodiment as a Black woman, have forged her imagination and inspired her uses of visuality to oppose and overturn the racial imaginary.

A Threshold of Black Visuality

Threshold abounds in *To Wander Determined*: not only the landing in "Excavations" but also the doorways and windows suspend the subject of each drawing to a *here* and a *there* and also, I would argue, to a *now* and a *then*. These images serve as reminders of the unique capacities of the aesthetic, which is as a portal to other ways of seeing, thinking, and being in relation to the idea of Blackness. In other words, in these images, beyond each threshold, lie revelations of a myriad of ways, *Black ways*, of inhabiting being (see figure 5.4). At the same time, the in-between and indeterminate nature of thresholds suggests a paradox that anchors this framing of Black aesthetics to the complexities of Black consciousness and Black existence. What I mean is that the threshold is a uniquely paradoxical architectural feature. It is a demarcated location that both *is* and *is not* a physical place. A person can stand on or near a threshold, but ultimately its purpose is transitory, moving us from one location or state of mind to another that exists somewhere on a horizon. This duality evokes the duality of nonbeing, that condition of Blackness that, according to Jared Sexton, represents "a human being whose being human raises the question of being human at all."[20]

Hortense Spillers conceptualizes the subjectivity that is also an "absence *from* a subject position" in her landmark essay "Mama's Baby, Papa's Maybe."[21] Here, Spillers uses the vocabulary of "body" and "flesh" to theorize the distinction between the ontological negation of "*being for* the captor" (i.e., body) and "the zero degree of social conceptualization that does not escape concealment under the brush of discourse, or the reflexes of iconography" (i.e., flesh).[22] The remarkable opening to "Mama's Baby" encapsulates the nature of Black female existence, suspended between "the central distinction between captive and liberated subject-positions."[23] The essay begins with a self-assertion, spoken in a colloquially performative voice that signifies Black womanhood: "Let's face it. I am a marked woman, but not everybody knows my name."[24] The declarative yet idiomatic nature of these sentences carries traces of Black female embodiment, of the histories of body and flesh that subtend the statement of selfhood. Ironically, however, racial discourse and iconography ensure that the subject spoken into existence is defined by negation. The fleshly subjectivity of the speaker is both present ("I am") and societally absented ("not everybody knows my name"). Black womanhood names an *absent presence*, a self-possession whose knowing is real in the sense of being felt and experienced subjectively while also being not real, or fully realized, in the sense of being illegible or invisible to the social imaginary.

FIGURE 5.4 Toyin Ojih Odutola, *Unclaimed Estates*, 2017. Charcoal, pastel, and pencil on paper, 77 × 42 inches (paper), 81 3/8 × 47 7/8 × 2 1/2 inches (framed). ©Toyin Ojih Odutola. Courtesy of the artist and Jack Shainman Gallery, New York.

This fine-grained analysis helps illuminate the distinction between agency-oriented discourse of social identity and phenomenological frameworks that prioritize notions of subjectivity as presence. Juxtaposing Ahmed's notion of orientation to Quashie's theory of quiet helps explain this nuance, for the former links *agency* to subjectivity, whereas the latter focuses its sight on interiority as the landscape of being. Jeta Mulaj astutely characterizes Ahmed's theory of sexual orientation as an "object-oriented theory" that is "restricted to the phenomenal world."[25] In other words, feelings of being oriented or misoriented to the world, along with the capacity to reorient oneself in it, represent social phenomena: how societal interpellations of a subject produces identities that determine if, how, and when the world makes itself available "as a space for action." Yet Quashie reminds us in *The Sovereignty of Quiet* that "action" must often take the form of resistance in order to be acknowledged and recognized; that *agency* and *identity* are the vocabulary of publicness, which often threatens to overshadow the multiplicity of other ways of being Black in the world.

To Wander Determined represents a threshold of imagination onto these other landscapes of being. Its depictions of figures in postures of leisurely repose and lost in reverie speak to this alternate geography of Blackness in which subjectivity exists freely, without need for explanation, persuasion, or insistence.[26] In a critical meditation on a different work by Ojih Odutola, Quashie argues that the image's value lies not in the case it makes for the humanity of Black people but rather in its rendering of the interior lives of Black subjects as "a thing" to behold.[27] In a similar vein, the curator Claire Gilman argues that "if [the characters in Ojih Odutola's drawings] are objects of our gaze, they are equally subjects of their own realms."[28] For both critics, the power of the work resides in its call to the audience, implicitly or explicitly, to set aside historical determinism and embrace the suspended temporality at the threshold of the aesthetic encounter in order to come into closer proximity to this inhabitance of the inner landscapes of thought, dreaming, and feeling.[29]

Temporalities

For Ojih Odutola, liminality is a marker with not only spatial but also temporal dimensions.[30] Her work grapples with an unresolvable yet productive quandary of the relationship between the meaning of Blackness produced by history and its litany of anti-Black violence and racialized trauma and other ways and forms of knowing represented by its images of subjects whom the

artist imagines as untethered from historical overdeterminations. In *To Wander Determined*, for example, the histories of European colonization and the trans-Atlantic slave trade are simultaneously invisible yet felt and known presences too. This suggests a temporal instability that compels the observer to oscillate between the knowledge she already possesses and other possibilities for interpretation.

In spatio-visual terms, the compositions' negative space represents the past: the area around and between the individual depicted that enables the eye to discern the subject's form. Located as they are "outside" historical time and its present-day resonances, these portraits represent forms of "critical fabulation" that strive to evade or exceed a historical archive of bodily captivity by envisioning the capaciousness of the landscape of interiority.[31] Here, the temporal unboundedness of the aesthetic represents another, speculative timeline, one that is ungoverned by the constraints and limitations of the social world, even as it finds ways, in both form and content, to reckon creatively with the history of Blackness.

In the space of the aesthetic, examples of Black untimeliness abound. This is a work that does the hard work of "disarticulating [Blackness] . . . from the historical accretions of slavery, race, and racism, or from a particular commitment to the idea that the slave past provides a ready prism for understanding and apprehending the black political present."[32] Thus, a drawing of the two sons clasping hands in a gesture of queer intimacy belies the fact that in present-day Nigeria same-sex marriage is legally prohibited. The futurity symbolized by their union sits in tension with the idea of tradition encapsulated by artifacts like the mask and the letter by "Ojih Odutola, Deputy Private Secretary, Udoka House," which references the objects in the families' archives that are "the result of a curated connoisseurship spanning nearly two hundred years." A traditional mask that elsewhere might be read as a reminder of the past sits comfortably alongside other objects, architecture, and dress associated with Western culture, refusing the stereotype that pits tradition against modernity. In other words, the time of *To Wander Determined*'s imaginings refuse to disentangle the Black past, present, or future, and they blur the distinction between the figurative and the real. Ojih Odutola's description of how her work is received underscores this point: "Everyone says, 'I wish they were real.' . . . And the thing is, they could be. It's just there was never the opportunity to discover that. And so just imagine that. Really and truly imagine that we were left to our own devices, and we developed on our own: Without any of the colonialist meddling, what would have happened?"[33] *To Wander Determined* suggests that to

make manifest the potentiality of Black being and becoming, we must recognize the existence of dimension(s) of being that exceed the rigidity and constraints of racialized logic and language. What this also suggests is that a praxis of critical engagement compels the awareness of imagination's inherent striving for openness and unfettered possibility. This, ultimately, is about an openness to being disoriented and then reoriented toward Black art and other creative texts, about a willingness to be transported out of normative time and into a time that doesn't yet exist.

Migration/Stasis/Stillness
Paule Marshall's Poetics of Change

Paule Marshall's reputation is founded on her deep and wide knowledge and love for African diasporic history and culture. Inspired by the experience of reading novels by Marshall, VèVè Clark famously coined the term "diaspora literacy" to describe the ability to read the literatures of Africa, Afro-America, and the Caribbean from an informed indigenous perspective."[1] Marshall's oeuvre defies fixed linguistic, national, and cultural borders, placing it squarely in the field of African Diaspora/Black Atlantic Studies, which is multicultural and multilingual. As a result, Clark argues, "Throughout the twentieth century, diaspora literacy has implied an ease and intimacy with more than one language, with interdisciplinary relations among history, ethnology, and the folklore of regional expression."[2] Her articulation of diaspora literacy concludes with the observation that "only recently has literary theory applied to Afro-Caribbean texts become indispensable."[3] While Clark's explicit intent in this final remark is to argue for the need for critics to apply a more vigorous attention to the question of representation, I also view it as a springboard for scrutinizing Marshall's aesthetic philosophy, or poetics.

In many ways, Marshall's fiction anticipates many of the concepts that have come to be associated with the post-soul aesthetic. She depicts Black female protagonists, often immigrants and migrants, who more often than not identify as cultural hybrids. Her characters negotiate complex social and spatial landscapes, all the while grappling with questions of identity and selfhood. Before concepts such as migration, pluralism, hybridity, and fragmentation became ubiquitous in Black (really, African American) literature and literary studies, Marshall's novels centered these ideas. Still, while she shares the post-soul imagination's preoccupation with identity, her imaginations diverge because her strongly held beliefs about the importance of communal bonds and collective identity remain pronounced, even in portrayals of individuals who wrestle with their complicated feelings about such affiliations. This is not to say that Marshall romanticizes collectivity. Indeed, in some texts, she actively explores the pressures to conform that belonging places on individuals.[4] Nonetheless, Marshall's willingness to explore these underlying tensions never overshadows her communalist ethos, setting her

stories apart from the individualism privileged in some post-soul literary works.

When Marshall reflected on her career, she often emphasized the idea of a diasporic connection and continuity. Her novels may explore the seams and fissures within the collective, but in interviews, she made clear that she aspired toward wholeness. For example, in a 1988 interview, she explains her understanding of diaspora through the language of continuity: "When I say African-American," she stated, "I'm talking about blacks from Brazil to Brooklyn."[5] In a subsequent interview, she reiterated the point: "I don't make any distinction between African-American and West Indian. All o' we is one as far as I'm concerned."[6] In many ways, Marshall's conceptualization of diaspora mirrors Heather Russell's view that the term represents an analytic framework that highlights the unifying experiences of Black people globally and hemispherically. According to Russell, a diasporic perspective recognizes that "we are always already bound up in each other irrespective of (seemingly fixed) national borders, discourses of cultural belonging, and deeply entrenched notions of history and place."[7]

In Marshall's fiction, wholeness and unity represent an aspiration and ideal as opposed to the characters' lived realities. Her novels complicate the vision of diasporic continuity espoused in these interviews by depicting collectivity as an assemblage produced via intersubjectivity. In other words, her representations of community and diasporic collectivity depict a process in which individuals strive for *or* resist *or* undermine attempts to hold the group together. In so doing, Marshall's characters find themselves having to reckon with the ways that, at times, endeavoring to reach this goal causes harm to some of the individuals who constitute the whole. Russell describes this as a practice of "piecing together seemingly disparate narrative strands and gleaning meaning via intersubjectively engaging the multiple voices that populate [a] narrative structure."[8] Because of Marshall's nuanced and layered approach to her representations of the "I" and their relationship to the "we," her novels helped lay the groundwork for the emergence of the post-soul generation of Black women writers. Fictional works by authors like Edwidge Danticat, Chimamanda Adichie, Yaa Gyasi, and Zadie Smith explore similar themes of belonging, migration, urbanity, and hybridity, leading them to acknowledge their indebtedness to Marshall's oeuvre.[9]

When Marshall published her first novel, *Brown Girl, Brownstones*, in 1959, it appeared at a time when she wouldn't have had much company. A community of other Black feminist writers did not yet exist, at least not in significant numbers, and would not until the Black Arts Movement of the 1960s

and 1970s and the development of a Black feminist literary tradition in the 1980s. Moreover, the mood of Marshall's novel diverged sharply from the protest fiction that defined Black literature in the 1930s and 1940s. In their novels and short stories, authors like Richard Wright and Ann Petry depict characters like Bigger Thomas and Lutie Johnson who find it impossible to escape the stranglehold of poverty, racism, and sexism.[10] As Farah Jasmine Griffin so cogently argues in her study of the African American migration narrative, in these early twentieth-century narratives of Black urbanity, the city represents nothing more than a site of alienation.[11] Against this backdrop, Marshall's use of the form of the *Bildungsroman* to tell a coming-of-age story of a Black girl named Selina Boyce who is raised in an immigrant community in Brooklyn is unusual, even iconoclastic. The contrast proves especially striking given that Selina's story ends on a note not of existential despair but rather of hopeful ambivalence as she leaves her Brooklyn home and community to commence a journey of self-discovery.[12]

Marshall published her fourth novel, *Daughters*, in 1991, returning to some of the same themes explored decades earlier in *Brown Girl, Brownstones*. In fact, the extent to which her literature overlaps with post-soul literature can be seen in the fact that many of the challenges Selina faces resonate with the experiences of Ursa Mackenzie, the protagonist of *Daughters*. As with Selina's portrayal, the narrative presents Ursa as a subject suspended between a number of opposing forces that include the struggle and urban dynamism of urban life, Caribbean and African American cultures, and ancestry ties and future possibility. Of all the narrative resonances, most important is the fact that Marshall imagines the aesthetic—both expressive forms and performances as well as encounters with works of art—as occasions for self-exploration. Thus, when they occupy the time-space of the Black imagination, Selina and Ursa experience being-ness as an aesthetic inhabitance that accommodates the duality of their *Black feeling* and *feeling Black*. Importantly, nowhere else but in the realm of art and imagination do they feel freed, albeit momentarily, to accept the totality of their experiences, free of the pressure to reconcile or choose between opposing forces.

History's Promise

Before attending to Marshall's aestheticism, it's important to turn to the subject of history because of the emphasis placed in her narratives on the importance of historical consciousness and ancestry to the development of Black consciousness. Marshall spoke of the past as a wellspring of stories and

lessons about cultural abundance and collective resilience, traits that could help repair the material and psychic wreckage left behind by the cataclysm that was the Middle Passage. For example, in a conversation with Daryl Cumber Dance, she describes diasporic history and literacy as countervailing forces against commonplace falsehoods and distortions that pathologized Black people and Black culture. Referring to minstrel figures like the "happy darky," tragic mulatto, and "n*** wench" and other caricatured "images that peopled my childhood in books and the movies," Marshall declares, "By the time I got to high school I realized that the history taught me, the little bit of history taught me about black people, was far from the truth. I sensed that early on. Somebody was lying through their teeth to me, trying to undermine my spirit and my sense of self."[13] Notably, she rejects such distortions, calling them lies as opposed to real history. The truth of the past had yet to be excavated.[14] "History to me is an antidote to the lies and I'm interested in unearthing what was positive and inspiring about our experience in the hemisphere—our will to survive and overcome."[15] Rather than conceptualizing the historical archive of Blackness as a grave, Marshall conceptualizes the past as replete with stories of resistance, empowerment, and cultural abundance that call for recuperation. In this sense, the Black past also appears as un- (or under-)explored territory. It represents a frontier-space that remains open and waiting for the attention of a people who will put historical knowledge in service of the larger goal of articulating a positive and self-affirming identity.

Marshall tells Dance, "We have the unique opportunity to create, to reinvent ourselves. . . . And I think that knowing and understanding history is an essential part of that endeavor."[16] In so doing, she alludes to a Black intellectual project, one that is hemispheric and diasporic in scope and focused on the kind of historical recovery that Stephen Best elucidates: "It is not hard to see in the recovery imperative a powerful and compelling theory of how history works—not simply the theory that the past persists in the present or the proposition that the past has to be made relevant to the present, but the idea that history is at its core a fundamentally redemptive enterprise, the idea 'that everything that has eluded [the subject]' may be restored to him."[17]

Ultimately, Best concludes, this approach represents a critical ethic whose investment in the "recovery imperative" stems from a belief that history can be mobilized to repair the foundational rupture that inaugurates modern Blackness. As Best puts it, this form of historicism is "directed toward the recovery of a 'we' at the point of 'our' violent origins."[18] Hence, the tendency

in Marshall's novels to join her characters' quest for personal and collective wholeness with the work of historical recovery.

The central conflict in *Daughters* takes up precisely this question: the role history plays in the personal and collective life of its protagonist, Ursa Mackenzie. Ursa wrestles with memories of a moment that for her counts as the source of a psychic injury from which she never fully recovers. Specifically, she nurses the hurt caused by her college advisor's rejection of a research proposal to study gender roles and relationships, "a neglected area in the study of the social life of New World slave communities."[19] The narrative frames Ursa's critical ethic toward the past as a kind of romance by exploring her desire to use history as a vehicle to correct the issues that plague (not coincidentally, heterocentric) coupledom in the present.

As the ensuing narrative makes clear, Ursa clings to an idea of the past that Hartman deems "a historical romance," hoping that the answers she will find to her questions about the past will unlock the key to overcoming the challenges she faces now. She elucidates these questions for her professor: "I'm curious to know what relations were like between the slave man and woman. How did they get along? What was the nature of their social, sexual and family life? How did they feel about each other, treat each other?"[20] Because Ursa internalizes his rejection as a lost opportunity to acquire what she considers essential knowledge, it inspires a feeling of melancholy that shadows her through adulthood. It is ironic perhaps that Marshall, through the portrayal of a protagonist who ultimately fails to realize her desire to instrumentalize the past, crafts a story about Blackness, history, and identity that entertains the possibility that the recuperative imperative is an unachievable ideal.

Many critics have written compelling and thought-provoking analyses of Marshall's contributions as a Black feminist to the literature of African diaspora and its culture.[21] For example, Moira Ferguson's reading of *Daughters* frames it as "a feminist intervention in empire" and her struggle against the corruption and paternalism of her father Primus Mackenzie, the Prime Minister of Triunion, as "another war of independence" against neocolonialism.[22] Like Ferguson, Joyce Pettis's analysis works at the intersection of inner and outer landscapes, turning her attention to the racial, gender, and sexual oppressions that contribute to the fractured psyches of Marshall's major characters (as opposed to intersubjective dynamics). Here, I build on the insights of these scholars by introducing another angle into the workings of interiority. Through the framework of aesthetic optimism, I strive for a more deliberate effort to move beyond the kind of "melancholy historicism" that

Best defines as "a kind of crime scene investigation in which the forensic imagination is directed toward the recovery of a 'we' at the point of 'our' violent origin."[23]

An Inner Landscape of Dreams and Imagination

In both *Brown Girl, Brownstones* and *Daughters*, representations of artists, art-objects, and aesthetic feeling are inspired by moments of immersion in the now-ness of the aesthetic present—for example, in Selina's high school dance performances and Ursa's attachments to a historical monument in Triunion, the fictional Caribbean island of her birth. A critical focus on these aesthetic encounters, as well as on the author's use of ekphrastic imagery, helps to illuminate the capaciousness of the Black interior and reveals other interpretive lenses beyond the framing of historicity. Stated directly, the art is there in the stories to be read as well, and in that reading one finds occasion to consider inner landscapes that are shaped but not overdetermined by the characters' sociohistorical contexts.

The opening passages of *Brown Girl, Brownstones* illustrate the point by describing Selina's Brooklyn neighborhood as a locale populated by an "unbroken line of brownstone houses . . . [that] resembled an army massed at attention."[24] The image gestures toward the narrative intent to center the perspectives of poor, working-class Black subjects, particularly women, in order to complicate the mythology of the immigrant pursuit of the American Dream.[25] Exploring the effects of anti-Black racism and patriarchy on the characters' lives renders untenable America's bootstraps mythology of self-improvement via personal initiative. Moreover, it underscores Williamson's and Farah Jasmine Griffin's arguments about the psycho-emotional and communal havens created by the bonds formed and maintained by forms of Black sociality. When read through the lens of these critical frames, it becomes clear the ways that *Brown Girl* clearly fits within a tradition of literary representation that uses community and kinship as symbols of refuge from the alienation engendered by having to navigate an anti-Black world.[26]

As the narrative goes on to introduce the novel's ten-year-old protagonist and her father, Deighton, a more complicated, ambivalent idea of collective strength and unity begins to emerge. Moments before joining her father in the sun parlor where he is studying correspondence courses on accounting, reading newspapers and letters, and listening to the radio, the narrator describes Selina as the embodiment of uncontained and conflicting energy, as a presence that simultaneously enlivens and clashes with the staid and so-

ber home: "Suddenly the child, Selina, leaped boldly to the edge of the step, her lean body quivering. At the moment she hurled herself forward, her hand reached back to grasp the banister, and the contradiction of her movement flung her back on the step."[27] After bumping her elbow, she shakes her fist, and the "two heavy silver bangles which had come from 'home' and which every Barbadian-American girl wore from birth . . . sounded her defiance."[28] This characterization of Selina's movements foreshadows the oppositions that determine the arc of her narrative trajectory. In this instance, however, it foreshadows her ambivalence toward family and community in ways that resonate *and clash* with her father Deighton.

When Selina finally joins her father in the parlor, the narrative description conveyed through her perspective offers a glimpse of the affinities between parent and child. Selina suddenly comes to a halt at an image of beautiful repose: "Deighton Boyce's face was like his eyelids—a closed blind over the man beneath. He was well-hidden behind the high slanted facial bones, flared nose and thin lips, within the lean taut body, and his dark skin, burnished to a high fine gloss, completed the mystery."[29] This image of Deighton at rest recalls an earlier description of Selina as "a dark girl alone and dreaming at the top of an old house."[30] Readers have yet to learn of the contempt his wife Silla and the larger community feel toward Deighton. From their perspective, which is not entirely wrong, his inability or refusal to keep a job and his disdain for the homeownership that they view as key to their economic security provide evidence that he is lazy and selfish. From Selina's perspective, however, readers get a sympathizing glimpse of a man whose failures can be attributed in part to his frustrations as an aspiring artist whose efforts at self-expression (like taking a correspondence course in playing the trumpet) are as likely to fail as his more pragmatic efforts to find a suitable job (like taking the course in accounting).

In the previously cited passage, Selina's gaze is nearly painterly in its focus on the angles, shapes, and shading of Deighton's features. When Deighton awakes, they begin a conversation that the narrator describes as "step[ping] into an intimate circle . . . joined together in the pause and beat of life."[31] In these ways, with its focus on intimacy and intersubjectivity, the passage alludes to a connection that readers eventually learn to connect to their shared identities as the dreamers in their family. At the same time, however, narrative emphasis on surface and sheen proves ironic, as does the reminder that Deighton's innermost thoughts remain opaque to Selina. They introduce a perspective that Selina lacks because of her youthful inability to see that Deighton's dreaminess leaves her mother—whom Selina perceives

as winter to her father's summer, a permanently embattled woman with a "strong-made body"[32]—to shoulder the responsibility of caring for their material well-being.

By contrasting Selina's kinetic energy to the image of her father, "stretched dark and limp on a narrow cot like someone drunk with sun,"[33] the narrative also alludes to a key difference between father and daughter, which becomes more sharply delineated as the story continues, for Deighton dreaming represents a retreat from life, whereas for Selina, it enlivens her and animates the connection she feels to others and her surroundings, a connection that extends beyond her community to include communities (including of the dead) who share no resemblance. "She rose, her arms lifted in welcome, and quickly the white family who had lived here before, whom the old woman upstairs always spoke of, glided with pale footfalls up the stairs. Their white hands trailed the bannister; their mild voices implored her to give them a little life."[34] Regardless of Deighton's and Selina's differences, my primary point is that the narrative depicts Selina as a character imbued with an aesthetic sensibility, as a subject able to tap into memory and imagination in order to conjure feelings of belongingness that are inspired by but not synonymous with racial kinship and community.[35]

Exploring the multiplicity of modes of Black aesthetic being proves challenging, even somewhat heretical, given Selina's changing relationship to her cultural heritage. In this regard, the parent–child dynamic proves especially relevant because Selina eventually acquires cultural literacy and self-knowledge through her father's recollections of "home" (i.e., Barbados) and the orality at the center of her mother's everyday existence. Add to this context Marshall's fierce articulation of Black women's culture as a repository of diasporic history, worldviews, and traditions. In 1983, the author famously published an essay on the importance of orality in Caribbean women's communities, "From the Poets in the Kitchen," that much like Alice Walker's *In Search of Our Mothers' Gardens* articulated a Black feminist poetics rooted in overlooked and disregarded vernacular traditions maintained by women like Silla, Selina's mother. Like Walker, Marshall's elucidation of Black women's culture as site and source of creativity inspired generations of Black feminist critics and theorists to frame the aesthetic forms and expressive performances as the product of the ordinary and every day. In "From the Poets in the Kitchen," we see this perspective articulated in Marshall's description of Bajan women's culture: "They really didn't count in American society except as a source of cheap labor. But given the kind of women they were, they couldn't tolerate the fact of their invisibility, their powerlessness.

And they fought back, using the only weapon at their command: the spoken word."[36] Here, the kitchen table symbolizes a vital sociality in that it functions as a communal space where Black women's voices and views are valued and they feel empowered to a measure of self-assertion and self-definition that the world otherwise refuses.[37] In Marshall's assertions that when "permanently separated from the world they had known, they took refuge in language," one hears echoes of those theorists of the Black interior who conceptualize it as a haven from the alienation engendered by larger forces of racial and gender domination.

Nonetheless, through her portrayal of Selina the daydreamer, it becomes possible to link this figuration of a Black social world whose offer of relation to the Other develops via reciprocal and respectful relationships to Édouard Glissant's conceptualization of Relation through the notion of an irreducible totality of being that compels a reckoning with the unknowing produced by the impossibility of reducing a whole to the sum of its parts. The opacity of the subject implied in the description of Deighton returns in a passage inspired by "The Poets in the Kitchen." As Silla and her women friends engage in craftwork (storytelling, cooking, and baking Barbadian delicacies), Selina occupies a liminal space between the uniqueness of her imagination and the women's social world. According to the narrator, as the women talked, "Selina would sit for hours, her feet hooked on the chair rung, her chin in her hands, staring out the window at the pear trees in the back yard, at the nude branches clacking in mournful chorus against the somber sky."[38] Here, Selina is both a part of and apart from the group of Bajan women. As she quietly absorbs the rhythms and sounds of the spoken word and the lessons within their stories, her outwardly directed gaze also suggests an inner world governed by dream and imagination that resists containment by the impositions of place or identity. In other words, although Marshall and her readers rightly stress the significance of Black sociality and vernacular traditions, the narrative tendency to map Black interior geographies according to subjective and social coordinates gestures toward disjunctive moments whose friction racial discursivity cannot fully explain or contain.[39]

Given Marshall's tendency to align Black culture forms, vernacular traditions, and literature to a collective project of self-invention, it is probably unsurprising that Brown Girl grapples with the utopianism and individualism typically associated with ideas of aesthetic sovereignty and freedom of imagination. For example, as Selina matures and her relationship with her parents evolves, the narrative implicitly cautions against a thoughtless embrace of individualism. It does so through the portrayal of Deighton, whose

narrative trajectory eventually ends in spiritual demise when he cuts himself off emotionally from his family and in literal death when he abandons them and boards a ship bound for Barbados. Moreover, by the end of the story, Selina underscores her bond to Silla, who strongly identifies with the Bajan culture and value systems. Ironically, this moment occurs as Selina explains her decision to defy communal expectations that she will make the pragmatic choice and attend college in order to pursue her ambitions as a dancer: "Everybody used to call me Deighton's Selina but they were wrong. Because you see I'm truly your child. Remember how you used to talk about how you left home and came here alone as a girl of eighteen and was your own woman? I used to love hearing that. And that's what I want. I want it!"[40] This conversation refuses to pit communalism against the individualism that propels Selina's dreams of artistic freedom. Rather, by having Selina credit Silla as the source of her boldness and resolve, the narrative frames the Black past and future not as a binary but as a spectrum. In fact, the notion that Bajan collectivism forms the foundation for Selina's future aspirations suggests a strikingly different approach, or critical ethic, to the Black past. Instead of a discourse on Blackness premised on shared experiences of oppression or on the non-ontological sameness implied by notions of historical recursiveness, Marshall's literary refusal of binarism points to another way of articulating Blackness by envisioning sameness and difference, past-ness and futurity as interdependent and interconnected constructs. In this way, through its multifaceted portrayal of an artist as a young Black girl, which eschews absolutist conclusions about Selina's unfettered, or foreclosed, access to freedom, *Brown Girl* models literary (aesthetic) optimism.

This critical orientation compels consideration of its depictions of interracialism, particularly in those passages that depict Black female artistry as a staging ground for reckoning simultaneously with social misrecognition and subjective freedom. I am thinking here of the description of a dance recital, in which the narrator describes Selina's performance of "the birth-to-death cycle" as a communion with music and movement, a relinquishment of bodily autonomy that she experiences not as a loss of self but rather as an ecstatic giving of the self to forces beyond her: "The music bore her up at each exuberant leap, spun her at each turn so that a wind sang past her ear; it responded softly whenever the sadness underscored her gestures—until at the climax, she was dancing, she imagined, in the audience, through the rows of seats, and giving each one there something of herself."[41] In this passage, dance is a vehicle for Black presence. Music moves Selina *and is also at the same time* moved by her as it "responded softly whenever the sadness

underscored her gestures."[42] Lost in the immediacy, the aesthetic now-ness, of music and dance, she experiences herself as a subject who acts on other objects around her as much as she is one who is acted on.

Not only does *Brown Girl*'s depictions of aesthetic encounters such as this present a broad range of expressive forms and performances, from vernac-ular culture to "classical" disciplines like modern dance, it also explores forms of engagement from the perspectives of the performer and members of her audience. Two passages that focus on audience reception offer divergent per-spectives: both focus on figures representative of the dominant societal gaze, but whereas one alludes to the pernicious effects of the racial imagi-nary, the other represents the aesthetic realm of art and imagination as a por-tal to other possibilities of Black being-in-relation. The latter is represented in an interaction that takes place after the recital, when another dancer de-scribed as "a heavy-set blond girl with fine white down on her flushed cheeks" greets Selina enthusiastically: "When you started dying I felt I was dying. . . . Oh, you were so Greek!"[43] The former is represented at a party held in cele-bration of the recital that is hosted by another of Selina's white peers. In this second instance, when confronted by the bigotry of a white friend's mother who refers to "your race's natural talent for dancing and music" and the West Indian "girl" who cleans her house in the same breath, Selina's sense of con-nectedness to the wider world recedes.[44]

This exchange inspires the kind of alienation associated with Du Boisian double-consciousness:

> Why couldn't the woman see, she wondered—even as she drowned—that she was simply a girl of twenty with a slender body and slight breasts and no power with words, who loved spring and then the sere leaves falling and dim, old houses, who had tried, foolishly perhaps, to reach beyond herself. But when she looked up and saw her reflec-tion in those pale eyes, she knew that the woman saw one thing above all else. Those eyes were a well-lighted mirror in which, for the first time, Selina truly saw—with a sharp and shattering clarity—the full meaning of her black skin.[45]

In many ways, this encounter corresponds to Frantz Fanon's articulation of the consequences of the colonial gaze and its power to objectify in *Black Skin, White Masks*. He describes the effect in this way: "I came into the world imbued with the will to find a meaning in things, my spirit filled with the desire to attain to the source of the world, and then I found that I was an object in the midst of other objects."[46] The experience of misrecognition,

which is reflected back to Selina as if from a mirror in the woman's pale blue eyes, evokes the othering and shattering of selfhood that Fanon theorizes as the defining "fact of blackness" and characterizes as "being for others."

Another line from Fanon resonates equally when juxtaposed to this passage: "But, when one has taken it into one's head to try to express existence, one runs the risk of finding only the nonexistent."[47] *Black Skin, White Masks* has long been considered, along with writings on social death, humanism, and modernity by Orlando Patterson, Sylvia Wynter, and Hortense Spillers, a foundational text in the Black pessimist school of thought. Too often, however, these lines are read literally as an unshakeable ontological statement of Black nonbeing as opposed to a description of Blackness as a liminal subjectivity—"straddling Nothingness and Infinity"—engaged in an irresolvable phenomenological quandary.[48] If we look to the example of Selina, we witness a subject who embraces the risk by using art to "try to express existence." And while the pale blue eyes reflect back to her own nonexistence, the suggestion that this grants her acuity, a perspective imbued "with a sharp and shattering clarity" gestures toward the mature insight she will carry when she risks again.[49]

Yet another response to this performance suggests why a subject like Selina might want to risk self-assertion and engagement in the world outside rather than retreating to a defensive or offensive posture against it. Her friend Rachel describes the feelings Selina's performance inspires within her as she watched: "It is frightening. Because you know that if you go on you'll almost fly out of yourself. *That's what you want but still, in a way, it scares you.*"[50] Here, Rachel's use of the second-person form of address is especially meaningful because it blurs the boundary between the "I" recalling her emotions and the "you" that she imagines probably feels the same. In other words, the effect of the aesthetic encounter is to encourage empathy by blurring the boundary dividing *self* and *other*. Rachel's reference to wanting to "fly out of yourself" speaks to this dynamic as well. During the performance, the dancer experiences her body, her selfhood, as fluid and dynamic. She can be both Bajan and "so Greek." Her movements feign death, and in so doing, the dancer internalizes the experience, as do the viewers who imagine, *who feel*, themselves dying alongside the performer ("When you started dying I felt I was dying").

The ideas of intersubjectivity and relationality that thread through this conversation suggest a countervailing approach to conventional approaches to envisioning the human at the intersection of racialized Blackness. The dis-

tinction I find can best be discerned by setting aside Black pessimism's focus on the political ontology of nonbeing and focusing instead on a particular line of inquiry within the critical discourse on Black interiority. The discourse of interiority takes as a given the uncontestable nature of Black humanity; this is a presumption that my aesthetic framework shares. But rather than looking exclusively to spaces and forms of Black sociality for affirmative models of intersubjective recognition and relation, the aesthetic framework conceives of recognition as risk, as a striving toward self-expression and self-invention whose effect is open, unknowable, and changeable.

This perspective resonates with the conclusion of *Brown Girl*, which ends on a dualism tinged with ambivalence as the protagonist finds herself suspended between past and future selves. Selina arrives at an ending that also represents a beginning of a continuous journey in search of self.[51] As the Brooklyn skyline recedes, she turns away, awash in melancholy from the knowledge that she leaves behind a community that has irrevocably shaped her sense of self: "She wanted, suddenly, to leave something with them."[52] In a gesture of abandon that conveys the mingled feelings of freedom and loss, she tosses over her shoulder one of the two silver bangles she has worn since girlhood. The graceful arc of the bangle—"a bit of silver against the moon"—hints at the glimmer of possibility in a Black woman subject in a state of becoming, unafraid of the mysteries of being unmoored from her community and at sea on a journey of self-invention for which no template exists.

Imagining Other Times and Other Ways of Being

More than three decades separated the publications of *Brown Girl, Brownstones* and *Daughters*, and as a consequence of the specificity of the characters' personal circumstances and historical contexts, Marshall replaces the hopefulness of the first novel with a melancholic tone in the second. It would be more accurate to describe it as the kind of racial melancholia or grief that Anne Anlin Cheng theorizes as a foundation for racial identity, for in *Daughters*, the forces of history appear as a "changing same" in the forms of anti-Black racism and coloniality, compelling a different kind of reckoning with power and selfhood.[53]

Daughters abounds with examples of historical recursiveness. For example, while Ursa dines at a restaurant with her boyfriend Lowell, they discuss the ways that the forces of racism and sexism fabricate a glass ceiling that limits their opportunities for career advancement. This dynamic proves

especially troublesome to Lowell, who exclaims, "The second reconstruction is over baby, haven't you heard? Hasn't anybody told you? It's over! Don't you see where the country's getting ready to put some cowboy in the White House come November? We might find ourselves back in the cotton patch."[54] As the plot develops, the boomerang arc of anti-Blackness recurs in the form of asymmetrical power dynamics that repeat in the various locales that Ursa traverses. For example, a pattern of complicity emerges over time as the narrative moves between the past and the present; from the period of anticolonial struggle to the era of postcolonial independence on Triunion, the fictional island where Ursa was born and her parents continue to live; and as characters traverse the Black Atlantic world from the Caribbean to the United States. In each place and time, political elections usher in powerful, idealistic young (always male) politicians who imagine themselves as liberators. These include Ursa's father Primus Mackenzie, a dominant political figure in Triunion, and Sandy Lawson, a candidate for mayor of a New Jersey city who Ursa helps get elected to office. Each time, their idealism gives way to pressures of capitalism and empire, which demand that they collude with structures of white power. When the novel ends with the election of another idealist, Justin Beaufils, who unseats Primus and replaces him in government, the question of whether the pattern will repeat itself remains open.

These dynamics lead Ursa to conclude, "the white people—them! Still running things in both places—everything superimposed on everything else. Inseparable, Inescapable. The same things repeated everywhere she turned."[55] And when she thinks of the similarities between Manhattan's gentrifying Upper West Side neighborhood and Triunion—"Columbus Avenue had been a run-down stretch of old-law tenements and SRO hotels, little dingy mom-and-pop stores, bodegas that reeked of bacalao, and a roadway that put her in mind of the old north/south colonial road back in Triunion"—the connection has less to do with cultural continuity across the diaspora and more to do with the reach of capitalism, the underlying force behind the gentrification of Black and Brown neighborhoods, and the "development schemes" that hold Triunion captive to the demands of the tourist industry.[56]

Much like its treatment of the relationship of the present to the past, *Daughters* frames the question of "difference from within" as a political quandary. In so doing, the focus shifts from the problem individual nonconformists pose to their communities to the value systems and actions that threaten to undermine political solidarity and racial unity and progress. Class stratification represents one such threat. Thus, as members of the Black

bourgeoisie, the more politically conscious members of Ursa's circle of family and friends struggle to reconcile their personal privilege with the ongoing inequities and forms of injustice that negatively affect Black communities. Moreover, Ursa remains mindful of other kinds of *isms*, beyond class, that threaten to sow the seeds of conflict and division. For example, when her American-born best friend expresses irritation over Ursa's still-strong allegiance to Caribbean culture and identity, it inspires her to reflect on the mutual distrust that has historically separated the two groups: "Instead of the handshake and embrace . . . the intimate, loving palaver, they hold off, shy away, step back."[57]

The ironic connection that Lowell makes between the Civil War and Reconstruction eras and the reactionary backlash to a changing society in the eighties helps establish a context that explains the protagonist's political ideology. Ursa and Lowell are confronted all around by signs of stalled racial progress and the intransigence of white supremacy and imperial domination. From the vantage point of politics and ideology, Ursa's view of resistance, which emphasizes the need for political solidarity, coalition building, and racial unity, appears to be not only progressive but also strategically sound. However, *Daughters* offers a multiplicity of perspectives on these issues that is nearly kaleidoscopic. Marshall weds the political and ideological with the personal and subjective (i.e., affective), with the effect of troubling the temptation to embrace a single point of view.

Ursa's tendency to blend the personal and political in her conceptualization of unity illustrates this point, particularly in situations in which unity is framed in terms of the personal and interpersonal rather than as a response to structural inequality. For example: "The black men–black women ratio thing to begin with, more of us than them. That's a downer right there. And these fancy-sounding job titles a few of us have . . . that scare the brothers away, and the little white girls out here eying what we eyeing, and the brothers who only have eyes for them. And not to mention, not to mention pu-leeze those among the brothers who have eyes only for each other, or for themselves."[58] Given her political rhetoric, Ursa's failure to see a connection between her own homophobic sentiments and the perniciousness of patriarchy is curious. It reveals a logical and ethical blind spot that invites more critical scrutiny of the notion of collectivity than might otherwise be possible if readers identify too closely with the protagonist, her point of view, and her desires.

Daughters's merging of two genres, romance and historical fiction, inspires such analysis. Throughout the narrative, Ursa remains as troubled by the

meager prospects for romantic connection as by the political urgencies of the present. The result is a narrative strategy, a generic hybridity, that frames the forces threatening to unravel Blackness as emanating from without and within. Marshall's approach to storytelling has led some reviewers to remark unfavorably on a perceived misfit between the novel's sociohistorical and political themes and the conventions of mass market romance fiction. Then and now, critics typically differentiate between the high-minded literary fiction associated with authors like Toni Morrison, Alice Walker, and Marshall and the kind of Black romances that were popularized by the phenomenal success of Terri McMillan, who with the publication of *Waiting to Exhale* in 1992 proved the existence of a sizeable readership interested in stories about ambitious Black couples falling in and out of love.[59] The widely held assumption was that literary fiction focused on Black people's historical and present-day struggles, while popular fiction focused on more superficial concerns that were palatable to a mainstream market, like the pursuit of love, jobs, and material objects.[60] In this context, *Daughters's* tonal and generic hybridity went against the grain, leading one reviewer to declare that it "reads like well-made commercial fiction with a Caribbean accent"[61] and yet another to bemoan its failure "to fuse its personal and political elements."[62]

Rather than reading Marshall's experimentation in form as a failure, I choose to read it as a provocation designed to inspire reflection on the irresolvable nature of present-day expressions of the yearning for wholeness. It's worth keeping in mind the idea that historical romance novels exist not to tell stories of the past but to hold a mirror to the present.[63] From that vantage point and borrowing from K. Merinda Simmons's formulation, it becomes clear that merging history and romance represents an attempt to put post-soul questions focused on *what it means to be Black now* in conversation with philosophical and ideological explorations that focus on *what it means to be Black at all*. From this perspective, the significance of Ursa's preoccupation with Triunion's historical freedom fighters against slavery, Will Cudjoe and Congo Jane, the subjects who were supposed to have been the subject of her research project, comes into focus. From Ursa's perspective, these figures, whom Marshall fashioned after Jamaica's Nanny of the Maroons, hold double meaning as idealized symbols of fugitivity and resistance as well as of (nonhierarchical) Black love.

According to legend, Will Cudjoe and Congo Jane are "coleaders, coconspirators, consorts, lovers, friends. You couldn't call her name without calling his, and vice-versa, they had been that close."[64] This model of radical

collaboration, which Ursa conceptualizes as a form of Black love, resonates in critical discourse—for example, in Hortense Spillers's conceptualization of the "ungendered" enslaved female body as a theory and praxis that offers "a text for living and for dying" in her seminal essay "Mama's Baby, Papa's Maybe."[65] Asked to elaborate on this concept during a public conversation, Spillers responded:

> When I was growing up, I thought I saw in black culture a kind of democratic form that I haven't seen quite like that since. It just seemed that community automatically did something in relationship to being human that was really quite different. That people did whatever work was to be done, whether it was "men's work" or "women's work," if it needed to be done, people simply did it; to raise children, to maintain communities. As I see it now, success in black culture has brought us a lot closer to appropriating gender dynamics that I do not necessarily like. That a black man can be an entrepreneur and a capitalist and a black woman can be "feminine" and sit at home—we're getting much closer to those binaries, and I suppose any issue of *Ebony* will show you this.[66]

Spillers's analysis underscores the reason why throughout the narrative Ursa regularly returns, literally and figuratively, to the massive stone sculpture of the duo (and their confederates Alejandro and Père Bossou, who are similarly commemorated).

While Spillers's theorization productively and generatively looks to the slave past as a basis for undoing the gender binary and hierarchy, Ursa uses the time of slavery to reenvision the Black past and future in ways that paradoxically reinforce them. We see this in Ursa and her best friend Viney's conversations about their romantic prospects, like the one cited previously, in which they disparage gay men based on the notion that queer desire represents one of a myriad of forms of racial betrayal. When asked to reflect on the significance of Will Cudjoe and Congo Jane's story, Marshall acknowledges a tinge of idealism in ways that ought to shade readers' perception of Viney's worldview: "It's about coming together, the working together not only of black men and women, but of the entire black community throughout the world. Idealistic, I know, romantic even—I've been accused of both—yet the possibility, the necessity of that union sustains me."[67] By exposing the heteropatriarchal underpinnings of the characters' vision of unity, the narrative offers readers an opportunity to critically scrutinize this idealized vision of Black love and collectivity.

Robert Reid-Pharr's analysis of literary deployments of figures of domesticity, like the household, in the discursive production of race amplifies this point. In *Conjugal Union*, Pharr uses this critical framework to structure his analyses of literary figurations of the stable Black bourgeois subject. From this critical perspective, the mulatto represents an unruly body that resists definition and containment by the logic and language of domesticity and race.[68] Although the references to gay men in *Daughters* are glancing and infrequent, their positioning as a symbolic scapegoat in Ursa's imagination resonates similarly. That is, the real problem with gay men is that queerness represents a refusal to comply with normative models of marriage and kinship, which is another way of saying that queerness refuses to be disciplined into normative modes and ideas of racial collectivity. It's worth noting that insights and arguments afforded by queer perspectives, voices, and theories come to prominence in the post-movement era and play a pivotal role in the development of the post-soul aesthetic. When framed in terms of *Black* presentism, the romance theme in *Daughters* suggests a different way of conceptualizing the relationship of the Black past to the present: not as simulacrum or antagonism, but rather as a dialectic that can be mutually informing when deployed in the critical discourse on Blackness and its shifting meanings across time and space.

From Political Stasis to Contemplative Stillness

In the final pages of the novel, Ursa returns in person to the site of the monument, and in this scene of aesthetic encounter, the narrative offers a glimpse of striving for a reorientation of perspective. On Ursa's visits to Triunion, she regularly travels to the monument that memorializes the figures of Will and Jane. In those moments, because of its commemorative function, the statue's value is discursive rather than affective. It is a "thing" constructed to signify fixed ideas and ideals, like "revolution" and "national unity." Juxtaposed to Marshall's ekphrastic passages, however, we can begin to reenvision even the monument as a site of a different order of radical possibility, as we see when the text describes Ursa's engagement of the sculpture in notably aesthetic terms by emphasizing the materiality of the statue and the immediacy of feelings it provokes. Ursa perceives the figures "looming above her on their base at the rear of the platform" and gazes into the stone faces, "as black and wide-nosed as her own."[69] She takes a visual account of the objects they hold: a conch shell, a conquistador's sword, a cutlass and a gun. Jane's shawl covering her breast, which has been wounded in battle, and a

bandage binding a wound on Will Cudjoe's forehead. The materiality of these possessions animates by evoking the presence of the people who owned then.

In this way, the description hearkens back to an earlier memory, in which Ursa remembers her mother's encouragement to touch Congo Jane's toes. She recalls straining "until she could just reach the tip of the stone foot. . . . Warmed by the sun, Congo Jane's toes had felt as alive as her own."[70] Throughout much of the narrative, as when she thinks of the monument as the inspiration for her research project, Ursa's proclivity is to turn art into discourse, to narrativize these objects so that they might serve as a historical record of a time when Blackness was defined by a revolutionary spirit and communal reciprocity and care. Yet the fact that these ideals are rendered as a representation is in and of itself a rupture of the very things—like love and struggle—that the monument is meant to signify. Indeed, the novel's portrayal of reality, of Ursa's lived experiences, as a series of challenges and obstacles functions as a reminder or subtle rebuttal of the complexities that discourse, this romance of the Black past in particular, cannot or *will not* allow.

This begs the question, what besides inspiration can Ursa discover through her encounters with art? Her recollection of looking into Congo Jane's and Will Cudjoe's "far-seeing, all-seeing" eyes as well as to the stars in the sky above them gestures toward an answer: that engaging art makes it possible to explore and experience other perspectives and ideas. That aesthetic engagement makes space for a productive and generative practice of relational orientation and reorientation. Through this creative-critical practice, the encountering subject finds themselves exploring other habits of mind and other ways of being in relation to the self as well as to others.

Although *Daughters* portrays Ursa's ability to realize the potentiality of artistic engagement as partial and provisional, the narrative offers readers opportunities to reflect on the kind of relational engagement that its protagonist fails to achieve. We see this, for example, in depictions of Ursa engaged in moments of reciprocity and care that evoke the kind of Black feminist "love-politics" that Jennifer Nash theorizes. Rather than seeking inspiration, finding a way forward, in such encounters, Ursa favors instead heteropatriarchal ideas of leadership and progress that drive her pursuit of marriage and keep her yearning for the respect of her domineering father. In a passage that I read as an aesthetic invitation to consider an alternate ethical orientation, Marshall gestures toward a Black feminist praxis of care for the well-being of one's community. And she does so with language that is suffused with lyrical ekphrasis. In this scene, as Ursa and Viney take an evening swim at a hotel pool, Viney becomes consumed with grief over the loss of a lover. The

description invites readers to regard her body, and the emotions of the moment, as if observing a work of art: "the head remained flung back, almost touching the gutter; the eyes were wide open, and there was this river on her face."[71] As Ursa's arms circle and hold up her friend's body, the objectification associated with the act of looking at Blackness is transfigured into a practice of striving for proximity and intimacy, an expression of tenderness. The narrator continues, "Ursa held her—as much of her as she could manage—and she felt her own river. . . . She tried gently rocking Viney, she kept repeating the words that went unheard, tried comforting her friend, and it was like trying to rock and comfort herself."[72]

In a third example, the narrative shifts the focus from Primus again in order to focus on his wife, Ursa's mother, Estelle. Although society tends to treat her as little more than Primus's helpmate, as an American transplant who strongly identifies as a civil rights activist, Estelle proves equally invested as Primus and Ursa in the struggle for Black autonomy and liberation. And like Ursa, her discussions of activist struggle and resistance evoke a linear, progressive movement from enslavement to emancipation. For example, in a letter to her family in the States written earlier in her marriage, Estelle states, "And just as we're finally a-moverin' up there, the Movement! I keep telling myself that maybe, just maybe, we'll start a-moverin' down here and won't run and hide the next time the navy shows up on our doorstep."[73] After decades of living in Triunion and after bearing witness to the many political compromises her husband has made, Estelle eventually becomes disillusioned. As with Ursa in New York City, the story of Blackness is one of political stasis rather than movement and progress.

Estelle's disappointment comes to a head when she attends a reception for American manufacturers that is organized by Triunion's Planning and Development Board and that she knows represents yet another concession to the demands of the tourist industry. Finding herself limited in the ability to effect social or political change by either changing minds or shaping policy, Estelle chooses in this moment to adopt an aesthetic habit of mind as a way of registering her objections. "Suddenly interrupting the plastic manufacturer and his talk of unions, she asked him if he had every played 'Statues' as a child."[74] She then spins before freezing in a pose reminiscent of the Statue of Liberty: "stone that couldn't see, couldn't hear, couldn't feel."[75] When the political desire for movement and progress stalls, an expressive instantiation of presence steps in to fill the lacuna.

Julius Fleming's analysis on civil rights–era theater proves especially helpful for understanding the significance of this moment. Estelle's rendering

of herself into a statue resonates with Fleming's discussion of dramatic productions that countered the dominant society's expectation that Black people ought to patiently wait for change with performances of the refusal to wait. I find especially compelling his use of performance and performativity as frameworks for conceptualizing "black patience." He states:

> Whether in the barracoon or the dungeon of the slave castle, in the hold of the slave ship or atop the auction block, whether waiting for emancipation or being cautioned to "go slow" in the pursuit of full citizenship, black patience is as pivotal to transatlantic slavery and colonialism as it remains to procuring their afterlives in the wake of emancipation. And yet, black people have historically recast black patience as a tool of black political and ontological possibility. We can glean the significance of these radical rearticulations of black patience in [the sit-in protests that Fleming describes as] the choreographies of civil rights activism. . . . It is, in other words, a challenge to black patience qua black patience—a performative attempt to unsettle "the wait" in and through a radical [embodied] performance of waiting.[76]

Like the sit-in protests of the sixties, Estelle's game of statues represents an aesthetic act, an "embodied political performance" that unsettles the imperative to wait by deploying an expressive mode that allows for the assertion of her Black, female, and defiant presence.

Taken together, these passages constitute a concerted attempt to reflect on a set of relationships that the discourse on Blackness typically thinks of in binaristic terms: the relationship between art and ideology, individualism and collectivity, the personal and the political. They function as reminders that while *Daughters* encourages readers to remember and take seriously the hold that the past has on the present, it also warns against clinging too tightly to claims of and about the racialized past at the expense of foreclosing other future possibilities. This note of caution clarifies the significance of Marshall's turn to romance, a genre that engages the past while working from the assumption that acts of representation are less about historical realism and more about understanding and reinvention.

Black Presence in the Twilight Hour
Dionne Brand's thirsty

Dionne Brand's expansive body of work offers a wealth of opportunities to explore the complexities of diasporic Blackness. What I find most compelling here is the opportunity *thirsty* offers to think through its poetic instantiation of Black presence. In particular, the ways that *thirsty* instantiates Black aliveness deeply resonate with the concept of a "Black Feminist Poethics of Blackness," theorized by Denise Ferreira Da Silva as a creative-critical ethos that surpasses the knowledge claims of history and science in order to "announce a whole range of possibilities for knowing, doing, and existing."[1] To fully engage *thirsty's* poethics, a brief discussion of Brand's conceptualization of diasporic history is warranted in order to understand the ways that liminality functions as an organizing framework in the poet's thinking about history and poetry.

Given the close proximity of their publication dates, I consider the long poem *thirsty* (2002) and *A Map to the Door of No Return: Notes to Belonging* (2001), a combination of memoir, travel writing, history, and philosophy, to be companion pieces. Shared preoccupations also join these texts, for both use concepts like migration, cartography, and temporality to explore the nature of diasporic identity and belonging.[2] Experiences of dislocation and displacement figure prominently in both works as well, for as the narrator asserts in *Door of No Return*, across the Black Atlantic world, daily existence is "continually upheaved by colonial troublings. We have no ancestry except the black water and the door of no return."[3] This context informs the development of Brand's poetics, which reflect an understanding that the impossibility of forgetting or transcending the event-horizon of the Middle Passage and slavery motivates the Black woman artist to explore how Black people live with and within this irresolvable terror. An exchange between the poet and an audience member at a public lecture underscores this point. "A young Turkish man asks a question about writing: 'When you start writing because it hurts so much, do you only write about racism?' I try to tell him you don't write about racism, you write about life. It is life you must write about. It is life you must insist on."[4] For the poet to arrive at this point,

however, *Door of No Return* depicts a journey in which the narrator wrestles with carving a path from dispossession to liveness.

Another way of framing this quest is as a reckoning with the existential quandary of Blackness in the New World Diaspora: of Blackness as an onto-logical condition of "having no name to call on" and "having no past" and di-aspora as a signifier of the "end of traceable beginnings."[5] From this history, the "Door of No Return" emerges as the text's primary metaphor for Black diasporic history, geographies, and metaphysics. The term references the passageways that captured Africans were forced to cross in order to board ships that would carry them through the Middle Passage into slavery. How-ever, more than a reference to physical locations, it also points to the inner landscapes of Blackness. Brand marks its boundaries in an epilogue:

> There are maps to the Door of No Return. The physical door. They are
> well worn, gone over by cartographer after cartographer, refined from
> Ptolemy's Geographia to orbital photographs and magnetic field
> imaging satellites. But to the Door of No Return which is illuminated
> in the consciousness of Blacks in the Diaspora there are no maps.
> This door is not mere physicality. It is a spiritual location. It is also
> perhaps a psychic destination. Since leaving was never voluntary,
> return was, and still may be, an intention, however deeply buried.
> There is as it says no way in; no return.[6]

Given these layers of meaning, the narrator concludes, the journey toward understanding the diaspora requires something more than simple carto-graphic instruments. As she asserts, "it is not enough just to have a map. We need a cognitive schema as well as a practical mastery of wayfinding."[7] As I've stated previously, Brand draws on a number of narrative modes, such as his-tory, travelogue, and poetry, in the attempt to construct a schema that might help organize and structure understanding. Poetry—a genre that balances freedom (of imagination) and containment (in the structure imposed by form)—functions as the primary "way-finding instrument" for Brand.

The concluding sentences in the preceding passage allude to a second rea-son the text ultimately turns our attention to the idea of poetics. Its ending is confoundingly ambiguous. The yearning to return to the Door of No Re-turn, the symbolic origin of Black diaspora, holds out the possibility that re-covering and repairing the ruptures of history is possible. Yet that yearning is for something that is ultimately unrealizable; there is "no way in; no re-turn." This dualism gestures toward liminality of diasporic Blackness, the

idea that it manifests as a mode of being-in-suspension between oppositions like being/nonbeing, belonging/estrangement, and yearning/refusal.

These two sentences also frame diasporic history through an aesthetic sentiment: that is, as the failure to become what might have been. In so doing, it offers a reminder to readers that we belong to history, but not only to history. We inhabit multiple dimensions of time. As such, *Door of No Return*'s ruminations on the narrator's inhabitance of the twilight hour imbues its temporal liminality with heightened significance. Through much of the narrative a specific time—4:45 A.M.—recurs, slowing the progression of the narrative trajectory across diasporic history and geographies. The narrative depicts 4:45 A.M. as an interlude between sleep and wakefulness, which is to say between dreaming and sociality. When the narrator notes that her sleep is often disrupted because, while spending time with friends, "I drink too much wine," it suggests that the social world represents an intrusion on the realm of quiet,[8] the quiet that Quashie refers to in his meditation on interiority as subjectivity.

Finding herself unable to fall back asleep and having to wait for signs of daybreak, Brand seeks refuge in literature by reading works written by Eduardo Galeano, Pablo Neruda, Gabriel García Márquez, and others. In so doing, reading functions as a gateway into a different but related realm of quiet, that which encompasses the imagination of authors whom she regards as literary companions. Brand conveys this affinity in an imagined conversation or letter addressed to Galeano, an author whose works she turns to frequently:

> It is 4:45 A.M. . . . I read. Eduardo Galeano falls open at this time: "I'm nostalgic for a country which doesn't yet exist on a map." Dear Eduardo, I am not nostalgic. Belonging does not interest me. I had once thought that it did. Until I examined the underpinnings. One is misled when one looks at the sails and majesty of tall ships instead of their cargo. But if it were a country where you were my compatriot, then I would reconsider. And thinking of the things we should have to sort out."[9]

In this imagined exchange, the narrator-reader offers a Black pessimist rebuttal to Galeano's optimistic outlook. Reminding him to not let the "majesty of tall ships" obscure their cargo metaphorically signals her rejection of the idea that the past stays in the past, her refusal of the imperative to ignore the ways that history continues to haunt the present. Yet this friction is portrayed as dynamic and generative; their differences in perspective inspire

and inform the kind of readerly-writerly engagement that embodies the kind of poethical reckoning with "a whole range of possibilities for knowing, doing, and existing" that Ferreira Da Silva envisions.

Within the dreamscape of sleep and the twilight encounters with literature, Brand explores the aesthetic inhabitance of time and imagination. In many of these passages, rather than making arguments, the writer relies on figurative language and symbolism to convey the range of other possibilities. For example:

> I dreamed of Gabriel García Márquez. He needed a pen and I searched for one, giving him one, then another, then finally a fountain pen with peacock blue ink.
> Once I dreamed of Wilson Harris and a steep slate incline of mountain with a river below and the sound of strange birds.
> Once I had Neruda within sight, on a bus on a cold night in China, a cold night of old faces, a night of intentions.[10]

Each dream recalled in this passage offers at least one acute, sensory detail: peacock-blue ink, the ruggedness of steep terrain and stone, and the physical and metaphysical "coldness" of a bus ride at night in a strange land. And also through the incantatory calling of each writer's name, she invokes closeness and intimacy. The beauty of the passage lies in the completeness of each memory. It lies in the narrator's attention to sensory details, to her sensitivity to images and feelings that, no matter how small, convey something keen, vivid, and thrilling about the author-narrator and her relationship to the writers who visit her in dreams.

Yet another way that these twilight encounters with literature resonate is that beyond the insights conveyed by the author's inventive use of language and imagery, they also model other ways of being-in-relation through their meditations on her reading practice. In fact, Brand makes explicit the resemblance between her and her readers, referring to all as "inhabitants of silence."[11] This description of readers proves evocative in that it envisions an assemblage or a gathering of individuals who are bound together not by a common identity or history but rather by the shared experience of aloneness and solitude. The very same description could be ascribed to diaspora's migratory subjects, albeit not without replacing the contemplative word "solitude" with the more fraught language of "loneliness" or "estrangement." *A Map to the Door of No Return* invites the reader into a story of the Black diaspora from multiple perspectives and angles. Most prominently, it examines the history of loss and subjection that engendered the diaspora. But by the

time readers reach its final pages, another set of considerations rises to the surface: the subject of the writer's own symbolic crossing of the Door of No Return. From this vantage point, the Door of No Return refers to the process of letting history pass through the writer's body and mind, to the blurring of boundaries between self and other that enables her narration of diaspora's ruptured geographies and fractured subjectivities. It focuses attention also on Brand's striving to assemble language, images, and ideas in order to animate the voices of the literally and socially dead and tell stories of diaspora's impossible longings.

Reading *thirsty*: Thresholds between Feeling Black and Black Feeling

The experience of reading *thirsty* calls to mind one of the more beautiful and hopeful assertions in *A Map to the Door of No Return*: "I want to say that life, if we are lucky, is a collection of aesthetic experiences as it is a collection of practical experiences, which may be one and the same sometimes, and which if we are lucky we make a sense of. Making sense may be what desire is. Or, putting the senses back together."[12] This articulation of an aesthetic philosophy resonates deeply with the etymological roots of the word "aesthetics." Its Greek and Latin origins point to a double meaning as it refers to the study of that which can be sensed (*aisthêta*) and that which can be understood (*noêta*).[13] Brand's description of life as a collection of aesthetic experiences informs my reading of *thirsty* because its poetics find meaning in the sensory realm and embodiment. Stated plainly, *thirsty*'s poetic evocation of sensation conjures Black aliveness into being, and in so doing, it invites consideration of a Black aesthetic performance of presence that also implicitly responds to the dehumanizing brutality of anti-Black racism.

Brand found inspiration for *thirsty* in the 1979 killing of a Black man by the Toronto police, who shot him in his home. The subject of the poem, named Alan, is modeled after Albert Johnson, a Jamaican immigrant who was known by the police to suffer from a mental illness and was prone to preaching sermons in the city's public areas. Johnson's murder galvanized Toronto's Black community, leading to protests and demands for accountability. The police officers involved were ultimately acquitted. An eyewitness account of this event describes it as one of the first police killings of a Black person to garner national and international attention. As such, it exposed the city's anti-immigrant and anti-Black

roots, which ran counter to Toronto's reputation as an open and inviting, multicultural city.[14]

This historical injustice, much like Alan himself, appears as an absent presence throughout *thirsty*'s thirty-three sections (each of which can also stand alone as an individual poem). In the vast majority of poems, the killing has already occurred, leaving Alan to exist in memory, as a haunting and an indelible presence in the lives of those who remain. This refusal to dwell on the violence as a "scene of subjection" defends the Black body from the kinds of pornotropic violence that, Saidiya Hartman argues, "immure us to pain by virtue of their familiarity."[15] Cognizant of this risk, the poetic gaze focuses elsewhere: specifically, toward the unmappable interior geography of human sensation, emotion, and memory.

Fittingly, though inspired by an historical event, *thirsty* actually calls readers into a different temporal register through its poetic meditations on the sensory, affective, and psychological landscapes of Blackness. In the fourth poem, the speaker, an omniscient narrator, explicitly cautions against overlooking or minimizing the small occurrences that constitute a life, saying, "history doesn't enter here, life, if you call it that, / on this small street is inconsequential."[16] The implication is that within the poem's fine-grained attention to details lie a "collection of aesthetic experiences" that contain the traces of aliveness—the presence that is precisely the thing that anti-Blackness would to obliterate.

The poem's evocation of liveness is framed not in opposition to death but rather as entanglement. This inextricable connection lends an air of melancholy to the poems, especially the second (II), which introduces Alan's mother, wife, and daughter, waiting on a corner, circling the pavement, hoping "without salvation" for a trolley to carry them to another place. The poem's final stanza gestures obliquely toward their memory of Albert, that constant reminder of the precarity that defines Black life:

> This slender lacuna beguiles them,
> a man frothing a biblical lexis at Christie
> Pits, the small barren incline where his mad sermons
> cursed bewildered subway riders, his faith unstrained.[17]

These images place Alan in Christie Pits, a park where he would go to sermonize that was the site of a 1933 riot fueled by anti-Semitic and nativist sentiment. This historical allusion contextualizes Alan's 1979 killing by connecting it to an even earlier example of nativist violence, reinforcing the point that racism and nativism are deeply woven into the fabric of the city's

institutions and ideologies. In what follows, I will focus on the first poem's portrayal of Black urbanity as vivid and animate. I begin my discussion here, however, with poem II because it underscores the dialectical nature of death and aliveness, from which Blackness derives its meanings.

In "'Can You Be BLACK and Look at This?': Reading the Rodney King Video(s)," Elizabeth Alexander conceptualizes Blackness as a political assemblage that coheres around the recognition of a shared and ongoing vulnerability to historical and present-day racial violence and oppression. She asserts that "traumatized African-American viewers have been taught a sorry lesson of their continual, physical vulnerability in the United States, a lesson that helps shape how it is we understand ourselves as a 'we,' even when that 'we' is differentiated. The King beating, and the anguished court cases and insurrections that followed, reminded us that there is such a thing as 'bottom line blackness' with regard to violence, which erases differentiations and highlights race."[18] Alexander further argues that Black people need not personally witness or experience acts of racist violence to know what it means to be racially subjugated and dispossessed. As *thirsty* gradually constructs a collective portrait of Toronto's Black community, each poem underscores this assertion that anti-Blackness is text that "is carried in African-American flesh."[19] At the same time, *thirsty* also endeavors to show how, when confronted with the facticity of racial abjection and death, a poet endeavors to write about life ("It is life you must write about. It is life you must insist on"). It does so, as I've suggested previously, by decentering the ravaged Black body and displacing its symbolism as a metaphor for the *event* that inaugurated Blackness. The poetry focuses instead on conveying the feeling, breathing, kinetic vivacity of those embodied subjects.

The first lines of the first poem illustrate this idea. They resonate with the lyricism of a love poem, albeit for a place and not a person: "This city is beauty/unbreakable and amorous as eyelids."[20] The first-person narrator announces her presence—"I am as innocent as thresholds / and smashed night birds, lovesick,"—by conveying the intensity of feeling enraptured by love, particularly when the object of desire, the city, is as dangerous as it is seductive.[21] This duality is reinforced by the interplay of other oppositional images, like eyelids that are both emotionally soft (amorous) and unbreakable.

In fact, the persona that moves through the poem identifies as a city-subject whose traits resemble that of the built environment: "I am innocent as thresholds / and smashed night birds, lovesick, / as empty elevators."[22] Like Toni Morrison's narrator in *Jazz*, this speaker interacts with all the city's

inhabitants and witnesses their public and private dramas. This narrator provides continuity by running through and threading together each poem, lending a sense of cohesion to a collection that is otherwise characterized by fragmentation, fracture, and a multiplicity of perspectives, characters, settings, and stories. Even more than lending narrative continuity, the "I" that narrates *thirsty* employs framing devices and figures of speech that hearken back to the self-reflexive meditations on the challenges of narrating Blackness in *A Map to the Door of No Return*.

Just as the city's Afro-Caribbean neighborhood is portrayed as complex and multifaceted, so too is the persona who identifies with the locale and its inhabitants — not only the people but animals too. Thus, in that first stanza, the speaker compares herself not only to the built environment but also to "smashed night birds" who fly to their deaths because they are drawn to the light emanating from the windows of high-rise buildings or perhaps confuse the reflection in the glass for open sky. This image portends the fate of Toronto's Black subjects who, like the migratory birds, take flight from home in search of some idea of freedom, only to crash into unyielding structures that uphold anti-Blackness. This idea continues to resonate, including in the ninth poem(IX) when the narrator describes Alan's dispossession: "he only wanted a calming loving spot, / we all want that but the world doesn't love you."[23] Faced with the hard fact of racism at the root of Western societies, questions of dislocation, unbelonging, and dispossession remain tethered to Black city-subjects, including those who identify strongly with, perhaps even love, the places where they have settled.

The first poem's architectural references to thresholds, such as doors, windows, and elevators, gesture toward the poet's preoccupation with arrivals and departures, and most especially with the liminal spaces between *there and then* and *here and now* and, perhaps more importantly, between the virtuosity and despair that *Door of No Return* associates with the diaspora's "rupture in the quality of being."[24] Working from the presumption articulated in *Door of No Return* that the "inexplicable space" of diaspora may be "the only space of true existence," in *thirsty*, Brand writes about life by envisioning this rupture as a threshold.[25]

If we return again to the initial stanzas of the first poem (I), we see this imagining at work — for example, "This city is beauty/unbreakable and amorous as eyelids" and "let me declare doorways," statements that with their biblical cadences and omniscience claim the power of poetry to inaugurate.[26] The narrator speaks about the city as if she owns it, with a tone of mastery and control: "This city is beauty/unbreakable and amorous as eyelids."[27] The

stanza resonates with the repetition of sibilants—city, amorous, streets, pressed, fierce, innocent, and so forth. These are joined in the second stanza with a litany that introduces the recurrence of the word "in"—"standing here in eyelashes, in / invisible breasts, in the shrinking lake / in the tiny shops of untrue recollections."[28] The effect is of breath inhaled and expelled, animating the city as the drama begins to unfold. The lines hiss, buzz, and breathe, capturing the aliveness of the city. Again, the conceptual work being done in these lines lies in their performance of aliveness, which, given the characters' strong identification with the city, extends beyond the built environment to include each of its inhabitants.

Ironically, the caesura, a metrical pause in poetic verse, recurs in the first two poems; functioning much like 4:45 in *Door of No Return* as a temporal interruption. In poem I, a caesura ends the second stanza when the speaker declares (I am partly paraphrasing), in memory and life "I am held, and held."[29] In the context of this poem about city dwellers, the caesura represents an interruption in the subject's regular pace. The tenderness evoked in the image of being held signifies too as a break in history's seemingly intractable hold on the meaning of Blackness. In the second poem (II), the caesura returns as a metaphor. It is one of two occasions in the poem when the poet deploys literary idioms, figures of grammar and syntax, as symbols of Alan's transfiguration by the action of the police. In the descriptions of his "body's declension," its shape "a curved caesura" an inverted echo of the first poem. Here too the caesura signifies a break, but in this case in the "collection of aesthetic experiences" that make up Alan's life. In this case, it functions as a bleak reminder that history's hold on the meaning of Blackness can sometimes feel intractable.

Against this backdrop, Brand's poethical stance envisions language and the literary as sources of sustenance for the spiritual (more than material) deprivation to which the title, *thirsty*, alludes. Even here, in this detail, life colludes with death, gesturing toward agency and aliveness, for "thirsty" (not "thirst) places the emphasis not on what the body lacks but on what it feels and craves. Poem II ends with an image of Alan in his final moment that conveys the same idea of dualism. He is a gardener; we learn in poem VI that "The neighbors complained that he borrowed, took things, / rakes, saws, gloves, shovels, flowers, weeds—without asking / one tulip, three peonies, seven irises."[30] The lightness of this later poem has yet to announce itself. Here in poem II, the narrator describes Alan holding "clematis cirrhosa and a budding grape vine he was still / to plant when he could, saying when he

had fallen, '. . . thirsty.'"[31] These images suggest life cut short by an environment that contributes to his failure to thrive.

In this collection of poems, only a handful employ first- or second-person narration; the majority rely on the omniscient narrator's third-person perspective to offer an accounting of events (as well as of the *event* of Alan's death). This in turn shades our perception of the "I" who is both like and not like the other city-subjects with whom she identifies. For example, in the first poem, the narrator bears witness to the plight of the injured and dispossessed, from "pigeons and wrecked boys" to "inconclusive women in bruised dresses"[32] As the poem progresses, however, its tone of assurance becomes more tentative and questioning, suggesting a willingness to question the narrator's mastery of the city and its inhabitants' stories. The declarative "this city is beauty" becomes a questioning: "would I have had a different life / . . . would I know these particular facts."[33] This moment, albeit a subtle one, delineates the speaker who represents the subjects for whom she speaks.

This suggestion is amplified in the second poem, whose first stanza begins with a set of observations about sights ("the unarranged light / that hovers on a street before a city wakes"[34]) and smells ("a Sunday morning scent" and "war fumes of fuel exhaust"[35]) that suggest a bird's-eye view of the cityscape. As the second stanza continues the work of portraiture by introducing its key players, the narrator maintains her distance:

The city was empty, except for the three,
they seemed therefore poised, as when you are alone
anywhere all movement is arrested, light, dun,
 except, their hearts, scintillant as darkness.[36]

This stanza emphasizes themes such as duality, paradox, confinement, and fugitivity. The three women are both light and dun, physically arrested and spiritually free as suggested by the image of their hearts sparkling "as" darkness. Indeed, this second poem's remembrance of Alan underscores ambiguity by describing him as physically alive while at the same time alluding to his impending death with comparisons to a "lacuna," "declension," and "caesura"; words that gesture toward Alan's social alienation and psychic fragmentation by evoking notions of lack, decline, and rupture. Images of fracture move throughout each poem and resonate metatextually as well by evoking the fissures that emerge between a narrator who, while empathetic, is ultimately imbued with a measure of mobility and insight that sets her apart from the poems' main actors.

The following poem (III) works to minimize the suggestion of a break between speaker and subjects by returning to a first-person form of narration in order to draw the persona closer to the narrative's center. It also gestures toward mutual reciprocity with references to a "me" and a "you" that remain unnamed and thus may refer to a range of subjects, from the speaker to the city, its inhabitants, and the reader, all of whom are drawn into community by the poem:

> That north burnt country ran me down
> to the city, mordant as it is, the whole
> terror of nights with yourself and what
> will happen, animus, loose like that, sweeps
> you to embrace its urban meter[37]

In comparison to the tableau in the preceding poem, the speaker is now implicated, more willing to express anxiety over the possibility of being discarded or pushed away by the "exquisite rush of nothing," like others in the community depicted. The idea of being "run down," as in chased away from and worn down by a hostile environment is reinforced by the enjambment that captures the momentum and chaos of diaspora's forced dispersals. These rhetorical gestures transform the image of the speaker who now appears more vulnerable. Moreover, the shift in these lines from first-person to second-person forms of address suggests that this precarity is a condition held in common with unnamed and unknown others.

Set beside each other, the second and third poems convey a narrative reckoning with the dualities of Blackness, which tie the narrator to Alan, the three women who loved him, and diasporic Blackness more broadly. They are all shadowed by the threat of subjection, and they are also always already experiencing life in all of its aesthetic manifestations. In these ways, *thirsty* implicitly calls on readers to consider what it means to tell a wholly, and holy, story of Black embodiment. This is a question that matters not only in terms of the stories recounted and the subject portrayed. It is especially a question for the one doing the telling. The speaker's version is vexed, reflecting her ambivalence given she isn't the one who is killed, though as a Black person she is always already vulnerable to being killed. Indeed, the narrator's ambivalence finds expression in her negotiation of a series of entries and exits into Alan's story. In the ninth poem, the last two lines of the opening stanza state, "and no one so far has said a word about him / that wasn't somehow immaculate with his disaster."[38] This statement is both a self-directed

warning and indictment, since she is the one who is saying "word[s] about him." In evocative ways, *thirsty* dares to imagine the whole and complex humanity of Black subjects, even when their presence, the mark they leave in the public imagination, is measured in relation to the violence, trauma, and melancholy that have come to define Blackness.

IN A PASSAGE FROM *Door of No Return*, Brand captures the pathos of a community produced out of and joined by alienation. In a meditation on a bus ride in which she counts herself among a small group of outsiders within the larger group of riders, she considers blurred and shifting lines drawn to divide self from other. Brand and a companion find themselves on a bus in Vancouver, a city with very few Black inhabitants, in 2000. She silently notes the irony of a Black man, a "driver of lost paths," giving direction to a Salish woman who is lost in a territory that as a member of the First Nations people she ought to be able to rightfully claim as her own. Somehow these four migratory subjects—Brand, her friend, the driver, and the Salish woman—find each other in their lost-ness: "The bus is full, but there are really only four of us on it. . . . One drives through lost paths, one asks the way redundantly, one floats and looks, one looks and floats—all marvel at their ability to learn and forget the way of lost maps. We all feign ignorance at the rupture in mind and body, in place, in time. We all feel it."[39] The "we" assembled on that bus ride signifies something radically different from the racialized performances of contested citizenship that immigrant groups often enact in order to nurture the feeling of communal belonging (think, for example, of the Barbadian Association in Paule Marshall's *Brown Girl, Brownstones*).[40] Rather than sanding down the different perspectives of the four passengers, the narrative recognizes them and even intensifies those that might at first glance seem to be inconsequential ("one floats and looks, one looks and floats").

In a similar vein, *thirsty* imagines and enacts a relational ethic that aspires to understand without adopting the perspective that Glissant associates with Western thought: "that its basis is this requirement for transparency."[41] Freed from the imperative to reduce and flatten the other, the poetic rendering of Alan's stolen life offers a fractured, fractal portrait of a subject. This portrayal simultaneously holds out to and withholds from readers the possibility of understanding and acquiring knowledge about Blackness. This may represent the most ethical orientation of all.

The penultimate poem, XXXII, metaphorically evokes the sterility and homogeneity engendered by the desire to dispose of forms of bodily excess

and contain elements that defy and disturb the normative social order. The narrator states:

> Every night the waste of the city is put out and taken away
> to suburban landfills and recycling plants,
> and that is the rhythm everyone would prefer in their life,
> that the waste is taken out, that what may be useful
> be saved and the rest, most of it, the ill of it,
> buried.[42]

Bracketing these stanzas are four others: two preceding and two that follow. *These* stanzas describe the narrator's olfactory experience of the city as it ebbs and flows with scents and sensations that penetrate the body's porous boundaries. The narrator sings, "Every smell is now a possibility, a young man / passes wreathed in cologne, that is hope."[43] The images that follow urge readers to join the narrator in movement through multiplicity, to embrace the disorientation and reorientation compelled by the traversal and transgression of borders as in its closing lines:

> Sometimes the city's stink is fragrant offal,
> Sometimes it is putrid. All depends on what wakes you up.
> The angular distance of death or the elliptical of living.[44]

In this poem, the olfactory gestures toward the possibility of a different orientation when encountering difference. Rather than reinforced walls and ruthless containment, *thirsty* extends an invitation to consider openness, mutual vulnerability, and the willingness to risk engaging those marked as other/Other as well as the unacknowledged otherness dwelling within. Inherently considering the perspectives and values of another, particularly if those views contradict a subject's strongly held beliefs, can engender feelings of disorientation. Rather than viewing this dynamic as negative, Brand implies and Sara Ahmed argues directly that disorientation can be a productive part of a process of acquiring new ideas and habits of being. As Ahmed states, one must first experience disorientation before achieving the orientation that is necessary for change to happen. Or else, she asks, "How do we begin to know or to feel where we are, or even where we are going."[45] This process of reorientation can be achieved by the kind of critical reading practice that makes space for the experiences, described by the narrator of *Door of No Return*, when "books leave gestures in the body."

In *thirsty*'s final poem, XXXIII, the narrator unflinchingly embraces the terrible beauty of poetic-making: "Your fingers may flutter in the viscera of an utter stranger / I wake up to it, open as doorways, / breathless as a coming hour, and undone."[46] In these final lines, boundaries prove tenuous, shifting, porous; more like thresholds than barriers. Again, as with poem III, the reader tries and fails to distinguish between "you" and "I," who from different perspectives might refer to poet, reader, or the subject of the poem. Who experiences the harm and suffers? Who has transgressed and longs for absolution? Is it possible for the tender, fluttering fingers of an artist to draw something beautiful from the social or inner lives of the socially dead? Is it right for the artist to appropriate another person's story, to transfigure life into representation, in order to articulate a truth about the group to whom they belong? Rather than arriving at answers to these questions, Brand offers poetry and other literary forms as a threshold-like space of reckoning with the confusions, tensions, ambiguities, and ambivalences—that is, the capaciousness and complexity—of Blackness.

Swing Time
Politically Minded with an Individual Soul

The Quest for Identity and the Art of Swinging Time

An encounter involving the protagonist and her mother that takes place fairly early in Zadie Smith's 2016 novel *Swing Time* resonates with the author's delineation of the "political mind" and the "individual soul." This passage's examination of their divergent worldviews resonates because it adds context to an unnamed protagonist whose character remains opaque through much of the story. At this point in the novel, readers have learned that as a child the protagonist has befriended a girl named Tracey, who, like her, is of mixed racial heritage, loves dance, and is growing up in a housing project in a corner of London. The relevant passage takes an extended look at the narrator's mother, whose worldview is conveyed through her daughter's eyes:

> Long before it became her career my mother had a political mind: it was in her nature to think of people collectively. Even as a child I noticed it, and felt instinctively that there was something chilly and unfeeling in her ability to analyze so precisely the people she lived among: her friends, her community, her own family. We were all, at one and the same time, people she knew and loved but also objects of study, living embodiments of all she seemed to be learning up at Middlesex Poly. She held herself apart, always.[1]

Although race isn't explicitly mentioned here, the narrative has at this point established that the mother (who also goes unnamed) is of Jamaican heritage and holds a feminist socialist political outlook. These details lead readers to surmise that her history as a Black Jamaican woman raised in poverty in England has informed the development of this politically minded activist. Her shrewd analyses of systemic forms of inequality reflect her ideals—for example, when she states that "people are not poor because they've made bad choices . . . they make bad choices because they're poor."[2] The narrative spans more than three decades, from 1982 to 2008. By the end, the mother has with great struggle acquired a college degree and is eventually elected to the British Parliament. These develop-

ments suggest a life motivated by the goal of positively affecting Black and poor people collectively.

A more conventional telling of the mother's story might read her individual success as a sign of racial progress, but neither the protagonist nor the narrative chooses this approach. The overarching narrative trajectory oscillates between past and present in a nonlinear fashion, underscoring the idea that the past and present are inextricably connected and entangled. From the daughter's perspective, the mother's "political mind" may be analytically sound and socially effective, but it also betrays her failings as an individual. We see this, for example, in her description of a person who approaches her neighbors with the clinical detachment of a sociologist focused on finding solutions to the community's various pathologies. The care she expresses for the other members of her community may be intellectual and political but lacks emotional intimacy.

The narrator's judgment isn't entirely unfounded, for by the end of the narrative the mother apologizes to her for responding with judgment to another character's personal struggles with drugs and petty crime as opposed to with compassion. Even so, in this passage, the protagonist's emphasis on her mother's emotional coldness suggests that, filtered through the daughter's immature perspective, she falls short of some unspoken ideal of motherhood. In the chapter's final sentence, the narrator makes this explicit when, while reflecting on her mother's tendency to speechify, she thinks, "How could she know my mother found it impossible to speak in a natural way to children?"[3] In the end, the two eventually reconcile when the adult narrator, finally capable of seeing her mother as a complete person, acknowledges that she is simply a woman trying to make space for herself in a hostile world.

Beyond these plot points, what I find especially compelling in this passage, however, is its narrative approach to portraiture. Rather than an accurate representation of the mother, the narrator's decidedly subjective perspective paints a picture of conflicting values that essentially works to fill in an aspect of her own formless identity. Thinking back to "On Optimism and Despair" helps illuminate this point because in that essay Smith represents an *individual soul* as the exact inverse of a *political mind*. Recall Smith's description of her father as the embodiment of this personality type: "one of the least ideological people I ever met: everything that happened to him he took as a particular case, unable or unwilling to generalize from it."[4] *Swing Time* goes beyond gesturing toward the narrator's individualism through her befuddled representation of her mother; it also implicitly ties her nonideological perspective to her artistic sensibilities. We see this, for example, in the

immediately preceding chapter, which focuses on her white father's background and estrangement from his older white children from a previous relationship. As in the rest of the narrative, this chapter offers a detailed and vividly rendered character sketch of a family dynamic defined by estrangement, shame, and resentment. When as an adult the narrator revisits "the story of my ghostly siblings" with her mother, *her* response to the memories recounted reveals exasperation with her daughter's too vivid imagination. She "lit a cigarette and said: 'Trust you to add snow.'"[5] This subtle admonishment suggests a protagonist with the tendency to embellish and a healthy appreciation of the ornamental.

This mother–daughter dyad gestures toward *Swing Time*'s approach to questions of identity: the contours of the self begin to form as the subject encounters and interacts with others. Structured as a classic coming-of-age story, the novel follows two mixed-race girls, the narrator and Tracey, who meet in 1982 in a tap dance class. The story attends to the complexities of this friendship. As the story progresses, however, it becomes clear that the protagonist uses Tracey as a mirror in whose reflection she hopes to find herself. As a result, *Swing Time* centers primarily on the unnamed protagonist's journey toward self-discovery. However, rather than following the conventional *Bildungsroman* arc by narrating the characters' linear progression from innocence to experience and maturity, the protagonist's quest for identity remains unresolved at the end, and her character remains indecisive and opaque.

This refusal of linearity is reflected as well in the text's formal elements. For example, we see it in the narrative's oscillation between past and present as well as in Smith's tendency to trouble the assumptions and expectations that readers tend to carry into the experience of reading. *Swing Time* differs from Smith's earlier novels in that the narrator speaks in the first person and the details of her childhood overlap with the author's biography to a greater extent than readers have seen before. The first-person voice encourages the perception that we are reading a semi-autobiographical novel, which in turn carries the presumption that the story will contain some measure of verifiable truth. The problem with this, however, is that the narrator is in fact *exceptionally* unreliable because she suffers from identity confusion and does not know her own mind, and she does not transcend or resolve this dilemma by the end. In addition, because, as in all of Smith's novels, everything is relative and "nothing exists in the absolute," the text invites consideration from multiple perspectives—a dynamic that undermines the assumption that the protagonist is solely authorized to tell her story.[6]

These thematic and formal characteristics, along with the story's time span, establish the narrative's origins in the post-soul imagination. As such, the framework of post-soul offers a fruitful and productive way of thinking about the protagonist's ambiguity, unreliability, and instability. Not only does *Swing Time*'s protagonist constantly probe the values, ideologies, and identities that govern the people she encounters on her journeys to different locations (London, New York, and an unspecified country in West Africa), her undecidability and unreliability subtly call on readers to engage in a similar process. That is, rather than framing identity as a conflict in need of resolution, the narrative imagines its protagonist instead as a kind of "becoming-object of the work of art." As Andrew Benjamin states, "There is therefore no question of Being qua Being, there is simply the plurality of questions pertaining to the plurality of ways in which things are."[7] In essence, the text frames each individual as a One who is internally plural and whose parts rearrange and change in relation to the others they encounter.[8]

This critical framing resonates with the kind of aesthetic exploration and troubling of identity that Bertram Ashe ascribes to post-soul "blaxploration." Thus, we could say that *Swing Time*'s conceptualization of identity as an aesthetic mode of being compels recognition of the pluralism inherent to readers' efforts to interpret and understand her characters. Not unexpectedly, much of the work of internal and external inquiry in the novel is inspired by scenes of expressive performance and/or aesthetic encounter. In fact, cultural expressivity and performance play central roles in the text. As I've stated previously, the protagonist possesses an artistic sensibility and is an avid consumer of movies and Black music, her best friend Tracey becomes a professional dancer, and the narrator also works as an assistant to a pop star named Aimee. Not surprisingly, this context results in a narrative that frames its explorations of identity, pluralism, politics, and relationality as objects of open-ended aesthetic and ethical inquiry.

The question of ethics resonates with the idea of swinging time, which in the narrative functions as a metaphor for how to orient oneself toward difference and otherness. In order to grasp the logic undergirding this notion, however, understanding the musicological origins of the term is necessary. In *Blues People*, a book Amiri Baraka published as Leroi Jones, the author distinguishes between the noun "Swing music," which referred to a subgenre of jazz associated with middle-class white musicians who performed in big band ensembles, and the verb "to swing." When audiences expressed admiration for players who could swing, Baraka argues, they were celebrating the dynamism and inventiveness expressed in solo improvisations. He viewed

swing as an essential trait of Black musicianship. *Swing Time* uses this history as a springboard for thinking about freedom and relation, in particular, freedom of imagination and being. The jazz performance that Baraka heralds demonstrated Black musicians' abilities to bend time and improvise over established rhythmic grooves. As a metaphor for the social world, the inventiveness, experimentation, and innovation associated with jazz serve as models of looking for other forms and ways of being in the world beyond the normative structures of the dominant social order.

In a review of the novel, Kaitlyn Greenidge frames swinging time as a response to the Black diaspora's experience of being "shaken out of time."[9] In other words, diasporic dispersal engenders the kinds of identity conflicts and confusions that the protagonist of *Swing Time* grapples with. Greenidge's framing of swing as a performative reorientation resonates with my own understanding of the term. That is, the experience of diasporic dislocation incites a set of questions that, in my view, are fundamentally about ethics—for example, "How do we reconcile, what are the lies and myths we tell ourselves to try and reclaim our time? And when do those lies hurt us and when do they help us find our footing again."[10] Swinging time offers a template for how to begin to find answers to such questions. Greenidge states, "In [Black music and dance], Smith suggests, exists another way—a way to play with time, to move off time, to recognize all of the incongruities and historical rhythms of the last century and this strange, destabilizing new one, and to respond by turning it all into dance."[11]

Through Window of an Individual Soul

The protagonist has yet to learn the art of swinging in time. Indeed, her propensity for binaristic thinking and need to categorize people make her particularly unsuited for the dynamic and inventive performances of subjectivity and intersubjectivity that swing evokes. This fact is conveyed early in the novel in a prologue that is also the end of the narrative trajectory, for the protagonist is now an adult and has returned home to London after having been fired from her job working for the pop star Aimee. She stumbles onto a panel on film in which an Austrian movie director delivering a lecture plays a clip of the film that inspires the novel's title. Notably, the film version of *Swing Time* features a tap performance in blackface by Fred Astaire. Astaire is accompanied by three shadow figures who mimic his movements. (An echo of Baraka's discussion of Swing music as cultural appropriation resounds.) He ignores the performance's racial implications and instead invites the au-

dience to focus on "the interplay of light and dark, expressed as a kind of rhythm, over time."[12] For him, the image invites analysis of questions having to do with form and abstraction. The performance presents an occasion to think conceptually about aesthetic ideas.

When the film begins, however, the narrator focuses instead on Astaire's elegant movements and the feelings they inspire. Her financial and material concerns after having "lost my job, a certain version of my life, my privacy," feel "small and petty next to this joyful sense I had watching the dance, and following its precise rhythms in my own body."[13] From her angle of vision, the power resides in art's capacity for beauty, which transcends the trivial concerns of mundane existence. The image of her seated in the back row balcony of the Royal Festival Hall, which she describes as "a seat in the gods," augments the impression that this uncritical celebration of expressive freedom and artistic beauty keeps her divorced from reality, especially given her trafficking in bankrupt notions of universality that make it possible for Astaire's whiteness to go unmarked and his minstrel performance of Blackness to appear unremarkable.

It isn't until the narrator goes home and shares a YouTube clip of Astaire's performance with her Senegalese lover Lamin that she becomes aware of her shortsightedness and acknowledges the violence of the film's racial/racist representation. Lamin recoils in disgust at the sight of blackface. Looking at it again from his perspective, the narrator now sees "the rolling eyes, the white gloves, the Bojangles grin." Perhaps just as importantly, she experiences her blindness to racism as a kind of racial betrayal. As she closes her laptop, she remarks, "I felt very stupid."[14] This sense of culpability is only amplified when, at the end of the passage, the narrator reads an anonymous message on her cell phone that declares, "Now everyone knows who you really are."[15] Read as an allegory, the prologue alludes to the protagonist's need to continue wrestling with how to strike a balance between the personal, nonideological temperament that leads to her unthinking enjoyment of Astaire's movements and the political acuity that could have prompted her to see and grapple with (if not outright reject, as Lamin does) such racist representations of stereotypical Blackness. In other words, this encounter with art underscores and indicts the narrator for her lack of a mature perspective.

At the same time, however, I don't read the text as necessarily validating one of these interpretations over the others. While Lamin's response is politically correct, the narrator's appreciation of Astaire's uniquely elegant movements is also valid. Even the director's ruminations on "pure cinema"

offer something to consider, for his description of "the interplay of light and dark, expressed as a kind of rhythm, over time" resonates with the concept of swing and the narrative focus on intersubjectivity. Each viewer sees something different in the dance, and each perspective contains an aspect of truth. To have this perspective in this context refers to the subject's capacity to see and interpret from multiple, sometimes conflicting angles. This introduction also establishes *Swing Time*'s status as an example of Black abstractionism, which Philip Brian Harper conceptualizes as a text that demonstrates "the resolute awareness that even the most realistic representation is precisely a *representation*, and that as such it necessarily exists at a distance from the social reality it is conventionally understood to reflect."[16] Stated plainly, the prologue introduces a framework that by highlighting questions of perspective and the relationship of representation to the real shifts the focus away from the protagonist's identity development and toward the interconnected questions of how art is received, and how a subject's way of seeing informs their ways of being.

THE SHALLOWNESS OF THE narrator's perceptual depth of field represents a cautionary tale in a narrative that regularly features interactions and events that are open to interpretation, such as a recollection of a disastrous afternoon at a classmate's birthday party. This particular incident proves especially consequential because it suggests a reason for the narrator's inadequate development of a racial consciousness. Valerie Smith has argued that beginning with the slave narrative, the tradition of Black life-writing represents Black subjects reaching maturity by moving from a state of ignorance to knowledge of both the meaning of identity and their status in relation to the power elite.[17] As I've indicated, *Swing Time* never arrives at this stage of development. The description of the party suggests one reason for this by dramatizing the complexities of growing up in a milieu in which racism and other forms of inequality are simultaneously invisible and perceptible.

The narrative conveys their rising anxiety in the days following the protagonist's and Tracey's acceptance of an invitation from a schoolmate, Lily Bingham, who lives in a middle-class neighborhood: "the invitation said a trip to the cinema—but who'd pay for this ticket? The guest or the host? Did you have to take a gift? It was as if the party was taking place in some bewildering foreign land, rather than a three-minute walk away, in a house on the other side of the park."[18] Having figured out the solutions to their financial concerns, like the costs of a present and movie tickets, does little to assuage their apprehension. The fact that their mothers dress them in formalwear

from "the local charity shop" proves the least of their worries, for as the only Black girls at the party, the stigma attached to their differences in class and race stings. Interestingly, Tracey and the narrator never experience any overt racism from the others ("Lily—always gracious, always friendly, always kind"[19]). The only obviously objectionable behavior occurs when Tracey, responding with hostility to the feeling of otherness, talks loudly during the movie, steals candy, and, worst of all, uses a racial slur in passing reference to a Pakistani classmate.[20] These transgressions peak when Lily Bingham's mother catches the two friends in the act of gyrating provocatively while lip-synching to a popular song.

The retelling of these events doesn't suggest a hierarchy of offenses. Tracey is in fact rude, her casual racism shocks the group, and the sexual titillation of the dance seems to shock the narrator, who, as she recalls it years later, says, "there's no need for me to describe the dance itself. But there were things not captured by the camera."[21] From *her* mother's perspective, the racial slur disturbs more than the dancing. On their way home, "she "delivered a brief but devastating lecture on the history of racial epithets."[22]

Nevertheless, despite these facts, the narrative stresses the moral ambiguity of these events and emphasizes their emotionally devastating effects on the narrator, who says, "I remember everything about Lily Bingham's tenth birthday and have no memory whatsoever of my own."[23] Embarrassed by Lily's mother's implied criticism of her mothering ("Don't you wonder where children of this age even *pick up* such ideas?"), the protagonist's mother defends the girls vociferously, dismissing the other woman's comments as 'typical bourgeois morality.'"[24] Tracey's hostile misbehavior seems an entirely understandable response to a situation in which the world has assaulted them with ample evidence of the apparent wrongness of their being. Not only their dresses and physical appearances but also the home's bourgeois trappings, Lily's gracious manners, her mother's "civilized conversation about the merits of the movie," even the movie itself, Disney's *Jungle Book*, convey the message that Tracey, the narrator, and everyone who looks like them represent the Other to civilized society.

Taking this all into consideration, Tracey's misbehavior appears much like Estelle's game of statues in Marshall's novel *Daughters* as a statement of refusal by a subject caught within a societal order that appears utterly powerful and unmovable. That is, the same logic that informs Julius Fleming's conceptualization of "Black patience" and makes it possible to read Estelle's actions as "a performative attempt to unsettle 'the wait'" for emancipation undergirds the girls' disruptive behavior. Left with few alternatives for re-

sisting the forces of domination that structure their lives, both narratives portray Black women and girls claiming agency however possible; in the case of *Swing Time* through a disruptive performance of the type of waywardness that society has historically projected onto the bodies of otherized subjects.[25]

From the Racialized Gaze to Aesthetic Looking and Being

In many ways, this scene illustrates the need for cultivating a capacity to hold both a political mind and individual soul, for alone, neither perspective would make it possible to fully grasp the complicated nature of the characters or their cultural milieu. The narrative exploration of perspective continues elsewhere in different moments of social and/or aesthetic encounter. Each encounter extends to the narrator an opportunity to experiment with different modes and levels of attention, intimacy, reciprocity. Consider, for example, the differences between the preceding passage in which the racialized gaze provokes a performance of transgressive Blackness and an earlier passage that describes the first time that the narrator and Tracey meet: "There were many other girls present but for obvious reasons we noticed each other, the similarities and the differences, as girls will."[26] In this counterexample, the narrative depicts a mutual gaze, a study on the interplay of sameness and difference.

The narrator notes the things they hold in common: they each have a white and a Black parent, and also "our shade of brown was exactly the same." At the same time, she also takes an accounting of their differences: her mother is Black and Tracey's is white; her face "was ponderous and melancholy, with a long, serious nose," while "Tracey's face was perky and round." The narrator catalogues their features: deeming her "long, serious nose" equally as "problematic" as Tracey's, which "went straight up in the air like a little piglet."[27] On the subject of hair, Tracey "won comprehensively. She had spiral curls, they reached to her backside," while the narrator's mother "pulled my great frizz back in a single cloud."[28] This interaction alludes to an idea that is amplified in the scene at the birthday party: that the demarcation of difference is never simply a neutral act. And yet, with the exception of hair, the protagonist's descriptions remain fairly even. It is nearly, though not entirely, possible to view her remarks about their "problematic" noses as a mere observation about shape and proportion, that the image reflected as she looks at Tracey conveys vital information about who she is and is not, without assigning value. Of course, the passage offers some subtle signs that the narrator even at this young age is not entirely free from racialized lan-

guage or ideas. However, what is certain is that by leaving this interaction open to interpretation, her accumulation of details reveals itself as an attempt to develop and solidify a sense of selfhood.

In subsequent passages that describe explicit moments of aesthetic encounter, the protagonist finds herself engaged in other moments of looking and in other performances that prompt further consideration. In most of these examples, readers must hold her political naivete and/or inscrutability while at the same time following the line of inquiry into the limits and possibilities of inhabiting different modes of aesthetic being as she envisions them.

An example of this can be found in the narrator's dreams about the Cotton Club performers she idolizes, Cab Calloway and Harold and Fayard Nicholas. In those dreams, the freedom she imagines is simply a synonym for racial transcendence: "In my dream we were all elegant and none of us knew pain, we had never graced the sad pages of the history books my mother bought for me, never been called ugly or stupid, never entered theaters by the back door, drunk from separate water fountains or taken our seats at the back of any bus . . . no, in my dreams we were golden!"[29] She repeats a similarly idealized, ahistorical vision of freedom when, after viewing Michael Jackson's *Thriller* video, she thinks, "a great dancer has no time, no generation, he moves eternally through the world, so that any dancer in any age may recognize him."[30] In both examples, the narrator clings to the idea that pure art remains separate from history, politics, or ideology.

Though it may be tempting to dismiss these musings as mere foolishness when juxtaposed to other declarations of aesthetic sovereignty and/or transcendence, they become instead an opportunity to think through questions of context and ethics. For example, later in the narrative, the protagonist's description of Jackson as a dancer so talented that "any dancer in any age may recognize him" resonates in the response of her employer, the pop star Aimee, to the accusation of cultural appropriation: "Aimee looked at me and then down at her own ghost-pale pixie frame wrapped in so much vibrantly colored cloth, and told me that she was an artist, and artists have to be allowed to love things, to touch them and to use them, because art is not appropriation, that was not the aim of art—the aim of art was love."[31] For some readers, the differences in these speakers' ages, identities, and status may determine whether one statement represents an attempt to justify unethical behavior and the other an attempt to convey the sublime nature of a singular artist's talent.

In another example, the focus of the passage shifts from interpretation to an aesthetic habit in mind, from questions that frame race in terms of

looking, historical consciousness, or aesthetic sovereignty to a focus instead on art as portal to unmarked landscapes of interiority. While working for a company based on MTV, the narrator watches Whitney Houston rehearse. Though she claims not to be a fan of Houston's crossover sound, she finds herself unexpectedly transported by the sound of her voice.[32]

> I never really liked her songs—but standing in that empty concert hall, listening to her sing without backing music, with no support of any kind, I found that the sheer beauty of the voice, its monumental dose of soul, the pain implicit within it, bypassed all my conscious opinions, my critical intelligence or sense of the sentimental, or whatever it is that people are referring to when they talk about their own "good taste," going instead straight into my spine, where it convulsed a muscle and undid me. Way back by the EXIT sign I burst into tears.[33]

The long, snaking length of the first sentence in this passage conveys the image of the music as it travels past the narrator's eardrums, down her spine, and through the muscle spasms. The sound travels through more than the physical body; it bypasses the speaker's preconceived expectations, desires, and judgments as well. The miracle of this moment is that the voice's "monumental dose of soul" conveys the existential feeling of pain engendered by Black history, the very same history the protagonist spends most of her childhood trying to ward away or deny.

Ironically, Houston's solitude during a sound check makes the reciprocity of this moment possible. Freed momentarily from the pressure to sing before an audience, the performance evokes a different kind of pureness than articulated before. What Houston offers is not the purity associated with racially authentic performances nor in the sense of artistic transcendence from material concerns. Rather, her performance of genuine and unmediated self-expression, which is also simultaneously collective, is the quality that shatters and dissolves the boundary between singer and listener. This exchange represents one of the narrator's most striking relational encounters because, rather than selfishly or self-centeredly choosing what to value (like aesthetic beauty) and dismissing or judging what remains (like Black pain), she receives what the other has to offer and allows it to move her.

Like music, dance represents another embodied example of Black expressive culture that encourages ethical relation, exchange, and change. These themes recur in a section titled "Middle Passage," which focuses largely on the narrator's work with Aimee to open a school in the unnamed African

nation. During her stay in what she describes as an "incomprehensible village," she is regularly confronted with experiences that shake her belief in her own competency and usefulness:

> I was not allowed to walk into the bush, pick my own cashews, help cook any meals or wash my own clothes. It dawned on me that he saw me as a sort of child, someone to be treated with kid gloves and presented with reality by degrees. Then I realized everyone in the village thought of me that same way. Where grandmothers crouched to eat from the communal bowl . . . I was brought a plastic chair and a knife and fork, because it was assumed, correctly, that I would be too weak to assume the position. As I poured a full liter of water down the drop toilet, to flush out a cockroach that disturbed me, not one of the dozen young girls I lived with ever let me know exactly how far she'd walked that day for that liter.[34]

The narrator's ability to acknowledge the uselessness of her British background and education in this context is striking given her usual solipsism. Rather than being defensive, however, spending time in the village leads her to see things from their perspectives, and from that vantage point, she finds herself lacking in skills and purpose: "Compared to their sense of personal destiny, I looked like I was in the world by mere accident."[35] Rather than abiding by Western binaries that would organize the world according to civilization and its others, the protagonist instead is inspired to try to reorient herself in this new context, to try to determine what she needs to do to become useful.

In this section, as in the rest of the novel, music and dance function as allegories for the characters' social and subjective lives. At this particular juncture, the concept of polyrhythmic movement becomes the symbol of true relation. Jace Clayton defines polyrhythms in such a way as to underscore this allegorical reading. Polyrhythms "occur when two or more irreducibly distinct rhythmic points of view (points of hear?) coexist within a single song."[36] He continues, "this plurality of understandings is part of what makes them so stubbornly human."[37] Moreover, compared to digital music, Clayton argues that polyrhythms are inherently human-scaled because they can "handle paradox or ambiguity. . . . Polyrhythms spring from an understanding of music, if not life itself, as shifting relationships of patterns, each with its own internal logic and timing."[38] The resonance with my earlier discussion of swinging time should be clear.

The protagonist's description of the greatest dancer she has ever seen echoes Clayton's summation. To her eyes, "the kankurang" is a revelation.

She says, "But in the moment I didn't know who or what it was: a wildly swaying orange shape, of a man's height but without a man's face, covered in many swishing, overlapping leaves. A large gang of boys trailed behind it in the red dust, and a phalanx of women, with palm leaves in their hands— their mothers, I assumed. The women sang and stepped heavily, beating the air with the palms, walking and dancing both."[39] The polyphony of movements and rhythms emanates from the dancer's swaying steps, the swishing leaves, the women clapping and singing, and even the footsteps that fall lightly and heavily, "walking and dancing both." They model for the narrator an improvisational adaptability that will serve her as she continues the journey toward self-realization. These same lessons exist in jazz as well, a genre of music that she knew and loved as a child but lacked the maturity to understand. Sometimes, Sara Ahmed reminds us, one must experience the unsettling effects of displacement and acquire a migrant's perspective in order to experience the disorientation and reorientation that can engender new ideas and insights about how to be in the world. Stated metaphorically in musical terms, sometimes a person has to surrender to new and unfamiliar rhythms in order to understand that bending time and inventing new grooves are possible and attainable.

THESE INSIGHTS SUFFUSE the final pages of the novel, which present the narrator in an anticipatory moment of reunification with Tracey. An inverse of the prologue, it is an ending that also gestures toward new beginnings. Finding herself caught in a state of temporal suspension between the past and an undefined future, the protagonist surrenders to the vibrancy and immediacy of this moment. By this point, the two now-estranged friends have followed strikingly divergent trajectories. While the narrator has pursued her professional goals in the music business, Tracey's career as a dancer eventually stalled due to drug use, sexual abuse, and single motherhood. After having fallen out of touch in high school, the two have only seen each other intermittently, and after a perceived slight, Tracey subjects the narrator and her mother to years of harassment. In other words, the connection they had, which was based largely on their similarities, has soured into a bond based on mutual loathing. Nonetheless, despite this mutual alienation, the pair remain spiritually bound to each other.

By the novel's conclusion, the protagonist has learned something about human complexity. Moreover, by virtue of multiple aesthetic encounters and experiments in being, she has acquired the skill to swing time. As a result, she approaches Tracey's flat with an understanding of a subject's totality and

the maturity to not try to reduce Tracey to a categorizable and easily comprehensible idea (like single mother or former addict). Smith frames this as a capacity to know "that individual citizens are internally plural: they have within them the full range of behavioral possibilities."[40] Imbued with this aptitude, the narrator approaches, and as she looks toward the flat, rather than seeking a reflection of herself, she looks on instead without expectation or prejudgment:

> Tracey's tower came into view, above the horse chestnuts, and with it reality. . . . I almost turned back, like someone who has woken abruptly from a sleepwalk, except of an idea, new to me, that there might be something else I could offer, something simpler, more honest, between my mother's idea of salvation and nothing at all. . . . I was about to enter the stairwell when I heard music, stopped and looked up. She was right above me, on her balcony, in a dressing gown and slippers, her hands in the air, turning, turning, her children around, her, everybody dancing.[41]

This ecstatic image of Tracey and her children moving in unison represents the kind of aesthetic event that Dionne Brand envisions as constituting diasporic Black life. And in that event, the narrator spies a glimpse of future possibility. In fact, she has no idea if Tracey will invite her to join the dance and every reason to believe that she will be rejected. Nonetheless, this image conveys hope because the narrator has experienced self-transformation. Earlier, her mother asks the narrator to adopt Tracey's children because they have been neglected. Now, she decides, "that there might be something else I could offer, something simpler, more honest, between my mother's idea of salvation and nothing at all." The open-ended nature of this overture resounds as an offering of grace in that it expresses an intention to enter into Relation with a subject who embodies otherness. In other words, the narrator's readiness to lend Tracey a hand carries neither expectation nor preconception; only openness to the potentiality of the encounter. Paraphrasing Paul Taylor's definition of the post-ness of post-soul, we might think of this gesture as a nascent condition that has yet to establish a name. And in this particular way, Smith's depiction of the unfinished migrations of a protagonist who finds herself always already suspended between *Black feeling* and *feeling Black* wonderfully convey the complexities of being Black and its multiple and ever-changing feelings and meanings.

Notes

Introduction

1. Ahmed, *Queer Phenomenology*.

2. Taylor, *Black Is Beautiful*, 12.

3. In the study of Black life, Alexander Weheliye locates potentiality within the "breaks, crevices, movements, languages, and such found in the zones between the flesh [that existed before racial assemblages] and the law." Weheliye, *Habeas Viscus*, 11.

4. "Essayism is tentative and hypothetical, and yet it is also a habit of thinking, writing and living that has definite boundaries. It is this combination that I am drawn to in essays and essayists: the sense of a genre suspended between its impulses to hazard or adventure and to achieved form, aesthetic integrity." Dillon, *Essayism*, 22.

5. According to Henderson, mascon images resonate with Black readers specifically while remaining impenetrable to whites who seek understanding of Black experiences. I will, especially in chapter 2, make a different kind of argument about the imaginative possibilities in reading that rely on less rigid understandings of racial community and affiliation. That said, Henderson's conceptualization of reading as exchange of experiential energy captures something of the world-making and remaking capacities of imagination that I aim to highlight in this book. Cook and Henderson, *The Militant Black Writer in Africa and the United States*.

6. I'm indebted to Margo Crawford's brilliant articulation of African American literary tradition as something that exists "outside of historical determinism and inside black improvisation." Crawford, *What Is African American Literature?*, 4. That said, my emphasis on the simultaneity of historical thinking and aesthetic mindedness in Marshall's and Brand's narratives focuses instead on the ways that Black literature not only depicts but also embodies some of the dualities, contradictions, ambiguities, and ambivalence associated with the condition of Black being.

7. Here, my thinking is informed by Hortense Spillers, who draws on the writings of Louis Althusser to caution Black Studies scholars of the need to remain attentive to the differences between Blackness as the "real object" and the "cognitive object of knowledge." Spillers, "The Crisis of the Negro Intellectual," 80–81.

Chapter One

1. The name "Stromae" plays on the word "maestro" and is itself an example of verlan, a form of linguistic wordplay specific to urban youth culture in France and Belgium.

2. Before Stromae released the music video for "Formidable" on May 27, online commentators eagerly speculated about the implications of his behavior. See, for example,

A.D., "Bruxelles: Stromae Saoul à 8h du matin à l'arrêt Louise"; Concetta C., "Stromae Bourré à Bruxelles!"; MegaADRISANCHEZ, "Stromae Bourré à Bruxelles! 2/2."

3. Stromae, "Formidable."

4. DeClue, *Visitation*.

5. Heidegger, *Being and Time*, 32.

6. Carman, "Foreword," xiii–xxi.

7. Best, *None Like Us*, 2.

8. Best, *None Like Us*, 2.

9. In a discussion of Kobena Mercer's influential treatise on Black cultural studies, *Welcome to the Jungle*, Nyong'o leans on Mercer's reframing of debates around the tensions between the desire for aesthetic sovereignty and assertions that Black artists have a moral and political obligation to speak on behalf of the racial collective. He states, "Mercer's analysis of the 'political economy of racial representation' is often evoked as establishing the right of individual artists, qua artists, to express themselves without fear of being taken as a representative of a community. And indeed, his critique clearly aimed at unburdening black representation, a process that for him involved resituating the artist from community delegate in the bourgeois public sphere to activist *intervening in a contested and agonistic social topography*." Nyong'o, "Unburdening Representation," 73. Framing Black artistic production in this way, Nyong'o notes, frees discussions of aesthetic sovereignty from conflations with present-day arguments for a post-racial ideology that "seeks to deny, on idealist and individualist grounds, any link between 'speaking for' and 'speaking as.'" Nyong'o, "Unburdening Representation," 73. By disavowing the bankrupt politics and tenuous ethics of rigid notions of racial representation, these critics strive to clear space — art historian Darby English specifies "black representational space" — to allow for the inclusion of a wider and more diverse range of artists, perspectives, and expressive forms; including Stromae, whose oeuvre certainly evinces an active engagement with complicated, often vexed, social geographies. English, *How to See a Work of Art in Total Darkness*; Mercer, *Welcome to the Jungle*; Nyong'o, "Unburdening Representation."

10. Nyong'o, "Unburdening Representation," 74–75, my emphasis.

11. For a fuller treatment of this topic, see Paula Massood's *Black City Cinema*. Massood traces the role of cinema in the development of notions of racial pathology. Although her analysis focuses on African American culture, its relevance extends beyond the borders of the United States. For a discussion of the dehumanizing effects of European policies toward migrants, see Christina Sharpe's *In the Wake*.

12. This is in stark contrast to the video for "Alor On Danse," which is set in a neighborhood pub and juxtaposes images of post-industrial malaise with others of working-class solidarity, and the video for "Ave Cesaria," which imagines an extended family celebrating in a community center or the basement auditorium of a school or church.

13. As I articulate this idea, Fred Moten's theorization of Black fugitive sound resonates even as I focus more on the possibility, rather than impossibility, of relational Blackness. For Moten, the nonverbal nature of sonic utterances, like the proverbial screams of Frederick Douglass's Aunt Hester while being abused, represents a fugitive spirit that resists and exceeds the totalizing forces of racial domination. Where I think Moten and I meet is in our conceptualization of the Black aesthetic as a location

for the manifestations of forms of Blackness that are otherwise illegible or invisible to the dominant social order. Moten, *In the Break.*

14. Best, *None Like Us*, 2. While they take strikingly different approaches to the study of alienation and historical Blackness, Stephen Best and Saidiya Hartman offer some of the most compelling and generative discussions about the subjective and affective manifestations of what Hartman calls "the afterlives of slavery." Hartman, *Lose Your Mother.*

15. Intertextually, "Formidable" reveals a promiscuous openness and receptivity to a diverse set of influences in works that also take up the themes of dislocation and dispossession. For example, one of its likely inspirations could be the work of the avant-garde Belgian filmmaker Chantal Akerman. In her 1977 avant-garde film *News from Home*, Akerman juxtaposes a voiceover of herself reading letters from her mother with moving images of New York's cityscape. Like "Formidable," *News from Home* meditates on urban alienation and personal disconnection through visual and thematic experimentations with time, space, and distance. The range of musical and visual intertexts that resonate with "Formidable" extends beyond obvious Belgian influences like Akerman (or, in terms of music, the singer Jacques Brel). For example, like Stromae and Akerman, the African American conceptual artist Dave McKenzie uses signifiers of city life to explore questions of estrangement and unbelonging in a film installation titled *Edward and Me* (2000). Stromae and McKenzie overlap in that both deploy the expressive capacities of the artist's body to explore these themes. In McKenzie's case, his performance of a series of frenetic dance movements in front of the electric glow of lights in a grocery store entryway evokes the tensions between containment and freedom of the Black male body in the public sphere. In comparison to the two Black artists who use their physical bodies as sites of aesthetic encounter, Akerman conveys her presence in *News from Home* solely through the sound of her disembodied voice reading letters written to her mother in Belgium. Akerman's placement of the camera in densely populated transit locations in New York, like Times Square and the subway, gestures toward the urban phenomena of anonymity and impermanence to underscore migratory feelings of loneliness and estrangement. For more insight on Akerman's body of work, see Michelle Orange's review of Akerman's *No Home Movie* (2015): Orange, "Femme Verité: The Films of Chantal Akerman."

16. Ahmed, *Queer Phenomenology.*

17. While it would be foolish to equate the voyeurism of celebrity culture with the epistemological violence encoded in the racialized gaze, "Formidable" is composed in such a way as to resist prioritizing one theme over another.

18. Stromae claims that duality is the essence of human experience: "And it's not just about saying that everything's going badly, because that's not what I say in my songs. But it's not about saying everything's fine, either. It's life." Sayare, "Stromae: Disillusion, with a Dance Beat."

19. Mercer views the decades beginning in the 1980s as an era in which theories of hybridity displaced modernity's "Euclidian geometry," along with the West's reification of racial, hemispheric and other binaries. Mercer, *Travel and See*, 14–18.

20. Critics regularly note the influence of the Belgian singer/songwriter Jacques Brel on Stromae. Brel's theatrical performance style was tremendously popular in the 1950s, 1960s, and 1970s.

21. The hybridity that Stromae embodies reaches beyond the racial and cultural to include gender as well. In the video "Tous Les Mêmes" ("All the Same"), he literalizes his typical androgynous style by dressing in bifurcated clothing, makeup, and hair in order to perform a gender binary that the song satirizes. Onstage, he performed this fluidity exclusively through gesture and movement as he danced a solitary tango while shifting between traditionally male and female parts. In this way, Stromae's performances exemplify what Francesca Royster describes as "eccentric" Blackness, which she views as a defining aspect of Post-Soul and its "landscape of shifting racial, gender, and sexual identity." Royster, *Sounding Like a No-No*, 5.

22. Sayare, "Stromae."

23. In 2014, Stromae wrote and performed "Ta Fête," Belgium's official anthem for the World Cup tournament held in Brazil. The video featured the performer cavorting with team members who themselves embodied the nation's diversity. Players claimed ancestry from a range of places, including the Democratic Republic of the Congo, Martinique, Mali, Morocco, and Croatia. Of course, this national celebration of multiculturalism concealed a dark underbelly when used to mask Europeans' antipathy toward asylum seekers and other non-European migrants.

24. Author Chika Unigwe describes Belgian nationalism as a pervasive yet unevenly applied phenomenon. White-appearing immigrants assimilate within a single generation simply by achieving fluency in the language and adopting a Belgian-sounding name. Yet these avenues toward cultural assimilation are denied the nation's Black and Brown immigrants, who are assumed to never have the capacity to assimilate. In another article, "How Belgium Became Home to Recent Terror Plots," journalists investigate the structural inequities—like the segregation and policing of immigrants in neglected sections of the capital city, such as the Molenbeek neighborhood—that led to deep-seated feelings of alienation and resentment among first-generation children of immigrants. Unigwe, "The Near-Impossibility of Assimilation in Belgium"; Stack and Karasz, "How Belgium Became Home to Recent Terror Plots."

25. Mercer, *Travel and See*, 3.

26. The title's neologism, a play on the phrase "father, where are you" (papa, ou t'es), signals the song's inspiration: the disconnect from his father. Stromae's mother raised him and his siblings alone because his father, Pierre Rutare, returned to Rwanda to work as an architect after completing his education in Belgium. He was killed during the 1994 genocide against the Tutsi. Kalimba, "Tracing Stromae's Rwandan Roots."

27. Hartman, *Lose Your Mother*.

28. Hartman, *Lose Your Mother*, 32.

29. Bailey, *Writing the Black Diasporic City in the Age of Globalization*; Dubey, *Signs and Cities: Black Literary Postmodernism*; Griffin, *Who Set You Flowin'*; Hartman, *Wayward Lives, Beautiful Experiments*; Murdoch, *Creolizing the Metropole*. See also De Souza and Murdoch, *Metropolitan Mosaics and Melting-Pots*.

30. In a disciplinary move that echoes Black Studies' turn to a more pessimistic approach to Critical Race Studies, some of Bourriaud's critics in the field of art history take him to task for downplaying the Eurocentric and colonialist practices and perspectives embedded within elite art institutions. Some, for example, focus on the

gatekeeping and exclusionary practices of the art market and elite art institutions that undermine Bourriaud's idealization of contact and exchange. To cite one frequently referenced example, Bourriaud regularly pointed to a 1990 installation by the conceptual artist Rikrit Tiravanija, in which the artist cooked rice and Thai curry for visitors of the Paula Allen Gallery to eat together. Skeptics view this as an example of a practice that fails to subvert Western traditions of uncritical consumption and appropriation of the exotic other. Nevertheless, when recently asked to speak about his ambitions for this particular installation, Tiravanija elaborated on the aspects he viewed as forms of postcolonial critique (e.g., the anti-essentialism at the basis of his emphasis on the diversity of cultural and artistic influences that informed his choices of recipe and cooking instruments and the hope that preparing and consuming a meal could contribute to the disruption of Western exhibition conventions that relied on "isolating objects from other cultures, of putting them in boxes in museums and studying them outside of their context"). Newell-Hanson, "Rirkrit Tiravanija's Pad Thai Is Both a Meal and an Artwork"; Bourriaud, *Relational Aesthetics*; Bishop, "Art of the Encounter."

31. According to Delaney, "exploring the story means engaging with possibility and resisting a complacent and fixed understanding of the work where meaning becomes managed." Delaney, "Other Lessons Learned from Relational Aesthetics."

32. For example, I see great resonance in Glissant's description of the Caribbean as a "place of passage that opens out onto diversity" and Stromae's depiction of the Belgian metropole. Glissant, "Creolization in the Making of the Americas." In making this connection, I am gesturing toward those scholars, including Glissant, who consider Relation a concept born of a Caribbean phenomenon that possesses global resonance. For a more comprehensive discussion of creolization, see Murdoch, "Édouard Glissant's Creolized World Vision," and Lionnet and Shih, *The Creolization of Theory*.

33. For a fuller discussion of *tout-monde* (the entirety of the world), *echos-monde* (the world of interdependence and resonance), and *chaos-monde* (the world that refuses to be ordered and systematized), see Glissant, "Dictate and Decree," *Poetics of Relation*. Together, these concepts convey Glissant's articulation of an aesthetic realm, or poetics, that exists beyond the limits of the political orde while simultaneously within reach of individuals who are trapped and marginalized within the hegemon.

34. Glissant captures this mindset in the statement: "In order to understand and thus accept you, I have to measure your solidity with the ideal scale providing me with grounds to make comparisons and, perhaps, judgments." Glissant, *Poetics of Relation*, 190.

35. Glissant, *Poetics of Relation*, 190, my emphasis.

36. Murdoch, "Édouard Glissant's Creolized World Vision," 885.

37. Glissant, *Poetics of Relation*, 154, my emphasis.

38. Denise Ferreira Da Silva refers to "poethics" to describe this creative-theoretical endeavor, which she views as an evolving process, a praxis that resonates in some ways with my own articulation of aesthetic encounter. To Da Silva, "the articulation of a theory is a gathering place, sometimes a point of rest as the process rushes on, insisting that you follow." Ferreira Da Silva, "Toward a Black Feminist Poethics."

39. Cailler, "Totality and Infinity."

40. Daphne Brooks's delineation of an "afro-sonic feminist praxis" offers one model, centered on the study of Black music, that enacts Glissant's poetics of relation. For Brooks, the content and form of the Black female singing voice "tells tales" and "relays the message." Discerning that message calls for critical listeners to focus on what Glissant might characterize as the sonic "textures of the weave," which means heeding the tonal registers and cadences of a singer's voice; paying attention to the said and unsaid; and noticing the disruption of normative ideas of meaning, communication, and musical structure made possible by the elision of sound and language. Brooks, "Afro-Sonic Feminist Praxis." Within the polyphonies and polyvocality of Black female sounding, Brooks discerns forms of "excess and excessive presence" that hearken back to Fred Moten's theorization of "chromatic saturation," which Brooks summarizes as a metaphor for "the theoretical coexistence of all possible notes that can be played." (See also Moten, "Chromatic Saturation," *The Universal Machine*, 154–157.) Whether implicitly and explicitly, both critics strive for musical/sonic idioms capable of animating the capaciousness of Blackness, which Glissant conceptualizes as a totality.

41. Sexton, "The Social Life of Social Death," my emphasis.

42. Campt, *Listening to Images*, 3.

43. Campt, *Listening to Images*, 6.

44. Sharpe, *In the Wake*, 120.

45. Rather than viewing the epistemological violence of the racialized gaze as cause for the disavowal of the act of looking, Sharpe articulates a critical practice of looking that relies on "registers of Black annotation and Black redaction" to refuse the systems that reduce Black people to objects of pity or contempt. Sharpe, *In the Wake*, 116. Annotation refers to additions to the historical archive that in time result in an accumulation of Black stories of racial injury to be appended to "the archives of the present." Sharpe, *In the Wake*, 82. Redaction refers to the excision or erasure of dehumanizing elements of images to allow for closer and more careful scrutiny of the human that "Blackness" as a discursive category is meant to erase. For a fuller discussion of Black annotation and redaction, see Sharpe, *In the Wake*, 113–120.

46. Sharpe, *In the Wake*, 116.

47. "Stromae's Lyrics 'Show a Different Vision of the World.'"

48. Quashie, *Black Aliveness, or a Poetics of Being*.

49. The literal translation of "minable" is "seedy" or "squalid," which capture the effect of Stromae's shabby appearance in the video. I prefer "pathetic," however, because it also captures the speaker's sense of emotional disarray.

50. Cailler acknowledges the utopian bent to Glissant's and Levinas's theories of relation, especially given the historical awareness of the kinds of brutality inflicted on entire categories of people (e.g., the enslavement of Africans, the Holocaust, genocidal campaigns against American Indians and in Rwanda, etc.). In the face of all this, there's a sense of inadequacy to the notion "that peace, not war, comes first; that to see the face of the Other is to answer to him, and to answer for him, rather than to kill him." Cailler, "Totality and Infinity," 146. Nevertheless, Cailler reminds us, "Both would be the first to argue that utopia is necessary" in that the development of new imaginaries is critical if we are to diminish or dismantle 2000 years of violence. Cailler, "Totality and Infinity," 146.

51. In this way, my analysis resonates with that of Royster, who, in her exploration of post-soul "eccentricity," emphasizes the concept's openness to the generative possibilities of differences within "blackness." Royster states, "While some cultural critics see Post-Soul as an aesthetic reflecting a loss of political ground, cultural authenticity, and overall discombobulation, my book instead sees powerful possibility in the very experience of racial unmooring, particularly as it opens up gender and sexuality." Royster, *Sounding Like a No-No*, 6.

52. The openness to the potentiality of encounter in "Formidable" suggests a condition of Black being whose version of "thrownness" moves beyond Heidegger's articulation of being-thrown-into-the-world. Rather than envisioning relationality in terms of a forward propulsion of a subject moving in sync with the linearity of historical time, the text offers instead an improvisational, layered, and intersubjective performance of selfhood in a subject enmeshed within multiple, overlapping temporalities.

Chapter Two

1. Smith, *Ordinary Light*, 3.

2. Morrison, "Invisible Ink," *The Source of Self-Regard*, 348.

3. Smith has published four books of poetry and won the Pulitzer Prize in 2011 for the collection *Life on Mars*. She served as the 22nd Poet Laureate from 2017 to 2019.

4. In the nineteenth century, a narrator like Frederick Douglass represented the fight for individual and collective emancipation as a reckoning with and resistance to the abjection and subjection associated with the category of "slave." In the context of slavery, narrators "affirm and legitimize their psychological autonomy by telling the stories of their own lives." Smith, *Self-Discovery and Authority in Afro-American Narrative*, 2.

5. The urge toward the conventions of Black storytelling is hard to resist, for the expectation that narratives should dwell on racialized forms of struggle and/or resistance in order to be deemed racially authentic exerts a strong gravitational pull. I have experienced this myself. For example, in another essay on *Ordinary Light*, this one focused on the post-soul aesthetic and the representation of a racial consciousness reflective of the particular ambivalences and contradictions of the contemporary moment, I found myself wrestling (and failing) to incorporate passages that felt too digressive from the thesis. I have returned to Smith's narrative because I find myself thinking about how digression represents a refusal, another indication of post-soul ambivalence, of the expectation that the individual's story must represent (speak for) collective experiences of Blackness. Lamothe, "On the Threshold of Change."

6. Citing the examples of Virginia Woolf and William Faulkner, whose uses of narrative "gaps" and "delays" model how to lead a reader "to operate within the text," Morrison describes her own narrative strategy: "I admit to this deliberate deployment in almost all of my own books. Overt demands that the reader not just participate in the narrative, but specifically to help write it. Sometimes with a question. Who dies at the end of *Song of Solomon* and does it matter? Sometimes with a calculated

withholding of gender. Who is the opening speaker in *Love*? Is it a woman or a man who says, 'Women spread their legs wide open and I hum'? Or in *Jazz* is it a man or woman who declares, 'I love this city'? For the not right reader such strategies are annoying, like a withholding of butter from toast. For others it is a gate partially open and begging for entrance." Morrison, "Invisible Ink," *The Source of Self-Regard*, 349.

7. Morrison, "Invisible Ink," *The Source of Self-Regard*, 350.

8. I borrow the phrase "post-movement" from Derik Smith because it captures the geographical span of the sea changes in law, politics, and social life that Black activist struggle across the diaspora achieved. Smith, *Robert Hayden in Verse*.

9. Glissant, *Poetics of Relation*.

10. Benjamin, "Interpreting Reflections," 37.

11. Benjamin, "Interpreting Reflections," 60.

12. Benjamin, "Interpreting Reflections," 42.

13. Benjamin, "Interpreting Reflections," 40.

14. Following the tradition of philosopher-theorists, from Aristotle to Jacques Derrida and Hortense Spillers, my references to Black presence gesture toward different modes of being—not the singularity of Being but rather beings whose selfhood is mediated and constituted by language, representation, and image. Aristotle, "Poetics," *Introduction to Aristotle*; Derrida, *Of Grammatology*; Spillers, "Mama's Baby, Papa's Maybe: An American Grammar Book."

15. Smith, *Ordinary Light*, 5.

16. Smith, *Ordinary Light*, 5.

17. Crowley, *Blackpentacostal Breath*, 33.

18. Quashie, *Black Aliveness, or a Poetics of Being*, 1–2.

19. Smith, *Ordinary Light*, 3.

20. Sharpe, *In the Wake*, 14.

21. Du Bois famously insisted that "all art is propaganda." Du Bois, "The Criteria for Negro Art."

22. In "The Negro Artist and the Racial Mountain," Hughes describes the "urge toward whiteness" and disregard for their "racial individuality" as "the mountain standing of any true Negro art in America." Hughes, "The Negro Artist and the Racial Mountain," 305. Several decades later, Larry Neal echoed these thoughts by advocating for a cultural revolution that would counter a decrepit Western aesthetic by speaking directly to Black people rather than appealing to white morality as well as by making use of the "most useable elements of Third World Culture." Neal, "The Black Arts Movement," 2039–2040.

23. While the artist-activists of the sixties and seventies emphatically rejected the New Negroes' bourgeois politics of respectability, they continued to view Blackness and anti-Blackness as forces that inherently yoke the aesthetic to the political. For example, in his 1968 manifesto "Towards a Black Aesthetic," Hoyt Fuller describes the aesthetic as "new and more effective means and methods of seizing power." Fuller, "Towards a New Black Aesthetic." These words suggest that, like Du Bois, he viewed the purpose of aesthetic production as inspiring the kind of transformation in consciousness that could ideally lead to political change. Similarly, Larry Neal echoes Hughes's arguments when he argues for a cultural revolution that would counter a

decrepit Western aesthetic by speaking directly to Black people rather than appealing to white morality as well as by making use of the "most useable elements of Third World Culture." Neal, "The Black Arts Movement," 2039–2040.

24. Crawford, *Black Post-Blackness*.

25. In "Crisis of the Negro Intellectual: A Post-Date," Hortense Spillers identifies not anti-Blackness but intra-racial divisions as the source of anxiety that fuels the perpetuation of monolithic and romanticized notions of Blackness: "Within this maelstrom of forces, the black, upwardly mobile, well-educated subject has not only 'fled' the old neighborhood (in some cases, the old neighborhood isn't even there anymore!) but, just as importantly, has been *dispersed* across the social terrain to unwonted sites of work and calling. From my point of view, this marks the *ace* development that today's Black creative intellectual neither grasps in its awful sufficiency nor wants to bear up under inasmuch as he/she is sorely implicated in its stark ramifications. (We chase, instead, after fantastic notions, quite an easier pastime than looking at what has happened to community.)" Spillers, "Crisis of the Negro Intellectual," 72, 73.

26. Cheng, "Psychoanalysis without Symptoms," 87.

27. Drawing on the insights afforded by psychoanalysis, this framing of the practice of interpretation begins with the understanding that the goal is not to achieve happiness but rather to learn how to "live with one's symptoms," which in the case of New World Blackness are unresolvable. Cheng states, "I say 'gift' because our contemporary culture is all about dispelling or denying discomfort, and political comfort means the reassurance of piety and solution. These works refuse to redeem the continued existence of racism and other forms of violent discrimination. They give us not the fact of discrimination, but its unruly etiology and the education of desire that it has instilled in both the dominant and minority subject. It is in those very moments when the boundaries of the subject and object of power are most jeopardized and most undetermined that we can truly begin to ask ethical questions." Cheng, "Psychoanalysis without Symptoms," 93, 95.

28. Quashie, *Black Aliveness, or a Poetics of Being*, 1, my emphasis. "What I want is the freeness of a black world where blackness can be of being, where there is no argument to be made, where there is no speaking to or against an audience because we are all the audience there is . . . and, as such, the text's work can manifest an invitation to study and to becoming for the black one." Quashie, *Black Aliveness, or a Poetics of Being*, 10.

29. Each of these formulations including my own envisioning of a methodology for reading *and* writing that approximates what Brent Edwards calls "*a queer practice of the archive*: an approach to the material preservation of the past that deliberately aims to retain what is elusive, what is hard to pin down, what can't quite be explained or filed away according to the usual categories." Edwards, "The Taste of the Archive," 970.

30. In many ways Spillers's enjoinder has been met by scholars of the post-soul aesthetic like Bertram Ashe, Mark Anthony Neale, and Francesca Royster, who actively grapple with the changing contexts of the post–civil rights period and the kind of societal changes that have resulted in the subjective and collective fragmentation of racial collectivity (that monomyth of community). The insights afforded by these theorists of the post-soul aesthetic help to contextualize the emergence of "difference" and "multiplicity" as defining features of contemporary representations of

Blackness. Ashe, "Theorizing the Post-Soul Aesthetic"; Mark Anthony Neale, *Soul Babies*; Francesca Royster, *Sounding Like a No-No*.

31. Similarly, Quashie's articulation of interiority gestures toward the irreduciblity of the subject. The "quality of being inward," he suggests, "gestures away from the caricatures of racial subjectivity . . . and it suggests what is essentially and indescribably human." Quashie, *The Sovereignty of Quiet*, 21.

32. For a fuller discussion of the ways that temporality shapes critics' engagement of African American literature and literary canon, see Ada Levy-Hussen, who offers a cogent and incisive analysis of a debate she characterizes as an opposition between *wasness* and *is-ness*. The debate that emerges is a result of Kenneth W. Warren's publication of *What Was African American Literature?*, in which he marks the civil rights era as the end of a literary tradition that emerged in response to the constraints and political urgencies of slavery and Jim Crow racism. Inspired by Aldon Lynn Nielson's critique of Warren in the *Los Angeles Review of Books*, Levy-Hussen focuses on Warren's rhetorical uses of "wasness" to object to "the pervasive, misguided desire of African American writers and critics to dissolve the fact of historical distance." Levy-Hussen, *How to Read African American Literature*, 17. Levy-Hussen cites Warren's objection in *What Was* to present-day actors who strive to cast themselves "'in the role of potential hero, or even freedom fighter, on behalf of a past that almost magically becomes our contemporary in terms of what it needs or demands from us.'" Levy-Hussen, *How to Read African American Literature*, 17–18. In much of the emerging scholarship on historical determinism in contemporary Black Studies discourse, Warren's polemic operates as a touchstone in that it represents the most explicit rejection of historicity as a frame of analysis. Though Warren's argument is admittedly flawed in that it overstates the amount of racial progress that has been achieved since the sixties, there is value in thinking about his insistence on distinguishing the Black present from the past because it gestures toward the literature as becoming-objects of interpretation, which in turn underscores the modes of Black being and becoming represented in Black texts. Nielson, "Wasness, Review of *What Was African American Literature?* by Kenneth W. Warren"; Warren, *What Was African American Literature?*

33. Locke cited in Crawford, *What Is African American Literature?*

34. Crawford conceptualizes literary tradition as an "archive of feelings," a record of "uncontainable black affect" that exists in tension with the rigidity of historical frameworks. To paraphrase Stephen Best, historical determinism posits that the past represents "an unassailable truth that the slave past provides a ready prism for apprehending the black political present." Best, *None Like Us*, 2. Crawford's focus on affect offers an alternative to the idea of a literary tradition that coheres around the slave past. In so doing, she challenges the historical thinking that motivates both proponents who argue for the omnipresence of the histories of racial trauma and the progress-oriented discourse of a critic like Kenneth Warren, who argues for the end of the literary canon as "a post-emancipation phenomenon that gained its coherence as an undertaking in the social world defined by the system of Jim Crow segregation, which ensued after the nation's retreat from Reconstruction." Crawford, *What Is African American Literature?*, 1. Warren, *What Was African American Literature?*

35. Quashie, *Black Aliveness, or a Poetics of Being*, 10.

36. Some of the more widely recognized figures associated with New Criticism are Robert Penn Warren, Allen Tate, and Cleanth Brooks.

37. Culler also notes the pedagogical challenges of close reading as a method by noting the deficiency of language to capture what it is that we are trying to do: "The crucial thing is to slow down, though 'slow reading' is doubtless a less useful slogan than either 'slow food' or 'close reading,' since slow reading may be inattentive, distracted, lethargic. *Close* asks for a certain myopia—a *Verfremdungseffeckt*. It enjoins looking at rather than through the language of the text and thinking about how it is functioning, finding it puzzling." Culler, "The Closeness of Close Reading," 23. Culler is far from alone in highlighting the estranging effects of slowness. For example, Elaine Showalter echoes these ideas when she writes that close reading represents "a deliberate attempt to detach ourselves from the magical power of story-telling and pay attention to language, imagery, allusion, intertextuality, syntax and form." Showalter, *Teaching Literature*.

38. Culler, "The Closeness of Close Reading," 24.

39. Culler, "The Closeness of Close Reading," 22.

40. Clayton does something similar toward the end of *Uproot* when he describes the curatorial strategies, the cutting and mixing that he deploys in order to move people out of the frame of mind of listening for pleasure and into a more contemplative mode. Clayton offers a "parable" about ending a party with Tracy Chapman's "Behind the Wall," a song about domestic violence, that illustrates how upending club goers' listening habits can work to invite them to remember the troubles of the world outside the club and their responsibilities to it. Clayton, *Uproot*, 257, my italics.

41. "The future always arrives a bit late. Listening to a song I love, I don't want it to end. Music needs time to unfold, as sure as that unfolding directs our attention to the mysterious moment of now. The line 'my presence is a present' appears in rap lyrics throughout the years. As a statement of ego, it's not so hot: rooms generally rearrange themselves to become less interesting when famous rappers walk into them. So I started listening against the intended meaning. *This nowness I inhabit is a gift.* There, that's better. How to make the most of it? Good music suggests that every moment is provisional. The details matter more than the scale." Clayton, *Uproot*, 257.

42. Clayton, *Uproot*, 257.

43. Sharpe, *In the Wake*, 10.

44. I would go so far as to say that Sharpe's inclusion of a section on "Black annotation" and "Black redaction" gestures toward the connection I have been trying to draw between ways of reading and ways of being in relation to Blackness. See Sharpe, "Black Annotation, Black Redaction," *In the Wake*, 113–120.

45. Sharpe, *In the Wake*, 7.

46. Nash, "Practicing Love."

47. Nash, "Writing Black Beauty," 103.

48. Quashie, *The Sovereignty of Quiet*, 6.

49. Ahmed, *Queer Phenomenology: Orientations, Objects, Others*, 27.

50. Ahmed, *Queer Phenomenology: Orientations, Objects, Others*, 27.

51. Despite Ahmed's caution, I think of the phenomenological as a framework that allows for the centering of Blackness. This perspective is shaped in part by LaMonda

Horton Stallings's arguments for why phenomenology offers a productive framework for studying racialized and gendered subjects' experiences of their personhood and surrounding environments. In *Funk the Erotic*, Stallings's conceptualization of "funk" as a metaphor for the queer Black sensorium represents a critical turn toward the phenomenological and the sensations, experiences, and expressions of beingness. "Funk" is a vehicle leading to "new sensoriums and ways of being that cannot and do not align with Western traditions of humanism." Stallings, *Funk the Erotic*, 11.

52. "What I want is the freeness of a black world where blackness can be of being, where there is no argument to be made, where there is no speaking to or against an audience because we are all the audience there is . . . and, as such, the text's work can manifest an invitation to study and to becoming for the black one." Quashie, *Black Aliveness*, 10.

53. Smith, *Ordinary Light*, 348–349.

54. This hint of possibility speaks too to the kind of aliveness that Quashie describes as an "inclination to imagine that the black text speaks to and in a black world, subjunctive and imaginary as that is, away from the false and damaging expectation that black texts have to speak universally, which means they speak to the larger racial project or conversation—that is, to people who are not black . . . which indeed they do (a text speaks to any reader who reads it)." Quashie, *Black Aliveness*, 14.

Chapter Three

1. "As an identity, blackness is always supposed to tell us something about race or racism, or about America, or violence and struggle and triumph or poverty and hopefulness. The determination to see blackness only through a social public lens, as if there were no inner life, is racist—it comes from the language of racial superiority and is a practice intended to dehumanize black people." Quashie, *The Sovereignty of Quiet*, 4. Importantly, Quashie reminds readers that this thinking, though rooted in the racial imaginary, has infiltrated Black consciousness and too often inspires the artistic "imperative to represent."

2. Mitchum Heuhls counts "presence" as among the ideas privileged by literary critics in the present day. "For me, a scholar of contemporary US literature, the way we read now has everything to do with the way authors write now. In particular, I've noticed that an increasing number of authors seem to be thinking about meaning ontologically, as a matter of location, relation, and presence, not epistemologically, as a matter of representation, signification, and reference. Post-critical reading practices are the methodological counterpart to this ontological turn in the literary sphere." Heuhls contrasts an earlier era of critical engagement that prioritized matters of representation and critique, with more recent trends in which scholarship focus instead on "connection, adjacency, being, transmission, and presence." Heuhls, "Risking Complicity."

3. Marriott, "Judging Fanon."

4. In *None Like Us*, critic Stephen Best models a form of Black Studies scholarship that aspires to "think like a work of art," in the sense of attending to the contingencies and contradictions of Black history and Black life. According to Best, art is "the very

medium in which thought happens." He points to the work of Ghanaian artist El Anatsui as an example of a kind of "self-consuming [art] form" whose ephemeral, changing, mutable qualities create perceptual effects that resist the historical and contextual frameworks that the viewer typically uses to impose meaning on the work. Thus, for Best, thinking like a work of art describes a reflexive critical praxis that acknowledges the work's and the critic's internal complexities and recognizes how they shape our understanding of Black texts and Blackness more broadly. Best, *None Like Us*, 34.

5. Marriott delineates the philosophical and ideological oppositions between pessimism and optimism to consider the ways that these points of view inform critical analyses of Frantz Fanon's canonical work *Black Skin, White Masks*. Marriott's own interpretation of Fanon gestures toward an interstitial suspension of critique that facilitates the kind of textual curiosity and interpretive openness that I associate with aesthetic optimism. For example, he states, "As opposed to the optimist, who is on the side of life, let us call any pessimistic reader of Fanon a *death-reader*; between the two, lies the actual text: books and essays written and published during the time of crisis, war, torture, and death. There is virtually no compatibility between the optimist's language and the pessimist's (they frequently coexist in one and the same individual); but to read Fanon is to come across something altogether more difficult, or singular; reading begins at the point where either becomes *impossible* (in the sense of an aporia)." Marriott, "Judging Fanon," 1.

6. Marriott delineates the philosophical and ideological oppositions between pessimism and optimism to consider the ways that these points of view inform critical analyses of Frantz Fanon's canonical work *Black Skin, White Masks*. Marriott's own interpretation of Fanon gestures toward an interstitial suspension of critique that facilitates the kind of textual curiosity and interpretive openness that I associate with aesthetic optimism. For example, he states, "As opposed to the optimist, who is on the side of life, let us call any pessimistic reader of Fanon a *death-reader*; between the two, lies the actual text: books and essays written and published during the time of crisis, war, torture, and death. There is virtually no compatibility between the optimist's language and the pessimist's (they frequently coexist in one and the same individual); but to read Fanon is to come across something altogether more difficult, or singular; reading begins at the point where either becomes *impossible* (in the sense of an aporia)." Marriott, "Judging Fanon," 1.

7. Around the same time, Chimamanda Adichie published a book with a similar narrative strategy, *Dear Ijeawele or a Feminist Manifesto in Fifteen Suggestions*. Adichie focuses on gender discrimination rather than race. My larger point is that the letter, written specifically for and to a family member, reveals something about the pessimist outlook that infuses so much of the discourse on Blackness and other marginalized identities. Coates, *Between the World and Me*; Perry, *Breathe*.

8. Perry, *Breathe*, 29.

9. Perry, *Breathe*, 29.

10. Perry, *Breathe*, 33.

11. According to José Esteban Muñoz, when anchored in historical, collective struggles for racial, class, gender, and sexual liberation, utopianism avoids the pitfalls of

uncritical optimism. It can offer true hope for a future-oriented mode of being and doing *because* it is critical and "concrete." Marxist philosopher Ernst Bloch's conceptualization of "concrete utopias" serves as the primary influence for Muñoz's articulation of a queer potentiality that "can be distilled from the past and used to imagine a future." Muñoz, *Cruising Utopia*, 1.

12. Wilderson differentiates between thinking about social turmoil "through the rubric of conflict (i.e., a rubric of problems that can be posed and conceptually solved) as opposed to the rubric of antagonism (an irreconcilable struggle between entities, or positions, the resolution of which is not dialectical but entails the obliteration of one of the positions)." He proceeds to indict the academy specifically, stating, "In sharp contrast to the late 1960s and early 1970s, we now live in a political, academic, and cinematic milieu which stresses 'diversity,' 'unity,' 'civic participation,' 'hybridity,' 'access,' and 'contribution.' . . . Since the 1980s, intellectual protocols aligned with structural positionality (except in the work of die-hard Marxists) have been kicked to the curb. That is to say, it is hardly fashionable anymore to think the vagaries of power through the generic positions within a structure of power relations — such as man/woman, worker/boss. Instead, the academy's ensemble of questions are fixated on specific and 'unique' experiences of the myriad identities that make up those structural positions. This would be fine if the work led us back to a critique of the paradigm; but most of it does not. Again, the upshot of this is that the intellectual protocols now in play, and the composite effect of cinematic and political discourse since the 1980s, tend to hide rather than make explicit the grammar of suffering which underwrites the United States and its foundational antagonisms." I would argue that twelve years after Wilderson wrote these words, academic protocols have once again come full circle. After a period of extended analysis of the perpetuation of anti-Blackness through racialized institutions and discourse, scholars have begun to look beyond pessimism for alternate critical and theoretical frameworks in an effort to explore other dimensions of Black life. Wilderson, *Red, White and Black*, 5–6.

13. Coates, *Between the World and Me*, 9.

14. Coates, *Between the World and Me*, 18.

15. Baldwin, *The Fire Next Time*, 10.

16. Coates, *Between the World and Me*, 10.

17. Warren, *Ontological Terror*, 3. It's likely that Warren would equate Coates's nihilistic statement with a declaration like "Black Lives Matter," which "compels us to face the terrifying question, despite our desire to look away." Warren, *Ontological Terror*, 1. According to Warren, "Black Lives Matter" functions as a philosophical provocation in that it engenders questions like "Can Blacks have life?" or "What would such life *mean* within an anti-Black world?" or "Is the Black, in fact, a human being?" These questions, in turn, incite ontological terror by forcing us to look at/into a metaphysical abyss. I would argue that in this case, *form* profoundly shapes the meaning of the assertion. From its origins, the declaration "Black Lives Matter" presumes to address an "other," or antagonist, on the receiving end, the result being a statement that, according to Warren, "conceals [the] question, even as it purports to have answered it resolutely." Warren, *Ontological Terror*, 1. In contrast, the literary *is-ness* that Margo Crawford conceptualizes also performs philosophical labor; but it does so without as-

suming the representational burdens of argument and political persuasion and instead hails a reader as a participant in the making of the story and its meaning.

18. Warren, *Ontological Terror*, 11–12.

19. "What unites these essays is an idea, a metaphor, of what I call 'the black interior,' that is, black life and creativity behind the public face of stereotype and limited imagination. The black interior is a metaphysical space beyond the black public everyday toward power and wild imagination that black people ourselves know we possess but need to be reminded of. It is a space that black people ourselves have policed at various historical moments. Tapping into this black imaginary helps us envision what we are not meant to envision: complex black selves, real and enactable black power, rampant and unfetishized black beauty." Alexander, *The Black Interior*, x.

20. "Black social life is, fundamentally, the register of black experience that is not reducible to the terror that calls it into existence but is the rich remainder, the multifaceted artifact of black communal resistance and resilience that is expressed in black idioms, cultural forms, traditions, and ways of being." Williamson, *Scandalize My Name*, 7, 9.

21. Williamson, *Scandalize My Name*, 16.

22. Spillers's analysis focuses on the ways that deploying the rhetoric of community tends to reinscribe a racial monomyth that is more psychologically and emotionally reassuring than intellectually astute or sociopolitically effective. This line of inquiry informs her brilliant analysis of the phenomenon in which individual experiences of social and professional mobility engender a new "crisis" of the intellectual that in turn shapes the work that we do and stories we tell. Spillers, "The Crisis of the Negro Intellectual," 20–21.

23. Quashie, *The Sovereignty of Quiet*, 6.

24. Quashie, *The Sovereignty of Quiet*, 15.

25. Quashie, *The Sovereignty of Quiet*, 15.

26. Williamson, *Scandalize My Name*, 9.

27. Quashie, *The Sovereignty of Quiet*, 3.

28. Hartman, "Venus in Two Acts."

29. "Picture them: The relics of two girls, one cradling the other, plundered innocents; a sailor caught sight of them and later said they were friends. Two world-less girls found a country in each other's arms. Beside the defeat and the terror, there would be this too: the glimpse of beauty, the instant of possibility." Hartman, "Venus in Two Acts," 8.

30. Hartman, "Venus in Two Acts," 9.

31. Hartman, "Venus in Two Acts," 9–10.

32. Hartman, "Venus in Two Acts," 10–11.

33. Hartman, "Venus in Two Acts," 11.

34. Hartman, "Venus in Two Acts," 9. Hartman confesses her desire repeatedly, stating, "I longed to write a new story, one unfettered by the constraints of the legal documents." Hartman, "Venus in Two Acts," 9. Yet she also cautions that the yearning to replace the omissions and erasures of the historical archive with stories of love, grief, and other forms of affective plenitude runs the risk of reinscribing "the habitual violence of the slave ship" and plantation by replacing one type of *romance*—for

example, enslavers' uses of euphemism to normalize their acts of rape—with another that appeals to the emotional and psychological needs of we in the present. Hartman, "Venus in Two Acts," 6.

35. Hartman, "Venus in Two Acts," 9.

36. In a different project, I might reflect on Coates's representation of two friends from college, biracial and/or bisexual, whom he remembers fondly as symbols of possibilities beyond his pessimistic window on the world. He recalls, "I know no what she was to me—the first glimpse of a space-bridge, a wormhole, a galactic portal off this bound and blind planet. She had seen other worlds, and she held the lineage of other worlds, spectacularly, in the vessel of her black body." Coates, *Between the World and Me*, 58.

37. Coates, *Between the World and Me*, 10.

38. Alexander, "Review."

39. Morrison, *Playing in the Dark*, 12–13.

40. Smith, *Feel Free*, xi–xii.

41. After affirming this commitment to "ideological inconsistency," as an "article of faith," the passage continues, "As is a cautious, optimistic creed, best expressed by Saul Bellow: 'There may be truths on the side of life.' I keep on waiting, but I don't think I'm going to grow out of it." Smith, *Changing My Mind*, xi–xii.

42. Smith, *Feel Free*, xii, my emphasis.

43. Smith, *NW*, 335.

44. Smith, *NW*, 335.

45. Smith, *NW*, 339.

46. Smith, *NW*, 337.

47. Smith, *NW*, 336.

48. Smith, *NW*, 337.

49. Smith, *Feel Free*, xii.

50. Smith, *Feel Free*, xii.

51. Smith, "Fences: A Brexit Diary," *Feel Free*, 22.

52. Smith, "Fences: A Brexit Diary," *Feel Free*, 27.

53. Smith, "On Optimism and Despair," *Feel Free*.

54. Smith, "On Optimism and Despair," *Feel Free*, 35.

55. Smith, "On Optimism and Despair," *Feel Free*, 36.

56. In nonfiction and fiction, Smith retains an ethical orientation toward the anti-ideological "individual soul." Her description of "ideological" worldview could be grafted onto a description of how we tend to read narratives of Blackness: taking the particular case and generalizing from it. Specifically, she describes her father as "one of the least ideological people I ever met: everything that happened to him he took as a particular case, unable or unwilling to generalize from it. In his mind he did not marry a black girl, he married 'Yvonne,' and he did not have an experimental set of mixed-race children, he had me and my brother Ben and my brother Luke." Smith, "On Optimism and Despair, *Feel Free*, 40.

57. Smith, "On Optimism and Despair," *Feel Free*, 38.

58. Warren, "Black Time," 64.

59. Warren's reflections on ethics are inspired by his own disagreement with Stephen Best's enjoinder for critics to consider the ethical relationship of the present to

the past. To this, Warren responds, "Best wants to capture the compulsion to engage this event-horizon, the necessity of it. The grammar of ethics, however, does not wield answers, only paradoxes and impasses." Warren, "Black Time," 65.

60. Smith, "On Optimism and Despair," *Feel Free*, 39.

Chapter Four

1. Rovelli, *The Order of Time*.

2. Fleming names himself, Anthony Reed, Calvin Warren, Gary Wilder, and Michelle Wright as examples of scholars contributing to this emerging field of inquiry. These and other scholars "map the racial character and the social function of time, unfurling its role in the historical project of anti-blackness." Fleming, "Sound, Aesthetics, and Black Time Studies," 282. Habiba Ibrahim's contributions to Black Time Studies prove especially compelling as she disaggregates historiography from temporality. Ibrahim's reminder that "history only exists as history when it constitutes, reifies, and fortifies western humanism" opens space for my articulation of Black aesthetic time as a temporality rooted in a Black imaginary. Ibrahim, *Black Age*, 29.

3. Warren, *What Was African American Literature?*, 15. Pointing to the long tradition of scholars and writers who interpret Black literature through the lens of slavery and its aftereffects, Warren argues that the legal dismantling of Jim Crow in the 1950s and '60s has deprived African American literature of its primary reason for being and hence its coherence. While thought provoking and generative, Warren somewhat overstates Black ideological unity and political coherence before and during the era of Jim Crow and minimizes the continued effects of de facto racial inequality after its demise.

4. Warren, *What Was African American Literature?*, 7.

5. Wright, *Physics of Blackness*, 7.

6. For a sample of the critical debate around the merits of Warren's thesis, see, for example, the *LARB* debate between Erica Edwards and Walter Benn Michaels. "What Was African American Literature: A Symposium."

7. Wright argues that the Middle Passage epistemology typically establishes a timeline that centers Black (American) men and excludes other subjectivities—like African immigrants who frame their experiences through the lens of colonialism or postwar socioeconomic change, women whose suffrage rights were gained decades after men, and queer subjects who have been "consigned to the shadows" of Black history. Wright, *Physics of Blackness*, 8, 12. Derik Smith makes a similar argument through the study of a specific author, the poet Robert Hayden. Smith offers an astute analysis of what he calls the "'temporal accumulation' theory of history in which time is collapsed into an eternal now, suggesting we remain haunted by a past that has not passed." Smith, *Robert Hayden in Verse*, 12–13. He also takes issues with Kenneth Warren's assertion that Black literature was uniformly produced in response to Jim Crow. Accepting the premise that African American literature coheres around the problems of slavery and Jim Crow, Smith implies, leaves uncontested a version of the canon that ultimately marginalizes a figure like Hayden whose poetics were shaped by different and other influences and urgencies.

8. Wynter, "Unsettling the Coloniality of Being/Power/Truth/Freedom."

9. Best, *None Like Us*, 1.

10. Given that the personal and individual is the precise location where the fissure between subjectivity and collectivity is felt and experienced, it's not coincidental that Best employs the personal voice to explain this impulse toward "a frank reappraisal." He writes that "as much as attempts to root blackness in the horror of slavery feel intuitively correct, they produce in me a feeling of unease, the feeling that I am being invited to long for the return of a sociality that I never had, one from which I suspect (had I ever shown up) I might have been excluded." Best, *None Like Us*, 1.

11. I am thinking, for example, of Calvin Warren's questioning the very possibility of theorizing the Black present given the enduring phenomenon of anti-Blackness. Warren, "Black Nihilism and the Politics of Hope."

12. Warren, "Black Time," 64.

13. Warren, "Black Nihilism and the Politics of Hope," 217.

14. Warren, "Black Nihilism and the Politics of Hope," 217.

15. Warren, "Black Time," 64. The thesis of Warren's conceptualization of Black time is best summed up in the assertion "that the logic of the Political—linear temporality, biopolitical futurity, perfection, betterment, and redress—sustains black suffering. Progress and perfection are worked through the pained black body and any recourse to the Political and its discourse of hope will ultimately reproduce the very metaphysical structures of violence that pulverize black being." Warren, "Black Nihilism," 218.

16. Best, *None Like Us*, 21.

17. Best, *None Like Us*, 65.

18. Best, *None Like Us*, 65. Hartman asserts the need to attend to "important questions regarding what it means to think historically about matters still contested in the present and about life eradicated by the protocols of intellectual disciplines." Hartman, "Venus in Two Acts," 9–10.

19. I realize my analysis strains against Calvin Warren's definition of Black time as "time without duration; it is a horizon of time that eludes objectification, foreclosing idioms such as 'getting over,' 'getting through,' or 'getting beneath.'" Warren, "Black Time," 56.

20. Dery, "Black to the Future," 180.

21. Nelson, "Introduction," 9.

22. Nelson, "Introduction," 9.

23. Nelson, "Introduction," 9.

24. Lordi, *The Meaning of Soul*, 155.

25. Lordi, *The Meaning of Soul*, 156.

26. Fleming, "Transforming Geographies of Black Time," 611. Fleming's privileging of the here and now is a response and expression of resistance to "a structure of racial-temporal violence I call *black patience*. By this I mean a racialized system of waiting that is historically produced and vitalized antiblackness and white supremacy by compelling black people to wait and to capitulate to the racialized terms and assumptions of these forced performances of waiting." Fleming, "Transforming Geographies of Black Time," 589.

27. Fleming, "Transforming Geographies of Black Time," 611.

28. Lordi describes this method as "one grounded in a moment-to-moment description of what is happening in the music. This mode of close listening, in addition to helping make soul a more knowable quantity, reflects the presentism of my artists, who often throw themselves into the moment of performance as if there might not be another." Lordi, *The Meaning of Soul*, 11. One hears echoes as well of Julius Fleming's formulation of "the time of black leisure," in his analysis of audience dynamics during Free Southern Theater's performances of *In White America* in 1964 before Black audiences. This temporality names a similar suspension of time: "In this moment of live performance, the audience suspends labor, body, and reality to linger in the theater's imaginative flights." Fleming, "Transforming Geographies of Black Time," 603.

29. Lordi, *The Meaning of Soul*, 154.

30. Quashie, *Black Aliveness*, 2.

31. Trey Ellis's 1989 essay "The New Black Aesthetic" is typically credited with asserting the "newness" associated with post-Blackness and post-soul. The new Black subject, he famously declared, could best be described as a hybrid, a "cultural mulatto," influenced by a diversity of cultures, who could easily navigate "the white world." Ellis, "The New Black Aesthetic," 235. Though the rhetoric of post-Blackness had yet to become popularized and despite the provocativeness of his language, Ellis's definition of the "cultural mulatto" as one who has "inherited an open-ended New Black Aesthetic from a few Seventies pioneers that shamelessly borrows and reassembles across both race and class lines" gestures toward the kind of anti-essentialist and hybrid, *and elitist and apolitical*, framing of identity typically associated with post-Blackness and/or post-soul. Ellis, "The New Black Aesthetic," 235.

32. Ashe, "Theorizing the Post-Soul Aesthetic," 609.

33. Ashe, "Theorizing the Post-Soul Aesthetic," 611. After twenty years, the passage of time had given critics the "proper scholarly distance," to produce a "coherent critical conversation about the art of this 'post' era." Ashe, "Theorizing the Post-Soul Aesthetic," 609. Ashe elaborates on the reasons for marking 1987 as the beginning (or the end of the beginning) of the post-soul era in the introduction to *Slavery and the Post-Black Imagination*. 1987 marks the year of the publication of Toni Morrison's *Beloved* as a "watershed moment with regard . . . to the kind of relationship to the past" articulated by artists raised in the years following the civil rights movement. They also note a geographical expansion in that neo-slave narratives became "transnational and global" as well as in poetics, in that they expanded beyond the first-person prose narratives that characterized the first wave of neo-slave narratives. Ashe and Saal, *Slavery and the Post-Black Imagination*, 3–4.

34. Royster, *Sounding Like a No-No*, 4. Royster also gestures toward the globalization of the post-soul landscape, noting that the aesthetic is "grounded in the history and cultures of the African diaspora." Royster, *Sounding Like a No-No*, 5.

35. Royster, *Sounding Like a No-No*, 4. See also Jeff Chang's history of the rise and fall of American multiculturalism. Chang's analysis includes a fuller discussion of the reactionary backlash to the societal changes post-soul indexes: from Richard Nixon's "southern strategy" to conservative attacks during the "culture wars" of the 1980s to a consumer culture that appropriated multicultural rhetoric and images, thereby diluting "color" into another commodity to be packaged, sold, and consumed. Referencing

the multi-hued images in advertisements for the Italian clothing maker Benneton, Chang states that "difference was not only in danger of coming Benetton-ized [i.e., reduced to spectacle and commodity], it was in danger of being stretched to the horizon, leaving all the old inequity and inequality in place." Chang, *Who We Be*, 216.

36. Neal, *Soul Babies*, 3.

37. Winters continues, "This all-too-familiar concept often functions in public discourse to downplay tensions, conflicts, and contradictions in the present for the sake of a more unified and harmonious image of the future." Winters, *Hope Draped in Black*, 6.

38. In addition to Ashe, Neal, Royster, and Winters, a number of scholars engage the temporality of post-soul and post-Black discourse in compelling ways. See also Ramsey, "An End of Southern History." In the field of art history and visual art, though he doesn't use the rhetoric of post-soul or post-Blackness, Darby English's examination of transformations in "black representational space" in *How to See a Work of Art in Total Darkness* also pertains.

39. Touré, *Who's Afraid of Post-Blackness*, 18.

40. Touré, *Who's Afraid of Post-Blackness*, 18.

41. Simmons, "Introduction," *The Trouble with Post-Blackness*, 4.

42. Touré, *Who's Afraid of Post-Blackness*, 18.

43. Crawford, "What Was Is," 22.

44. Simmons gestures toward the reasons for her and her coauthor's skepticism in the rhetoric of post-Blackness by presenting a reading of Touré's *Who's Afraid of Post-Blackness* that highlights the internal contradictions and unspoken assumptions of the concept: "Somehow, though the 'possibilities of Blackness' are endless and variant, one can find ways to experience them fully. What's more, blackness is cast as a deeply personal journey of self-discovery—certainly not a discursive device orchestrating the various modes by which one might describe or identify oneself. . . . The insistence on this personal space as one beyond discourse and impervious to question or critique is what I find less than compelling." Simmons, "Introduction," *The Trouble with Post-Blackness*, 7–8. Moreover, "Touré's discussion thus keeps up and running a stable and hegemonic whiteness that is left untroubled and underarticulated. There's a universal 'humanness' that, implicitly, throughout the book, he casts as transcending the particularities of race-based discourse." Simmons, "Introduction," *The Trouble with Post-Blackness*, 12.

45. Simmons, "Introduction," *The Trouble with Post-Blackness*, 7.

46. Simmons, "Introduction," *The Trouble with Post-Blackness*, 8.

47. Nelson George coined the term *post-soul* in an essay, "Buppies, B-boys, BAPS, and Bohos," that he originally published in the *Village Voice* and in which he explores the political, social, and cultural shifts that reshaped African American experience. He returned to the subject later in *Post-Soul Nation: The Explosive, Contradictory, Triumphant and Tragic 1980s as Experienced by African Americans (Previously Known as Blacks and Before That Negroes)*.

48. Lordi, *The Meaning of Soul*, 13.

49. Crawford, *Black Post-Blackness*, 3.

50. Crawford, "What Was Is," 26.

51. Ashe, "Theorizing the Post-Soul Aesthetic," 616.

52. "We became 'soul sistas' and 'soul brothers' who dined on 'soul food,' exchanged 'soul shakes,' celebrated with 'soul claps' as 'soul children' marching for 'soul power' while listening to 'soul brother number one,' James Brown." George, *Post-Soul Nation*, vii–viii.

53. Both Mark Anthony Neal and Francesca Royster explain the reasoning behind their preference for "post-soul" over post-Blackness. They argue persuasively for the ways in which during the sixties, a rhetoric of "soulfulness" developed that connoted racial authenticity. Nelson George makes a similar point in his meditation on the meaning of "soul" in *Post-Soul Nation*. It bears remembering, however, as Paul Taylor rightfully reminds us, that ideas of "contemporary diversity seems to diverge from a common unitary root only if we flatten out the diversity that has always existed among African Americans." Taylor, "Post-Black, Old Black," 635.

54. Ashe, "Theorizing the Post-Soul Aesthetic," 617.

55. Ashe, "Theorizing the Post-Soul Aesthetic," 619.

56. Ashe, "Theorizing the Post-Soul Aesthetic," 617, my emphasis.

57. Wilderson, *Red, White and Black*, 11.

58. Wilderson, *Red, White and Black*, 5.

59. "Even when films narrate a story in which Blacks or Indians are beleaguered with problems that the script insists are conceptually coherent (usually having to do with poverty or the absence of 'family values'), the nonnarrative, or cinematic strategies of the film often disrupt this coherence by posing the irreconcilable questions of Red and Black political ontology—or nonontology. The grammar of antagonism breaks in on the mendacity of conflict." Wilderson, *Red, White and Black*, 5.

60. Golden, "Introduction," *Freestyle*, 14.

61. Ashe, "Theorizing the Post-Soul Aesthetic," 610.

62. Cited in Chang, *Who We Be*, 218.

63. Ashe, "Theorizing the Post-Soul Aesthetic," 614.

64. Lordi, *The Meaning of Soul*, 45.

65. Lordi, *The Meaning of Soul*, 38. "While my ambition to shift the terms of soul's representation is broad, my specifically academic intervention is to challenge theories of post-soul art that create their own mystical versions of soul by framing soul as post-soul's vague yet racially essentialist, masculinist, heterosexist other. The term *post-soul* is used most neutrally as a historical marker; it helps scholars designate the cultural productions of black Americans born after 1963. However, scholars inspired by Trey Ellis's and Greg Tate's laudatory accounts of black aesthetic diversity in the late 1980s and abetted by Henry Louis Gates Jr.'s influential dismissal of Black Arts–era writing often frame post-soul as the liberated alternative to soul itself." Lordi, *The Meaning of Soul*, 13.

66. Lordi, *The Meaning of Soul*, 9.

67. Lordi, *The Meaning of Soul*, 42.

68. Ashe, "Theorizing the Post-Soul Aesthetic," 614.

69. Ashe, "Theorizing the Post-Soul Aesthetic," 614, my emphasis.

70. Ashe, "Theorizing the Post-Soul Aesthetic," 614.

71. Black Lives Matter, "Herstory."

72. Ashe, "Theorizing the Post-Soul Aesthetic," 613.

73. K. Merinda Simmons usefully identifies the overlap between personal, political, and philosophical registers of race by reminding us "that processes of identification (the personal) are political ends in themselves, inarguable facts of a phenomenological matter." Simmons, "Introduction," *The Trouble with Post-Blackness*, 6.

74. This point is implied in Taylor's examination of the origins of the term: Thelma Golden's introduction to the *Freestyle* exhibition in 1993. Taylor concludes that while post-Blackness makes sense in that context, it doesn't pertain to a social reality in which "most black people seem unwilling to distance themselves from traditional forms of racial identification and racial conditions haven't undergone the startling alteration that makes ideas about blackness irrelevant or mystifying." Taylor, "Post-Black, Old Black," 635. Taylor equates the function of "post" in post-Blackness to the rhetorical/philosophical work it does in the Hegelian notion of the end history: both attempt to name what can't be named. In an echo of Ashe's discussion of "blaxploration," Taylor defines post-Blackness as "blackness empowered by self-knowledge—the knowledge that race thinking helped create the world." Taylor, "Post-Black, Old Black," 640.

75. Taylor, "Post-Black, Old Black," 627.

76. Taylor, "Post-Black, Old Black," 630.

77. Taylor also describes posteriority as, "a positive assertion, indicating the relation to the past." Taylor, "Post-Black, Old Black," 629.

78. For an especially illuminating discussion of oneness, see chapter 2, "Aliveness and Oneness," in *Black Aliveness*. In this chapter, Quashie distinguishes between oneness, which he defines as "a grammar of the materiality and immateriality of consciousness" and the Western imaginary's "bankrupt" conception of individuality. Quashie, *Black Aliveness*, 32.

Chapter Five

1. Many of Ojih Odutola's drawings look like portraits of specific individuals, but they are in fact composites of people whom she has encountered, friends, and acquaintances (some of them famous in their own right). As such, each image inspires reflection on the relationship of the subject's singularity and racial collectivity.

2. Ojih Odutola, "Artist Statement."

3. Philosopher-theorists, from Aristotle to Jacques Derrida, Hortense Spillers, and Sylvia Wynter, provide us with the conceptual tools required to look beyond the myth of the singularity of Being to the notion of beings whose selfhood is mediated and constituted by language, representation, and image. Aristotle, "Poetics," *Introduction to Aristotle*; Derrida, *Of Grammatology*; Spillers, "Mama's Baby, Papa's Maybe."

4. "[The Koba] are as plentiful as they are dispensable, outnumbering the *Eshu* in population. They live in constant fear of their rulers who can 'decommission' them at any given time for any reason or lack thereof." Ojih Odutola, "The Tale of Akanke and Aldo." See also Zadie Smith's incisive review of the exhibit in the *New Yorker* magazine.

5. "Toyin Ojih Odutola: (QuarARTine Special Episode)."

6. Publicity materials produced by the design office Zak Group for the exhibition catalogue describe *A Countervailing Theory* as "an afro-futurist tale of ancient myth,

popular culture and contemporary politics." Zak Group, "Toyin Ojih Odutola." Noting that Ojih Odutola named Octavia Butler's novels and the archeological discovery of the rock formation of Plateau State in central Nigeria, Helen Opuama states, "Therefore, 'A Countervailing Theory' is an exploration of blackness, specifically African mythical history in Sci-Fi, mixed with a non-fictional geological starting point." Opuama, "Toyin Ojih Odutola." According to Jennifer Brough, "In her 'imagined, ancient myth,' Toyin Ojih Odutola uses narrative to rewrite an expansive history of the Jos Plateau outside of a Eurocentric legacy." Brough, "A Countervailing Theory."

7. "The inauthenticity of the fabulist is of particular value on this score, insofar as his or her speech is not contained by a correspondence to its particular context, but carries over concepts, percepts, and affects from one regime of representation into another in a manner that is neither up-to-date nor out-of-date but truly untimely." Nyong'o, "Unburdening Representation," 74–75.

8. The Whitney curated Ojih Odutola's first major solo exhibition in New York from October 20, 2017, to February 25, 2018. My analysis here is informed in part by supplemental materials published on the Whitney Museum's website as well as remarks made by the artist at Barnard College during a public conversation titled "Art and Equity: A Conversation between Toyin Ojih Odutola and Mary Sibande."

9. "The black body is a troubling presence to the scopic regimes that define it as such." Fleetwood, *Troubling Vision*, 6. See also art-historical discussions of Blackness by Denise Murrell, Tina Campt, and Kara Keeling, who examine the processes that render Blackness a "visual manifestation" as well as, in some cases, the technologies of looking used to construct a discourse of racial difference.

10. Though primarily invested in the relationship between queerness and migration, Ahmed acknowledges and indeed includes a chapter on Frantz Fanon's theorization of the "historic-racial schema" that overtakes the "corporeal schema" that inform a subject's phenomenological experience of the world. Ahmed cites Fanon, who asserts, "The elements that I used had been provided for me not by 'residual sensations and perceptions primarily of a tactile, vestibular, kinesthetic, and visual character,' but by the other, the white man, who had woven me out of a thousand details, anecdotes, stories." Ahmed, *Queer Phenomenology*, 110. See also Fanon, *Black Skin, White Masks*.

11. Campt, *A Black Gaze*, 17.

12. Campt, *A Black Gaze*, 17.

13. Ahmed, *Queer Phenomenology*, 1.

14. Johnson's theorization of the generative possibilities in the practice of deconstructive analysis resonates with my own arguments about the imperative to engage the capaciousness of Blackness and Black texts. Expanding upon the distinction Roland Barthes makes between reading to consume and rereading as critical inquiry, Johnson notes, "When we read a text once, in other words, we can see in it only what we have already learned to see before." Johnson, "Review: The Critical Difference," 2. We might expand Johnson's argument for the value of deconstructive analysis beyond the act of reading to that of looking. For example, "Excavations" invites viewers to engage "Blackness" through a "deconstructive" practice of seeing and seeing again, reading and rereading, assessment and reassessment. Given the wealth of critical analyses of the history of subjugation and objectification symbolized by the racialized gaze, the

problematic nature of looking at Blackness may seem like a settled matter. In Michele Wallace's analysis of the "problem of visuality," which she summarizes as a question of "who produces and reproduces vision," she refers to music as "the founding discourse of the African American experience." Wallace, *Dark Designs and Visual Culture*, 191–192. This idea leads some critics, led by Moten and Campt, to look to sonic texts and sound culture for signs of free Blackness that evade the grasp of the racialized look. Though I find these ideas provocative and use them in my analysis of African American expressive culture, my reading of "Excavations" suggests that it is indeed possible for a visual text invested in Blackness as presence (as opposed to a sign of ontological erasure) to clear space for the imagining and experience of a "free" Black subject. See, for example, bell hooks's *Black Looks*, Tina Campt's *Listening to Images*, Fred Moten's *In the Break*, and Nicole Fleetwood's *Troubling Vision*.

15. "The normative dimension can be redescribed in terms of the straight body, a body that appears 'in line.' Things seem 'straight' (on the vertical axis), when they are 'in line,' which means when they are aligned with other lines" (Ahmed, 66).

16. Frank Wilderson offers an extended, cogent analysis of the difference between racial conflicts (a temporary and changeable dynamic) and racial antagonisms (a constitutive feature of racial formations). Wilderson, *Red, White and Black*.

17. Ahmed, *Queer Phenomenology*, 109–110. This is because agency emerges in dynamics in which objects make themselves available and responsive to the subject: "Bodies inhabit space by how they reach for objects, just as objects in turn extend what we reach." Ahmed, *Queer Phenomenology*, 109–110.

18. Africa has no meaningful role to play in Hegel's formulation of the development of the modern world. "Africa is no historical part of the World; it has no movement or development to exhibit. Historical movement in it—that is in its northern part—belong to the Asiatic or European part of the world." Hegel, *The Philosophy of History*, 99.

19. "An encyclopedic and expansive thinker, she has also made travel—both as metaphor and as literal activity—an important theme in her practice. The idea of transporting or transforming the self—a process critical to artistic development—emerges continuously and manifests itself variously in her work. For example, she has described her depiction of skin in terms of transmutation, as a world unto itself that can be traversed and explored." Hockley and Lang, "Toyin Odutola: By Her Design."

20. "More precisely, what is the nature of a human being whose human being is put into question radically and by definition, a human being whose being human raises the question of being human at all? Or rather, whose being is the generative force, historical occasion, and essential byproduct of the question of human being in general." Sexton, "The Social Life of Social Death," 6–7.

21. Spillers, "Mama's Baby, Papa's Maybe," 67.

22. Spillers, "Mama's Baby, Papa's Maybe," 67.

23. Spillers, "Mama's Baby, Papa's Maybe," 67.

24. Spillers, "Mama's Baby, Papa's Maybe," 65.

25. Quashie uses the metaphor of "quiet" to characterize the inner landscape of subjectivity in order to convey the unseen and underappreciated character of such other modes of being. Jeta Mulaj makes a similar point about the dangers of foreclos-

ing other modalities, though focused specifically on Ahmed's writing and the question of queer desire. In "A Critique of *Queer Phenomenology*: Gender and the Sexual," she argues that the unintended entrenchment of social norms comes at the expense of the psychoanalytic and shifts the focus to the workings of the unconscious in the production of sexual desire. She states, "Ahmed's theory of sexual orientation is restricted to the phenomenal world; it is an object-oriented theory that overlooks the unconscious and is limited to conscious and mental processes and social forces. She renders sexual desire transparent through, and synonymous with, sexual practices and gender expressions. As a result, Ahmed misses that the psychoanalytic unconscious in Freud's work points to a socialized formation of sexuality." Mulaj, "A Critique of *Queer Phenomenology*," 189.

26. Although my conceptualization of Black aesthetic being overlaps with the thinking of a scholar like Paul Taylor who is similarly concerned with the invention of being, our thinking diverges in that Taylor's discussion of "human acts of aesthetic self-fashioning" literally and figuratively equates imagination with the kind of active "doing" that Ahmed links to subjectivity. For example, in *Black Is Beautiful*, Taylor argues that when stripped of their "cultural armaments," the enslaved played an active role in transfiguring themselves from chattel into a people in possession of culture, agency, and collective identity. This occurred not in spite of but "because they had first been seen and treated as blacks." Taylor, *Black Is Beautiful*, 2. The distinction I am trying to make rests on the difference between acts of aesthetic invention whose reason for being is to persuade, challenge, or overturn racist beliefs and those whose potential lies in the claim to a self-possession that grants a becoming-Black object the freedom to simply exist without explanation.

27. These thoughts are in response to another of Ojih Odutola's drawings, "Last Portrait of the 18th Marquess." Gilman, "For Opacity"; LaNay and Quashie, "Double Take."

28. Gilman, "For Opacity," 15.

29. To Gilman, the opacity of Ojih Odutola's color-work conveys the subject's "right to not be understood," their right of refusal of society's demands for transparency. Gilman, "For Opacity," 11. Gilman's analysis pertains to portraits made by Ojih Odutola for another exhibition that use shades of black and brown to explore the interplay of darkness to light and black to white; it resonates nonetheless with the materials and techniques used to produce *To Wander Determined*, which is uncharacteristic in its use of pastels to introduce a wider spectrum of colors than is typical of the artist's output. In many ways, Gilman's discussion of opacity resonates with the theorization of Moten, Saidiya Hartman, Sarah Cervenak, and J. Kameron Carter, each of whom conceptualizes in varied and provocative ways the illegibility, untranslatability, unspeakability, and ungraspability of expressions of Black emancipation and/or fugitivity. See also Glissant's *Poetics of Relation*; Hartman, *Scenes of Subjection*, and *Wayward Lives, Beautiful Experiments*; and Moten, *In the Break*.

30. Viewers who approach this work in search of ideations of liberated Blackness might wonder about the absences and omissions that its seductive beauty obscures. On the one hand, in *To Wander Determined*, utopianism is expressed in its depiction of queer desire and androgyny. On the other hand, it links the families' ontological freedom to their material wealth, an unbroken genealogy, and geographical rootedness,

as well as to the absence of other kinds of "otherness," such as disability or fatness. These portraits implicitly reinscribe some societal norms even as they strive to imagine others.

31. Relatedly, Tavia Nyong'o's conceptualization of the Afro-fabulist expands on philosopher Gilles Deleuze's theorization of fabulation as "play with representation" and Hartman's articulation of "critical fabulation" as a strategic response to "the demand that a representation be either true or false, either history or fiction." Hartman, "Venus in Two Acts"; Nyong'o, "Unburdening Representation," 70–71, 76–77.

32. Best, *None Like Us*, 2.

33. Felsenthal, "At the Whitney, a Vision of Africa."

Chapter Six

1. "This type of literacy is more than a purely intellectual exercise. It is a skill for both narrator and reader which demands a knowledge of historical, social, cultural, and political development generated by lived and textual experience." Clark, "Developing Diaspora Literacy and *Marasa* Consciousness," 11.

2. Clark, "Developing Diaspora Literacy and *Marasa* Consciousness," 11.

3. Clark, "Developing Diaspora Literacy and *Marasa* Consciousness," 11.

4. Tammy L. Brown makes a similar point: "Marshall's persistent concern with 'reconciling' her multiple identities reflects the cultural clashes among American-born and foreign-born blacks. If black American and Caribbean cultures were similar and harmonious, there would be nothing to 'reconcile.'" Brown, "Paule Marshall and the Voice of Black Immigrant Women," *City of Islands*, 162.

5. Russell, "Interview with Paule Marshall," 15.

6. Dance, "An Interview with Paule Marshall," 15.

7. Russell, "Post-Blackness and All of the Black Americas," 119.

8. Russell, "Post-Blackness and All of the Black Americas," 119.

9. Danticat in particular emphasizes the influence of Marshall's *Brown Girl, Brownstones*, identifying it as one of the "classics of the [immigrant story] form." She also claims to have read "pretty much everything else [Marshall] has written." These authors also credit other Black women writers as inspirations, many of whom were Marshall's peers. They include Toni Morrison, Alice Walker, and Jamaica Kincaid. Reaching further back, Smith and Danticat also name Zora Neale Hurston as a major influence in their development as writers. "The Books That Influenced Yaa Gyasi"; "Zadie Smith: By the Book"; Knox, "Chimamanda Ngozi Adichie"; Treisman, "Edwidge Danticat on Her Caribbean Immigrant Experience"; Begley, "A 26-Year-Old Looks to the Past for Her Literary Debut."

10. Petry, *The Street*; Wright, *Native Son*.

11. Griffin, *"Who Set You Flowin'?"*

12. Perhaps Marshall's involvement in political organizing and protest during the 1950s, a decade that brought a resurgence of civil rights activism, inspired *Brown Girl*'s hopeful and aspirational tone regarding Selina's future prospects. Scholars like Carole Boyce Davies, Mary Helen Washington, and Erik McDuffie have chronicled the roles played by Black feminists in the Cold War period, describing their place at the

vanguard of multiple movements in the struggle for human rights. "Black women who had joined the CPUSA during the 1930s . . . had gained international reputations as leading spokespersons in struggles for civil rights, racial justice, peace, decolonization, women's rights, and democracy." McDuffie, *Sojourning for Freedom*, 192; Davies, *Left of Karl Marx*; Washington, *The Other Blacklist*.

13. Dance, "An Interview with Paule Marshall," 5.

14. We might think of Saidiya Hartman's discussion of the history of slavery—both her critique of an archive that shows a predilection to romanticize the brutality of slavery and embrace of critical fabulation as a method—as a postmodern approach to the same dilemma that Marshall addresses. The critical difference is that while Marshall frames the issue as a search for the truth, Hartman acknowledges and reckons with the fact that historiography inevitably reflects a practice that tells a story of the past, mediated by the psychological and affective needs and desires of the author's present.

15. Dance, "An Interview with Paule Marshall," 4.

16. Dance, "An Interview with Paule Marshall," 4–5.

17. Best, *None Like Us*, 12.

18. Best describes "the recovery imperative" as a "critical ethic" within Black Studies, dating at least as far back as the 1925 publication of Arturo Schomburg's essay "The Negro Digs Up His Past." Best, *None Like Us*, 11–12. He describes the particular commitment of this ethos as directed to the production of a collective racial consciousness. Marshall was not alone in her embrace of this framework. The recovery imperative informed the proliferation of neo-slave narratives published in and after the sixties, from Margaret Walker's *Jubilee* (1966) to Sherley Ann Williams's *Dessa Rose* (1986) and Toni Morrison's *Beloved* (1987), among other narratives. Best links the neo-slave narrative tradition to the "recursive . . . practice of writing history" and concludes that "the history of the black Atlantic [itself the basis for political coalition and racial solidarity] comes into existence only through loss and in turn, can be sustained only through more tales of its loss." Best, *None Like Us*, 66–67. A straight line can be drawn linking the neo-slave narrative's epistemological ambitions to the critical and theoretical interventions of scholars like Saidiya Hartman, whose experimentation with critical fabulation represents a metaphorical attempt to return to the "crime scene" of the Middle Passage and slavery in order to bear witness to this irresolvable loss.

19. Marshall, *Daughters*, 13. "Twelve years and it still rankles. And now that she can finally write the paper, she hasn't as yet put down the first word. Reams of notes all over the apartment and not even the introduction written. That part of her life still on hold for some reason. The Janes and Will Cudjoes still waiting on her to tell about them." Marshall, *Daughters*, 377.

20. Marshall, *Daughters*, 11–13.

21. DeLamotte, *Places of Silence, Journeys of Freedom*; Dorothy Denniston Hamer, *The Fiction of Paule Marshall*; Ferguson, "Of Bears & Bearings"; Pettis, *Toward Wholeness in Paule Marshall's Fiction*.

22. Ferguson, "Of Bears & Bearings," 177.

23. Best, *None Like Us*, 21.

24. Marshall, *Brown Girl, Brownstones*, 3. Juxtaposing this passage to the introduction to Ann Petry's 1946 novel *The Street* underscores Marshall's communalist ethos.

As opposed to an army prepared for battle against hostile forces, Petry presents her protagonist Lutie Johnson as a solitary figure struggling valiantly as she is buffeted by wind and debris that "did everything it could to discourage the people walking along the [Harlem] street." Petry, *The Street*, 7.

25. Donnette Francis describes it as the difference between telling an immigrant story of progress, as *Brown Girl* demonstrates, and telling a story of successful assimilation into American society, which it does not. Francis, "Paule Marshall: New Accents on Immigrant America."

26. In addition to Williamson's *Scandalize My Name*, see also Griffin's *"Who Set You Flowin'?."* Because *Brown Girl, Brownstones* begins in 1939, Selina's circumstances closely resemble the dynamics that Griffin describes in her analysis of early- and mid-twentieth-century representations of urban alienation in African American literature and popular culture. The similarities between stories of transnational migrant experiences and the Great Migration from the American South to northern and urban centers underscore the racial alienation and displacement that run through the African diaspora and shape the formation of a diasporic consciousness.

27. Marshall, *Brown Girl, Brownstones*, 4–5.

28. Marshall, *Brown Girl, Brownstones*, 5.

29. Marshall, *Brown Girl, Brownstones*, 8–9.

30. Marshall, *Brown Girl, Brownstones*, 5.

31. Marshall, *Brown Girl, Brownstones*, 9.

32. Marshall, *Brown Girl, Brownstones*, 16.

33. Marshall, *Brown Girl, Brownstones*, 8.

34. Marshall, *Brown Girl, Brownstones*, 5.

35. Martin Japtok examines the narrative critique of ethnic nationalism and affirmation of individualism as a value. The narrative scrutinizes these issues by exploring the pressure to conform to the values and expectations of a group that Selina disparages as a "band of small frightened people. Clannish. Narrow-minded. Selfish"; the devastating effects suffered by individuals like Deighton who refuse to comply; and the textual affirmations of a protagonist who is not "a joiner." Japtok, "Paule Marshall's *Brown Girl, Brownstones*," 308.

36. Marshall, "From the Poets in the Kitchen."

37. Marshall describes orality as a vehicle for conveying an individual's "profound feelings and complex ideas about himself and the world." Moreover, she argues, "common speech and the plain, workaday words that make it up are, after all, the stock in trade of some of the best fiction writers." Marshall, "From the Poets in the Kitchen."

38. Marshall, *Brown Girl, Brownstones*, 67.

39. Lisa McGill's analysis of the mother–daughter dynamic, which she describes as the novel's primary conflict, gestures similarly toward the social/subjective dichotomy. Accordingly, the narrative "situates a young heroine attempting to escape the dominion of the maternal voice through the construction of relationships outside of Silla's space." Gill, "Thinking Back through the Mother," 35. McGill astutely reads these friendships as Selina's attempts "to sever her connection to the archetypal Barbadian mother in the United States." Gill, "Thinking Back through the Mother," 35.

40. Marshall, *Brown Girl, Brownstones*, 307.

41. Marshall, *Brown Girl, Brownstones*, 281.

42. Marshall, *Brown Girl, Brownstones*, 281.

43. Marshall, *Brown Girl, Brownstones*, 282.

44. Marshall, *Brown Girl, Brownstones*, 287–288.

45. Marshall, *Brown Girl, Brownstones*, 289.

46. Fanon, "The Fact of Blackness," *Black Skin, White Masks*, 108.

47. Fanon, "The Fact of Blackness," *Black Skin, White Masks*, 137.

48. Fanon, "The Fact of Blackness," *Black Skin, White Masks*, 140.

49. Fanon ends "The Fact of Blackness" with an expression of ambivalent optimism: "Nevertheless with all my strength I refuse to accept that amputation. I feel in myself a soul as immense as the world, truly a soul as deep as the deepest of rivers, my chest has the power to expand without limit. . . . Without responsibility, straddling Nothingness and Infinity, I began to weep." Fanon, "The Fact of Blackness," *Black Skin, White Masks*, 140.

50. Marshall, *Brown Girl, Brownstones*, 282, my emphasis.

51. Marshall has noted this pattern in her stories, stating, "But it is true that at the end of my novels my characters are often moving off in a continuous search for self." Bonetti, "Paule Marshall Interview with Kay Bonetti."

52. Marshall, *Brown Girl, Brownstones*, 310.

53. Cheng, *The Melancholy of Race*.

54. Marshall, *Daughters*, 45.

55. Marshall, *Daughters*, 333.

56. Marshall, *Daughters*, 52.

57. Marshall, *Daughters*, 86–87.

58. Marshall, *Daughters*, 71.

59. One writer dubs the publishing industry's discovery of "how starved for relatable stories black women were" the "Terry McMillan Effect." Wheeler, "Novelist Terry McMillan on Love, Death and 'Dirty Secrets.'"

60. McMillan's novels were often criticized for featuring materialistically driven characters engaged in conspicuous consumption, but Daphne Brooks offers a cogent analysis of the overlap between purportedly "lowbrow, apolitical mass-market African American expressive forms" and "highbrow" literature by authors like Marshall. Her characters share with *Daughters*'s protagonist a striving for emotional connection that materialism cannot provide. Brooks, "'It's Not Right, but It's Okay.'"

61. Klawans, "Review of *Daughters*."

62. Kirkus, "Review of *Daughters*."

63. "Historical romance does a different kind of work than historical fiction, Sarah MacLean, a popular historical romance author, told me during a phone call. 'The work of the romance novel is not to tell the story of the past. It is to hold a mirror to the present.'" Fallon, "'Bridgerton' Isn't Bad Austen."

64. Marshall, *Daughters*, 14.

65. Spillers, "Mama's Baby, Papa's Maybe," 68. "It is this 'flesh and blood' entity, in the vestibule (or pre-view) of a colonized North America, that is essentially ejected from 'The Female Body in Western Culture' . . . but it makes good theory, or

commemorative 'herstory' to want to 'forget,' or to have failed to realize, that the African female subject, under these historical conditions, is not only the target of rape—in one sense, an interiorized violation of body and mind—but also the topic of specifically *externalized* acts of torture and prostration that we might imagine as the peculiar province of *male* brutality and torture inflicted by other males. . . . This materialized scene of unprotected female flesh—of female flesh 'ungendered'—offers a praxis and a theory, a text for living and for dying, and a method for reading both through their diverse mediations." Spillers, "Mama's Baby, Papa's Maybe," 67–68.

66. Spillers, "Watcha Gonna Do?," 304.

67. Dance, "An Interview with Paule Marshall," 4. Hartman makes a similar point in *Scenes of Subjection*, 101.

68. Reid-Pharr, *Conjugal Union*.

69. Marshall, *Daughters*, 376.

70. Marshall, *Daughters*, 36.

71. Marshall, *Daughters*, 76.

72. Marshall, *Daughters*, 77.

73. Marshall, *Daughters*, 224.

74. Marshall, *Daughters*, 240.

75. Marshall, *Daughters*, 241.

76. Fleming, "Transforming Geographies of Black Time," 587–590.

Chapter Seven

1. "Would the poet's intention emancipate the Category of Blackness from the scientific and historical ways of knowing that produced it in the first place, which is also the Black Feminist Critic worksite? Blackness emancipated from science and history wonder about another praxis and wander in the World, with the ethical mandate of opening up other ways of knowing and doing? To both questions, this paper provides one provisory answer: Yes. From without the World as we know it, where the Category of Blackness exists in/as thought—always already a referent of commodity, an object, and the other, as fact beyond evidence—a Poethics of Blackness would announce a whole range of possibilities for knowing, doing, and extending." Denise Ferreira Da Silva, "Toward a Black Feminist Poethics," 81.

2. Brand, *A Map to the Door of No Return*.

3. Brand, *A Map to the Door of No Return*, 61.

4. Brand, *A Map to the Door of No Return*, 82.

5. Brand, *A Map to the Door of No Return*, 5.

6. Brand, *A Map to the Door of No Return*, 1.

7. Brand, *A Map to the Door of No Return*, 34.

8. Brand, *A Map to the Door of No Return*, 52.

9. Brand, *A Map to the Door of No Return*, 85.

10. Brand, *A Map to the Door of No Return*, 72–73.

11. "In cities at 4:45 A.M., Toronto or Calgary or Halifax, there are these other inhabitants of silence. Two hundred miles outside, north of any place, or in the middle of it, circumnavigating absence. For a moment it is a sweet country, in that

moment you know perhaps someone else is awake reading Galeano." Brand, *A Map to the Door of No Return*, 52–53.

12. Brand, *A Map to the Door of No Return*, 195.

13. Marc Jiminez's summation of the field of aesthetics merges these meanings. The aesthetic refers to "the attempt to understand how 'humble' sensations . . . form in man the ideas that he then reincarnates in what he calls 'works of art.'" Jiminez, "Aesthetics," in *Dictionary of Untranslatables*, 17.

14. "Justice for Albert Johnson."

15. Hartman, *Scenes of Subjection*, 3.

16. Brand, *thirsty*, IV, ll. 1–2.

17. Brand, *thirsty*, II, ll. 33–36.

18. Alexander, "'Can You Be BLACK and Look at This?," 95.

19. Alexander, "Can You Be BLACK and Look at This?," 95.

20. Brand, *thirsty*, I, ll. 1–2.

21. Brand, *thirsty*, I, ll. 5–6.

22. Brand, *thirsty*, I, ll. 5–7.

23. Brand, *thirsty*, IX, ll. 27–28.

24. According to Jody Mason, "the door functions as a trope for fixed forms, such as slavery and capitalism, that limit our ability to understand how past and present experience interact. Like the disabling aspect of the door of no return, the sundering of memory and history, these fixed forms cannot adequately account for the lived present. The ghosts of *thirsty*, however, insist that past injustices continue to assert themselves in the present in material ways, particularly in the sites of bodies." Mason, "Searching for the Doorway," 784–785.

25. "There is the sense in the mind of not being here or there, of no way out or in. As if the door had set up its own reflection. Caught between the two we live in the Diaspora, in the sea in between. Imagining our ancestors stepping through these portals one senses people stepping out into nothing; one senses a surreal space, an inexplicable space. . . . Our inheritance in the Diaspora is to live in this inexplicable space. That space is the measure of our ancestors' step through the door toward the ship. One is caught in the few feet in between. The frame of the doorway is the only space of true existence." Brand, *A Map to the Door of No Return*, 20.

26. Brand, *thirsty*, I, ll. 1–2, 8.

27. Brand, *thirsty*, I, l. 1.

28. Brand, *thirsty*, I, ll. 10–12.

29. Brand, *thirsty*, I, l. 14.

30. Brand, *thirsty*, VI, ll. 1–3.

31. Brand, *thirsty*, II, ll. 37–40.

32. Brand, *thirsty*, I, ll. 16, 18.

33. Brand, *thirsty*, I, ll. 1, 22.

34. Brand, *thirsty*, II, ll. 2–3.

35. Brand, *thirsty*, II, ll. 1, 4.

36. Brand, *thirsty*, II, ll. 5–8.

37. Brand, *thirsty*, III, ll. 1–5.

38. Brand, *thirsty*, IX, ll. 1–2.

39. Brand, *A Map to the Door of No Return*, 220–221.

40. Brand lists "crossnationalist beauty pageants," community newspapers, and trips back home as examples of the kinds of collective projects designed to cultivate the feeling of communal belonging. Brand, *A Map to the Door of No Return*, 71.

41. "If we examine the process of 'understanding' people and ideas from the perspective of Western thought, we discover that its basis is this requirement for transparency. In order to understand and thus accept you, I have to measure your solidity with the ideal scale providing me with grounds to make comparisons and, perhaps, judgments. I have to reduce." Glissant, *Poetics of Relation*, 189–190.

42. Brand, *thirsty*, XXXII, ll. 7–12.

43. Brand, *thirsty*, XXXII, ll. 1–2.

44. Brand, *thirsty*, XXXII, ll. 13–15.

45. Ahmed, *Queer Phenomenology*, 6.

46. Brand, *thirsty*, XXXIII, ll. 16–18.

Chapter Eight

1. Smith, *Swing Time*, 49.

2. Smith, *Swing Time*, 49.

3. Smith, *Swing Time*, 63.

4. Smith, "On Optimism and Despair," *Feel Free*, 40.

5. Smith, *Swing Time*, 48.

6. "Here we come to Smith's second major preoccupation: relativity. Nothing in this novel exists in the absolute. Race, colour, class, even happiness, exist only as relative concepts." Selasi, "*Swing Time* by Zadie Smith Review."

7. Benjamin, "Interpreting Reflections," 42.

8. "One of the essential characteristics of the dream of multiplicity is that each element ceaselessly varies and alters its distance in relation to the others." Deleuze and Guattari, *A Thousand Plateaus*, 30.

9. Greenidge describes the disorienting effects of a dance being moved from a bedroom, club, or drag ball to entirely different contexts as an example of being shaken out of time. It "can suddenly be transmitted everywhere, much, much faster, the movements that used to describe a group, an attitude, a community, *suddenly shaken out of time*, to be collated into the latest trend piece on memes, reduced to disposable internet content." Greenidge, "Shaken Out of Time," 198, my emphasis.

10. Greenidge, "Shaken Out of Time," 196.

11. Greenidge, "Shaken Out of Time," 198.

12. Smith, *Swing Time*, 3.

13. Smith, *Swing Time*, 4.

14. Smith, *Swing Time*, 5.

15. Smith, *Swing Time*, 5.

16. Harper differentiates abstractionist artwork from abstractionism, and thusly, "An *abstractionist artwork, by extension*, is one that *emphasizes* its own distance from reality by calling attention to its constructed or artificial character—even if it also enacts real-world reference—rather than striving to dissemble that constructedness

in the service of the maximum verisimilitude so highly prized within the realist framework just sketched." Harper, *Abstractionist Aesthetics*, 2.

17. Smith, *Self-Discovery and Authority in Afro-American Literature*.

18. Smith, *Swing Time*, 74.

19. Smith, *Swing Time*, 79.

20. Smith, *Swing Time*, 77–78.

21. Smith, *Swing Time*, 81.

22. Smith, *Swing Time*, 82.

23. Smith, *Swing Time*, 82.

24. Smith, *Swing Time*, 82. This exchange recalls Nicole Fleetwood's conceptualization of Black women's embodiment as "excess flesh" in *Troubling Vision*. Fleetwood analyzes the ways that the projection of colonial fantasies entrap Black women's bodies within forms of iconicity that efface their subjectivity. Fleetwood, *Troubling Vision*.

25. Fleming, "Transforming Geographies of Black Time Studies," 590. In addition to building on Fleming's analysis of Black patience, my reading of this chapter is also informed by Saidiya Hartman's conceptualization of Black queer/women's waywardness as expressive acts that "hint at the possibility of a life bigger than poverty, at the tumult and upheaval that can't be arrested by the camera [of the social reformer and other outsiders]." Hartman, *Wayward Lives, Beautiful Experiments*, 5.

26. Smith, *Swing Time*, 9.

27. Smith, *Swing Time*, 9.

28. Smith, *Swing Time*, 9.

29. Smith, *Swing Time*, 100.

30. Smith, *Swing Time*, 38.

31. Smith, *Swing Time*, 369–370.

32. Houston's sound represented the full gamut of Black musical tradition given her deep roots in R&B and gospel. She famously modulated these sounds to achieve crossover success on pop music charts.

33. Smith, *Swing Time*, 90.

34. Smith, *Swing Time*, 177.

35. Smith, *Swing Time*, 180.

36. Clayton, *Uproot*, 180.

37. Clayton, *Uproot*, 181.

38. Clayton, *Uproot*, 181.

39. Smith, *Swing Time*, 163.

40. Smith, "On Optimism and Despair," *Feel Free*, 41.

41. Smith, *Swing Time*, 453.

Bibliography

A.D. "Bruxelles: Stromae Saoul à 8h du matin à l'arrêt Louise." Sudinfo.be. May 25, 2013. www.sudinfo.be/art/729404/article/regions/bruxelles/actualite/2013-05-23 /bruxelles-stromae-saoul-a-8h-du-matin-a-l-arret-louise-video.

Adichie, Chimamanda Ngozi. *Dear Ijeawele or a Feminist Manifesto in Fifteen Suggestions*. New York: Vintage, 2018.

Ahmed, Sara. *Queer Phenomenology: Orientations, Objects, Others*. Durham, NC: Duke University Press, 2006.

Alexander, Elizabeth. "'Can You Be BLACK and Look at This?': Reading the Rodney King Video(s)." In *Black: Representations of Masculinity in Contemporary Art*, edited by Thelma Golden, 91–110. New York: Whitney Museum of Art, 1994.

Alexander, Michelle. "Review: Ta-Nehisi Coates's 'Between the World and Me.'" *New York Times*. August 17, 2015. www.nytimes.com/2015/08/17/books/review/ta -nehisi-coates-between-the-world-and-me.html.

Aristotle. *Introduction to Aristotle*. Translated by Ingram Bywater. Chicago: University of Chicago Press, 1973.

"Art and Equity: A Conversation between Toyin Ojih Odutola and Mary Sibande." January 31, 2018. https://whitney.org/Essays/ToyinOjihOdutola.

Ashe, Bertram D. "Theorizing the Post-Soul Aesthetic: An Introduction." *African American Review* 41, no. 4 (Winter 2007): 609–623.

Ashe, Bertram D., and Ilka Saal. *Slavery and the Post-Black Imagination*. Seattle: University of Washington Press, 2020.

Bailey, Carol. *Writing the Black Diasporic City in the Age of Globalization*. New Brunswick, NJ: Rutgers University Press, forthcoming 2023.

Baker, Houston, Jr., and K. Merinda Simmons, eds. *The Trouble with Post-Blackness*. New York: Columbia University Press, 2015.

Baldwin, James. *The Fire Next Time*. New York: Holt, Rinehart and Winston, 1962, 1990 reprint.

Begley, Sarah. "A 26-Year-Old Looks to the Past for Her Literary Debut." *Time*. June 6, 2016. http://time.com/4357214/homegoing-yaa-gyasi-profile/.

Benjamin, Andrew. "Interpreting Reflections: Painting Mirrors." Philosophical Encounters, *Oxford Literary Review* 11, no. 1/2 (1989): 37–71.

Best, Stephen. *None Like Us: Blackness, Belonging, Aesthetic Life*. Durham, NC: Duke University Press, 2018.

Bishop, Claire. "Art of the Encounter: Antagonism and Relational Aesthetics," *Circa: Art Magazine* 114 (Winter 2005): 32–35.

Black Lives Matter. "Herstory." Accessed January 21, 2023. https://blacklivesmatter .com/herstory/.

Bonetti, Kay. "Paule Marshall Interview with Kay Bonetti." Recorded March 1984 at KNPO Radio. Columbia MO: American Audio Prose Library, 1984.

"The Books That Influenced Yaa Gyasi." January 14, 2017. www.penguin.co.uk /articles/2017/books-that-influenced-yaa-gyasi.html.

Bourriaud, Nicolas. *Relational Aesthetics*. Paris: Les Presses Du Reel, 1998.

Brand, Dionne. *A Map to the Door of No Return: Notes to Belonging*. New York: Vintage, 2001.

———. *thirsty*. Toronto: McClelland and Steward, 2002.

Brooks, Daphne A. "Afro-Sonic Feminist Praxis: Nina Simone and Adrienne Kennedy in High Fidelity." In *Black Performance Theory*, edited by Thomas F. DeFrantz and Anita Gonzalez, 210. Durham, NC: Duke University Press, 2014.

———. "'It's Not Right, but It's Okay': Black Women's R&B and the House That Terry McMillan Built." *Souls* 5, no. 1 (2003): 32–45.

Brough, Jennifer. "A Countervailing Theory: The Visual Language of Speculative Storytelling." *The Debutante: The Feminist-Surrealist Arts Journal*. April 13, 2021.

Brown, Tammy L. *City of Islands: Caribbean Intellectuals in New York*. Jackson: University Press of Mississippi, 2015.

Cailler, Bernadette. "Totality and Infinity, Alterity, and Relation: From Levinas to Glissant." *Journal of French and Francophone Philosophy* 19, no. 1 (2011): 135–151.

Campt, Tina. *A Black Gaze: Artists Changing How We See*. Cambridge, MA: MIT Press, 2021.

———. *Listening to Images*. Durham, NC: Duke University Press, 2017.

Carman, Taylor. "Foreword." In *Being and Time*, translated by John MacQuarrie and Edward Robinson. New York: Harper Perennial, 2008, 1962 edition.

Cassin, Barbara, ed. *Dictionary of Untranslatables*. Translated by Emily Apter et al. Princeton: Princeton University Press, 2004.

Chang, Jeff. *Who We Be: The Colorization of America*. New York: St. Martin's Press, 2014.

Cheng, Anne Anlin. *The Melancholy of Race: Psychoanalysis, Assimilation and Hidden Grief*. New York: Oxford University Press, 2001.

———. "Psychoanalysis without Symptoms." *differences: A Journal of Feminist Cultural Studies* 20, no. 1 (Spring 2009): 87–101.

Clark, VèVè. "Developing Diaspora Literacy and *Marasa* Consciousness." *Theatre Survey* 50, no. 1 (May 2009): 9–18.

Clayton, Jace a.k.a. DJ Rupture. *Uproot: Travels in 21st-Century Music and Digital Culture*. New York: Farrar, Straus and Giroux, 2016.

Coates, Ta-Nehisi. *Between the World and Me*. New York: Spiegel & Grau, 2015.

Concetta C. "Stromae Bourré à Bruxelles!" Uploaded May 24, 2013. YouTube video. www.youtube.com/shorts/LL-icEs28hw.

Cook, Mercer, and Stephen E. Henderson. *The Militant Black Writer in Africa and the United States*. Madison: University of Wisconsin Press, 1969.

Crawford, Margo. *Black Post-Blackness: The Black Arts Movement and Twenty-First Century Aesthetics*. Urbana: University of Illinois Press, 2017.

———. *What Is African American Literature?* New York: John Wiley & Sons, 2021.

———. "What Was Is: The Time and Space of Entanglement Erased by Post-Blackness." In *The Trouble with Post-Blackness*, edited by Houston Baker Jr. and K. Merinda Simmons, 21–43. New York: Columbia University Press, 2015.

Crowley, Ashon. *Blackpentacostal Breath: The Aesthetics of Possibility*. New York: Fordham University Press, 2017.

Culler, Jonathan. "The Closeness of Close Reading." *ADE Bulletin* 149 (2010): 20–25.

Dance, Daryl Cumber. "An Interview with Paule Marshall." *Southern Review* 28, no. 1 (Winter 1992): 1–20.

Davies, Carole Boyce. *Left of Karl Marx: The Political Life of Black Communist Claudia Jones*. Durham, NC: Duke University Press, 2008.

DeClue, Jennifer. *Visitation: The Conjure Work of Black Feminist Avant-Garde Cinema*. Durham, NC: Duke University Press, 2022.

DeFrantz, Thomas F., and Anita Gonzalez, eds. *Black Performance Theory*. Durham, NC: Duke University Press, 2014.

DeLamotte, Eugenia C. *Places of Silence, Journeys of Freedom: The Fiction of Paule Marshall*. Philadelphia: University of Pennsylvania Press, 1998.

Delaney, Rachel. "Other Lessons Learned from Relational Aesthetics." *Visual Arts Research* 40, no. 1 (Summer 2014): 25–27.

Deleuze, Giles, and Félix Guattari. *A Thousand Plateaus: Capitalism and Schizophrenia*. Translated by Brian Massumi. Minneapolis: University of Minnesota Press, 1987.

Derrida, Jacques. *Of Grammatology*. Translated by Gayatri Spivak. Baltimore: Johns Hopkins University Press, 1997.

Dery, Mark, ed. *Flame Wars: The Discourse of Cyberculture*. Durham, NC: Duke University Press, 1994.

De Souza, Pascale, and H. Adlai Murdoch, eds. *Metropolitan Mosaics and Melting-Pots: Paris and Montreal in Francophone Literatures*. Newcastle upon Tyne: Cambridge Scholars Publishing, 2013.

Diggs Colbert, Soyica, R. J. Patterson, and A. Levy-Hussen. "Black Time: Slavery, Metaphysics, and the Logic of Wellness." *The Psychic Hold of Slavery: Legacies in American Expressive Culture*. New Brunswick, NJ: Rutgers University Press, 2016.

Dillon, Brian. *Essayism: On Form, Feeling, and Nonfiction*. New York: New York Review of Books, 2017.

Dubey, Madhu. *Signs and Cities: Black Literary Postmodernism*. Chicago: University of Chicago Press, 2003.

Du Bois, W. E. B. "The Criteria for Negro Art." In *The Norton Anthology of African American Literature*, 2nd ed., edited by Henry Louis Gates and Nellie McKay, 777–784. New York: W.W. Norton, 2004.

Edwards, Brent Hayes. "The Taste of the Archive." *Callalloo* 35, no. 4 (Fall 2012): 944–972.

Ellis, Trey. "The New Black Aesthetic." *Callaloo* 38 (Winter 1989): 233–243.

English, Darby. *How to See a Work of Art in Total Darkness*. Cambridge, MA: MIT Press, 2007.

Fallon, Claire. "'Bridgerton' Isn't Bad Austen—It's an Entirely Different Genre." www.huffpost.com/entry/bridgerton-netflix-romancegenre_n _60086fd5c5b6ffcab969dafa.

Fanon, Frantz. *Black Skin, White Masks*. New York: Grove Press, 1967.

Felsenthal, Julia. "At the Whitney, a Vision of Africa—Without the Colonialist Meddling." *Vogue*. October 27, 2017. www.vogue.com/article/toyin-ojih-odutola -whitney-museum-interview.

Ferguson, Moira. "Of Bears & Bearings: Paule Marshall's Diverse *Daughters*." *MELUS* 24, no. 1 (Spring 1999): 177–195.

Ferreira Da Silva, Denise. "Toward a Black Feminist Poethics: The Quest(ion) of Blackness toward the End of the World." *The Black Scholar* 44, no. 2 (Summer 2014): 81–97.

Fleetwood, Nicole. *Troubling Vision: Performance, Visuality, and Blackness.* Chicago: University of Chicago Press, 2011.

Fleming, Julius B. "Sound, Aesthetics, and Black Time Studies." *College Literature* 46, no. 1 (Winter 2019): 281–288.

——. "Transforming Geographies of Black Time: How the Free Southern Theater Used the Plantation for Civil Rights Activism." *American Literature* 91, no. 3 (2019): 587–615.

Francis, Donnette A. "Paule Marshall: New Accents on Immigrant America." *The Black Scholar* 30, no. 2 (2000): 21–25.

Fuller, Hoyt. "Towards a New Black Aesthetic." In *The Norton Anthology of African American Literature*, 2nd ed., edited by Henry Louis Gates and Nellie McKay, 1853–1859. New York: W. W. Norton, 2004.

Gates, Henry Louis, and Nellie McKay. *The Norton Anthology of African American Literature.* New York: W.W. Norton, 2004.

George, Nelson. *Post-Soul Nation: The Explosive, Contradictory, Triumphant, and Tragic 1980s as Experienced by African Americans (Previously Known as Blacks and Before That Negroes).* New York: Penguin, 2004.

Gilman, Claire. "For Opacity: Elijah Burgher, Toyin Ojih Odutola and Nathaniel Mary Quinn." *Drawing Papers* 138 (October 19, 2018). New York: Drawing Center, 2018.

Glissant, Édouard. "Creolization in the Making of the Americas." In *Race, Discourse, and the Origins of the Americas*, edited by Vera Lawrence Hyatt and Rex Nettleford, 268–275. Washington, DC: Smithsonian Institution, 1995.

——. *Poetics of Relation.* Translated by Betsy Wing. Ann Arbor: University of Michigan Press, 1997.

Golden, Thelma, ed. *Black: Representations of Masculinity in Contemporary Art.* New York: Whitney Museum of Art, 1994.

——. *Freestyle.* New York: Studio Museum in Harlem, 2001.

Greenidge, Kaitlyn. "Shaken Out of Time: Black Bodies and Movement in Zadie Smith's *Swing Time*." *Virginia Quarterly Review* 93, no. 1 (2017): 196–199.

Griffin, Farah Jasmine. *"Who Set You Flowin'?": The African-American Migration Narrative.* New York: Oxford University Press, 1995.

Hamer, Dorothy Denniston. *The Fiction of Paule Marshall: Reconstructions of History, Culture, and Gender.* Knoxville: University of Tennessee Press, 1995.

Harper, Phillip Brian. *Abstractionist Aesthetics: Artistic Form and Social Critique in African American Culture.* New York: New York University Press, 2015.

Hartman, Saidiya. *Lose Your Mother: A Journey Along the Atlantic Slave Route.* New York: Farrar, Straus and Giroux, 2008.

——. *Scenes of Subjection: Terror, Slavery and Self-Making in Nineteenth-Century America.* New York: Oxford University Press, 1997.

——. "Venus in Two Acts." *Small Axe* 26 (June 2008): 1–14.

——. *Wayward Lives, Beautiful Experiments: Intimate Histories of Riotous Black Girls, Troublesome Women, and Queer Radicals.* New York: W. W. Norton, 2019.

Hegel, Georg Wilhelm Friedrich. *The Philosophy of History.* Translated by J. Sibree. New York: Dover, 1956.

Heidegger, Martin. *Being and Time.* trans. John MacQuarrie and Edward Robinson. New York: Harper Perennial, 1962.

Heuhls, Mitchum. "Risking Complicity." *Arcade: A Digital Salon.* https://arcade .stanford.edu/content/risking-complicity.

Hockley, Rujeko, and Melinda Lang. "Toyin Odutola: By Her Design." Whitney Museum of Art. Accessed January 21, 2023. https://whitney.org/essays/toyin-ojih-odutola.

Huggins, Nathan Irvin, ed. *Voices from the Harlem Renaissance.* New York: Oxford University Press, 1995.

Hughes, Langston. "The Negro Artist and the Racial Mountain." In *Voices from the Harlem Renaissance*, edited by Nathan Irvin Huggins, 305–309. New York: Oxford University Press, 1995.

Hyatt, Vera Lawrence, and Rex Nettleford, eds. *Race, Discourse, and the Origins of the Americas.* Washington, DC: Smithsonian Institution, 1995.

Ibrahim, Habiba. *Black Age: Oceanic Lifespans and the Time of Black Life.* New York: New York University Press, 2021.

Japtok, Martin. "Paule Marshall's *Brown Girl, Brownstones*: Reconciling Ethnicity and Individualism." *African American Review* 32, no. 2 (Summer 1998): 305–315.

Johnson, Barbara. "Review: The Critical Difference." *Diacritics* 8, no. 2 (Summer 1978): 2–9.

Jones, LeRoi (Amiri Baraka). *Blues People: Negro Music in White America.* New York: Perennial, 1963, 1999 reprint.

"Justice for Albert Johnson." Accessed January 21, 2023. https://archives.library.yorku .ca/exhibits/show/pushingbuttons/social-activism/justice-for-albert-johnson.

Kalimba, Stephen. "Tracing Stromae's Rwandan Roots." *The New Times Newsletter.* October 9, 2015. www.newtimes.co.rw/section/read/193313.

Kelly, Michael, and Monique Roloef. *Black Aesthetics: Beyond the Resistance-Relationality Duality.* London: Bloomsbury Press, 2023.

Kirkus. "Review of *Daughters*." October 9, 1991. www.kirkusreviews.com/book -reviews/paule-marshall/daughters/.

Klawans, Stuart. "Review of *Daughters*." *Entertainment Weekly.* October 4, 1991. http://ew.com/article/1991/10/04/daughters/.

Knox, Jennifer L. "Chimamanda Ngozi Adichie." *New Yorker.* June 14 and 21, 2010. www.newyorker.com/magazine/2010/06/14/chimamanda-ngozi-adichie.

Lamothe, Daphne. "On the Threshold of Change: Reflections on Blackness, Memoir, and the Post-Soul Aesthetic in Tracy K. Smith's *Ordinary Light*." In *Black Art and Aesthetics: Relationalities, Interiorities, Reckonings*, edited by Michael Kelly and Monique Roelofs. London: Bloomsbury Press, 2023.

LaNay, Sade, and Kevin Quashie. "Double Take." *Manual: A Journal of Art and Its Making.* Providence: RISD Museum, 2020, 82–85. https://digitalcommons.risd .edu/cgi/viewcontent.cgi?article=1040&context=risdmuseum_journals.

Leader-Picone, Cameron. *Black and More Than Black: African American Fiction in the Post Era*. Jackson: University of Mississippi Press, 2019.

Levy-Hussen, Aida. *How to Read African American Literature: Post–Civil Rights Fiction and the Task of Interpretation*. New York: New York University Press, 2016.

Lionnet, Françoise, and Shu-mei Shih, ed. *The Creolization of Theory*. Durham, NC: Duke University Press, 2011.

Lordi, Emily J. *The Meaning of Soul: Black Music and Resilience since the 1960s*. Durham, NC: Duke University Press, 2020.

Marriott, David. "Judging Fanon." *Rhizomes: Cultural Studies in Emerging Knowledge* 29 (2016). www.rhizomes.net/issue29/marriott.html.

Marshall, Paule. *Brown Girl, Brownstones*. New York: Dover, 1959, 2009 reprint.

——. *Daughters*. New York: Atheneum, 1991.

——. "From the Poets in the Kitchen." *New York Times*. January 9, 1983. www .nytimes.com/1983/01/09/books/from-the-poets-in-the-kitchen.html.

Mason, Jody. "Searching for the *Doorway*: Dionne Brand's *thirsty*." *University of Toronto Quarterly*, 75, no. 2 (Spring 2006): 784–800.

Massood, Paula. *Black City Cinema: African American Urban Experiences in Film*. Philadelphia: Temple University Press, 2003.

McDuffie, Erik S. *Sojourning for Freedom: Black Women, American Communism, and the Making of Black Left Feminism*. Durham, NC: Duke University Press, 2011.

McGill, Lisa D. "Thinking Back through the Mother: The Poetics of Place and the Mother/Daughter Dyad in *Brown Girl, Brownstones*." *The Black Scholar* 30, no. 2 (April 14, 2015): 34–40.

MegaADRISANCHEZ. "Stromae Bourré à Bruxelles! 2/2." YouTube video. May 24, 2013. www.youtube.com/watch?v=LD5ZcKBdSZo.

Mercer, Kobena. *Travel and See: Black Diaspora Art Practices since the 1980s*. Durham, NC: Duke University Press, 2016.

——. *Welcome to the Jungle: New Positions in Black Cultural Studies*. New York: Routledge, 1994.

Morrison, Toni. *Playing in the Dark: Whiteness and the Literary Imagination*. Cambridge, MA: Harvard University Press, 1992.

——. *The Source of Self-Regard: Selected Essays, Speeches, and Meditations*. New York: Alfred A. Knopf, 2019.

Moten, Fred. *In the Break: The Aesthetics of the Black Radical Tradition*. Minneapolis: University of Minnesota Press, 2003.

——. *The Universal Machine: Consent Not to Be a Single Being*. Durham, NC: Duke University Press, 2018.

Mulaj, Jeta. "A Critique of *Queer Phenomenology*: Gender and the Sexual." *Studies in Gender and Sexuality* 20, no. 3 (2019): 189–203.

Muñoz, José Esteban. *Cruising Utopia, 10th Anniversary Edition: The Then and There of Queer Futurity*. New York: New York University Press, 2019.

Murdoch, H. Adlai. *Creolizing the Metropole: Migrant Caribbean Identities in Literature and Film*. Bloomington: Indiana University Press, 2012.

——. "Édouard Glissant's Creolized World Vision: From Resistance and Relation to *Opacité*." *Callaloo* 36, no. 4 (Fall 2013): 875–890.

Nash, Jennifer C. "Practicing Love: Black Feminism, Love-Politics, and Post-Intersectionality," *Meridians* 11, no. 2 (2011): 1–24.

——. "Writing Black Beauty." *Signs: Journal of Women in Culture and Society* 45, no. 1 (2019): 101–122.

Neal, Larry. "The Black Arts Movement." *The Norton Anthology of African American Literature*, 2nd ed., edited by Henry Louis Gates and Nellie McKay, 2039–2050. New York: W. W. Norton, 2004.

Neal, Mark Anthony. *Soul Babies: Black Popular Culture and the Post-Soul Aesthetic.* New York: Routledge, 2002.

Nelson, Alondra. "Introduction: Future Texts." *Social Text* 71, no. 20 (Summer 2002): 1–15.

Newell-Hanson, Alice. "Rirkrit Tiravanija's Pad Thai Is Both a Meal and an Artwork." *New York Times Magazine.* April 21, 2022. www.nytimes.com/2022/04/21/t -magazine/rirkrit-tiravanija.html.

Nielson, Aldon Lynn. "Wasness, Review of *What Was African American Literature?* by Kenneth W. Warren." *Los Angeles Review of Books.* June 13, 2011. https:// lareviewofbooks.org.

Nyong'o, Tavia. "Unburdening Representation." *The Black Scholar: Journal of Black Studies and Research* 44, no. 2 (2014): 70–80.

Ojih Odutola, Toyin. "Artist Statement. (MAPS)." Jack Shainman Gallery. 2011. https://toyinojihodutola.com/Timeline.

——. "The Tale of Akanke and Aldo." *Toyin Ojih Odutola: A Countervailing Theory* [Exhibition Catalogue], edited by Lotte Johnson. Barbican Art Gallery. 2020. https://hirshhorn.si.edu/explore/the-tale-of-akanke-and-aldo/.

Opuama, Helen. "Toyin Ojih Odutola: A Countervailing Theory." *Medium.* October 16, 2020. https://medium.com/@helenaopuama/toyin-ojih-odutola-a-countervailing -theory-b4b73f3acb48.

Orange, Michelle. "Femme Verité: The Films of Chantal Akerman." *Virginia Quarterly Review* 92, no. 2 (Spring 2016): 203–206.

Perry, Imani. *Breathe: A Letter to My Sons.* New York: Beacon, 2019.

Petry, Ann. *The Street.* New York: Mariner Books, 1946, 1998 reprint.

Pettis, Joyce. *Toward Wholeness in Paule Marshall's Fiction.* Charlottesville: University of Virginia Press, 1995.

Quashie, Kevin. *Black Aliveness, or a Poetics of Being.* Durham, NC: Duke University Press, 2022.

——. *The Sovereignty of Quiet: Beyond Resistance in Black Culture.* New Brunswick, NJ: Rutgers University Press, 2012.

Ramsey, William. "An End of Southern History: The Down-Home Quests of Toni Morrison and Colson Whitehead." *African American Review* 41, no. 4 (2007): 769–785.

Reid-Pharr, Robert. *Conjugal Union: The Body, the House, and the Black American.* New York: Oxford University Press, 1999.

Rovelli, Carlo. *The Order of Time*. Translated by Erica Segre and Simon Carnell. New York: Riverhead Books, 2018.

Royster, Francesca. *Sounding Like a No-No: Queer Sounds and Eccentric Acts in the Post-Soul Era*. Ann Arbor: University of Michigan Press, 2012.

Russell, Heather D. "Post-Blackness and All of the Black Americas." In *The Trouble with Post-Blackness*, edited by Houston Baker Jr. and K. Merinda Simmons, 110–143. New York: Columbia University Press, 2015.

Russell, Sandi. "Interview with Paule Marshall." *Wasafiri* 4, no. 8 (Spring 1988): 14–16.

Sayare, Scott. "Stromae: Disillusion, with a Dance Beat." *New York Times*. October 15, 2013. www.nytimes.com/2013/10/15/arts/15iht-stromae15.html.

Selasi, Taiye. "*Swing Time* by Zadie Smith Review—A Classic Story of Betterment." *The Guardian*. November 13, 2016. www.theguardian.com/books/2016/nov/13/swing-time-zadie-smith-review.

Sexton, Jared. "The Social Life of Social Death: On Afro-Pessimism and Black Optimism." *InTensions* 5 (Fall/Winter 2011). www.yorku.ca/intent/issue5/articles/jaredsexton.php.

Sharpe, Christina. *In the Wake: On Blackness and Being*. Durham, NC: Duke University Press, 2016.

Showalter, Elaine. *Teaching Literature*. London: Wiley-Blackwell, 2002.

Smith, Derik. *Robert Hayden in Verse: New Histories of African American Poetry and the Black Arts Era*. Ann Arbor: University of Michigan Press, 2018.

Smith, Tracy K. *Ordinary Light*. New York: Knopf, 2015.

Smith, Valerie. *Self-Discovery and Authority in Afro-American Narrative*. Cambridge, MA: Harvard University Press, 1987.

Smith, Zadie. *Changing My Mind: Occasional Essays*. New York: Penguin, 2009.

———. *Feel Free*. New York: Penguin, 2018.

———. *NW*. New York: Penguin, 2012.

———. "Toyin Ojih Odutola's Visions of Power." *New Yorker*. August 17, 2020. www.newyorker.com/magazine/2020/08/17/toyin-ojih-odutolas-visions-of-power.

Spillers, Hortense. "The Crisis of the Negro Intellectual: A Post-Date." *boundary 2* 21, no. 3 (Autumn 1994): 65–116.

———. "Mama's Baby, Papa's Maybe: An American Grammar Book." *Diacritics: A Review of Contemporary Criticism* 17, no. 2 (Summer 1987): 65–81.

Spillers, Hortense, et al. "Watcha Gonna Do?—Revisiting 'Mama's Baby, Papa's Maybe: An American Grammar Book': A Conversation with Hortense Spillers, Saidiya Hartman, Farah Jasmine Griffin, Shelly Eversley, & Jennifer L. Morgan." *Women's Studies Quarterly* 35, no. 1/2 (Spring–Summer 2007): 299–309.

Stack, Liam, and Palko Karasz. "How Belgium Became Home to Recent Terror Plots." *New York Times*. March 23, 2016. www.nytimes.com/interactive/2015/11/15/world/europe/belgium-terrorism-suspects.html.

Stallings, LaMonda Horton. *Funk the Erotic: Transaesthetics and Black Sexual Cultures*. Urbana: University of Illinois Press, 2015.

Stromae. "Formidable." *Racine Carrée*. Universal Music, 2013.

"Stromae's Lyrics 'Show a Different Vision of the World.' *Tell Me More*. February 19, 2014. www.npr.org/2014/02/19/279627227/music-star-stromaes-lyrics-show-a-different-vision-of-the-world.

Taylor, Paul C. *Black Is Beautiful: A Philosophy of Black Aesthetics*. Malden, MA: Wiley Blackwell, 2016.

———. "Post-Black, Old Black." *African American Review* 41, no. 4 (Winter 2007): 625–640.

"Toyin Ojih Odutola: (QuarARTine Special Episode)." June 1, 2020. www.iheart.com/podcast/256-talk-art-30960052/episode/toyin-ojih-odutola-quarartine-special-episode-63297533/.

Treisman, Deborah. "Edwidge Danticat on Her Caribbean Immigrant Experience." *New Yorker*. May 7, 2018. www.newyorker.com/books/this-week-in-fiction/fiction-this-week-edwidge-danticat-2018-05-14.

Unigwe, Chika. "The Near-Impossibility of Assimilation in Belgium." *New York Times*. November 25, 2016. www.nytimes.com/2015/11/25/magazine/the-near-impossibility-of-assimilation-in belgium.html?_r=0.

Wallace, Michele. *Dark Designs and Visual Culture*. Durham, NC: Duke University Press, 2004.

Warren, Calvin. "Black Nihilism and the Politics of Hope." *CR: The New Centennial Review* 15, no. 1 (Spring 2015): 215–248.

———. "Black Time: Slavery, Metaphysics, and the Logic of Wellness." In *The Psychic Hold of Slavery: Legacies in American Expressive Culture*, edited by Soyica Diggs Colbert, R. J. Patterson, and A. Levy-Hussen, 55–68. New Brunswick, NJ: Rutgers University Press, 2016.

Warren, Kenneth W. *What Was African American Literature?* Cambridge, MA: Harvard University Press, 2011.

Washington, Mary Helen. *The Other Blacklist: The African American Literary and Cultural Left of the 1950s*. New York: Columbia University Press, 2015.

Weheliye, Alexander. *Habeas Viscus: Racializing Assemblages, Biopolitics, and Black Feminist Theories of the Human*. Durham, NC: Duke University Press, 2014.

"What Was African American Literature: A Symposium." *Los Angeles Review of Books*. June 13, 2011. https://lareviewofbooks.org/article/what-was-african-american-literature-a-symposium/.

Wheeler, André. "Novelist Terry McMillan on Love, Death and 'Dirty Secrets.'" *The Guardian*. March 31, 2020. www.theguardian.com/books/2020/mar/31/novelist-terry-mcmillan-interview-its-not-all-downhill-from-here.

Wilderson, Frank. *Red, White and Black: Cinema and the Structure of U.S. Antagonisms*. Durham, NC: Duke University Press, 2010.

Williamson, Terrion L. *Scandalize My Name: Black Feminist Practice and the Making of Black Social Life*. New York: Fordham University Press, 2016.

Winters, Joseph R. *Hope Draped in Black: Race, Melancholy, and the Agony of Progress*. Durham, NC: Duke University Press, 2016.

Wright, Michelle M. *Physics of Blackness: Beyond the Middle Passage Epistemology*. Minneapolis: University of Minnesota Press, 2015.

Wright, Richard. *Native Son*. New York: Harper Perennial, 1940, 1993 reprint.

Wynter, Sylvia. "Unsettling the Coloniality of Being/Power/Truth/Freedom: Towards the Human, after Man, Its Overrepresentation—An Argument." *CR: The New Centennial Review* 3, no. 3 (Fall 2003): 257–337.

"Zadie Smith: By the Book." *New York Times*. November 17, 2016. www.nytimes.com /2016/11/20/books/review/zadie-smith-by-the-book.html.

Zak Group. Accessed January 21, 2023. www.zak.group/projects/toyin-ojih-odutola -a-countervailing-theory.

Index

abstraction, 72, 125; abstractionism, 126, 166n16

activism: antiracist, 31; Black Power/Black Art and, 64, 142n23; civil rights, 104–105, 160n12; post-soul, 57, 62, 64–65

Adichie, Chimamanda, 86, 147n7

aestheticism: aesthetic affect, 39; aesthetic encounter, 2, 7, 12, 16, 30, 57, 82, 96, 102, 123, 128, 137n15, 139n38; aesthetic engagement, 7, 57; aesthetic experiences, 110–111, 114; aesthetic habit, 15, 104, 129; aesthetic invention, 1–2, 4, 159n28; aesthetic modes of being, 42, 123; aesthetic optimism, 2, 35–36, 44, 47, 66, 89, 147n5, 147n6; aesthetic sovereignty, 26, 49, 93, 129–130, 136n9; aesthetic thinking, 2, 27, 36; Black aesthetic time, 1–3, 15, 35, 52, 56, 66 151n2; post-soul aesthetic, 2, 40, 57, 60, 62–63, 65–68, 85, 102, 141n51, 143n30, 153n33; relational aesthetic, 14. *See also* Black aesthetic

Africa, 75, 79, 158n18; Ghanaians, 13, 147n4; and Middle Passage, 107, 151n7; 85; Nigeria, 72, 77, 79, 83, 157n6; refugees from, 8, 13; Rwanda, 11, 138n26, 140n50; and slavery, 107; West Africa, 6, 75, 123. *See also* diaspora, African

African Americans. *See* Blackness

Afrofuturism, 52, 55, 72

Afrohistoricism, 52, 55

Afropresentism, 52, 56–57

agency, 39, 70, 82, 114, 127, 158n17

Ahmed, Sara, 77, 118, 132, 159n26; *Queer Phenomenology* by, 1, 10, 32, 78–79, 82, 157n10, 159n25

Alexander, Elizabeth, 39, 112

Alexander, Michelle, 42

alienation, 27, 53, 115, 117, 137n14, 137n15; in *Brown Girl, Brownstones*, 87, 90, 93, 95, 162n26; Stromae and, 9, 11–12

aliveness, 18, 25, 33, 35, 52, 106–107, 110–112, 114

ambiguity, 44, 77, 115, 119, 123, 131

ambivalence, 47, 87, 91, 97, 116, 119, 135n6, 141n5

anti-essentialism, 46, 59, 65, 139n30, 153n31

antiblackness, 28, 31, 39, 152n26. *See also* racism

archives, 17, 41, 88, 140n45, 143n29, 144n34, 149n34, 161n14

art, 3, 119: art history, 14, 17, 24, 138n30; art-historical traditions, 70–71, 73, 79; art-objects, 2, 14, 19, 24, 27, 90; Black, 8–9, 11, 14, 24, 26–27, 60, 62, 64, 84, 86–87, 142n22, 147n4; Black Power/Black Art movement, 26, 60, 64, 142n23; in *Brown Girl, Brownstones*, 90–91, 94–96; in *Daughters*, 103–105; Eurocentrism and, 138n30; New Criticism and, 30; post-soul, 57–58, 60–65, 67–69, 153n33, 154n38, 155n65; Stromae and, 5, 11–12, 14, 19–20, 136n9, 137n15; in *Swing Time*, 120–121, 123–125, 129–130; thinking like a work of, 36, 49, 146n4; Toyin Ojih Odutola and, 70–79, 81, 83; W.E.B. Du Bois on, 142n21

Ashe, Bertram, 40, 57, 60–66, 123, 153n33

Astaire, Fred, 124–125

fiction: Afro-futurism and, 55; Paule Marshall and, 85–87, 99–100, 162n37; popular, 100; Zadie Smith and, 44, 49–50, 150n56

Fleetwood, Nicole, 73, 167n82

Fleming, Julius B., 51, 56, 104–105, 151n2, 152n26, 153n28, 167n25

fluidity, 6, 24, 47, 60, 62, 138n21

"Formidable" (Stromae), 5–12, 14–17, 19, 23, 135n2, 137n15, 137n17, 141n52

freedom, 15; Black aesthetic optimism and, 37, 39, 43–44, 47; Black time and, 56, 61, 63–64, 66, 69; freedom dreams, 37, 56; Paule Marshall and, 93–94, 97; in *Swing Time*, 123, 125, 129; Toyin Ojih Odutola and, 73, 78; unfreedom, 67

futurity, 1, 7, 24, 27, 33–34, 37–38, 133, 148n11, 152n15; Afrofuturism, 52, 55–56, 72, 156n6; Paule Marshall and, 94, 97, 101, 105; Toyin Ojih Odutola and, 83

Galeano, Eduardo, 108, 165n11

gay men, 37, 101–102

gender, 23, 44, 65, 72, 89, 101, 142n6, 147n7; Black men, 8, 12, 19, 38, 61, 65, 99, 101–102, 137n15, 151n7; fluidity, 19, 138n21. *See also* women

George, Nelson, 59, 61, 154n47, 155n53

Gilman, Claire, 82, 159n29

Glissant, Édouard, 14–16, 19, 23, 93, 117, 139n32, 139n33, 139n34, 140n50

Golden, Thelma, 62–63, 67, 156n74

Greenidge, Kaitlyn, 124, 166n9

Griffin, Farah Jasmine, 13, 87, 90, 162n26

Guiot, Jérôme, 5–6, 9, 19

Harper, Philip Brian, 126, 166n16

Hartman, Saidiya, 12–13, 39–43, 54, 89, 111, 137n14, 139n34, 152n18, 159n29, 160n31, 161n14, 167n25; "Venus in Two Acts" by, 30–32, 54

Heidegger, Martin, 1, 7, 51, 141n52

hip-hop, 6, 11, 37, 46

history: Afrohistoricism, 52, 55; art history, x, 14, 17, 24, 138n30; Black time, 151n6; Blackness and, 3, 7–9, 16, 26, 39, 52–54, 57, 59, 63, 66, 164n1; Caribbean, 14; Dionne Brand, 106–111, 114; fictions of, 41; historical consciousness, 58, 87, 130n; historical criticism, 54; historical determinism, 4, 82, 135n6, 144n32, 144n34; historicism, 51, 54–55, 88–89; historicity, 37, 53, 55, 66, 68, 90, 144n32; historiography, 7, 10, 41, 151n2, 161n14; Paule Marshall and 85–90, 92, 97, 99–100; post-soul and, 57–61, 65–69; slavery and, 52–53, 151n7, 161n14; sociohistorical contexts, 4, 38, 44, 65, 90; Toyin Ojih Odutola and, 71–73, 79, 82–83, 151n6; Zadie Smith, 129–130

Houston, Whitney, 130, 167n32

Hughes, Langston, 26, 142n23

humanity, 15, 25, 49, 51–52, 62–63, 131–132, 158n20; Blackness and, 3, 28, 38–41, 80, 75, 97, 140n45; humanism, 19, 47, 53, 56, 73, 146n51, 151n2; posthumanism, 67

hybridity, 6, 11, 42, 62, 85–86, 100, 137n19, 138n21

identity: agency and, 82; Blackness and, 7, 36, 49, 52–53, 58–60, 66, 68, 78, 82, 88–89, 146n1; identity politics, 46; Paule Marshall and, 85, 88, 91, 97, 160n4; post-soul era and, 58–60, 66, 68, 153n31; social, 12, 46, 82; Stromae and, 5, 7, 11–12, 14, 19; time and, 52–53, 63; Zadie Smith and, 44–47, 49, 121–124, 126

imagination, 1–4; Black imaginary, 3, 36, 40–44, 56–57, 78, 135n5, 149n19, 151n2, 159n26; Black time and, 52–54; Dionne Brand and, 108–109, 113, 117; imaginative freedom, 44, 47; Paule Marshall and, 85, 87, 90, 92–97; Stromae and, 12, 14–16, 18; Toyin

Printed in the USA
CPSIA information can be obtained
at www.ICGtesting.com
LVHW091914101123
763623LV00006B/31